Mounted Oriental
PORCELAIN

in the J. Paul Getty Museum

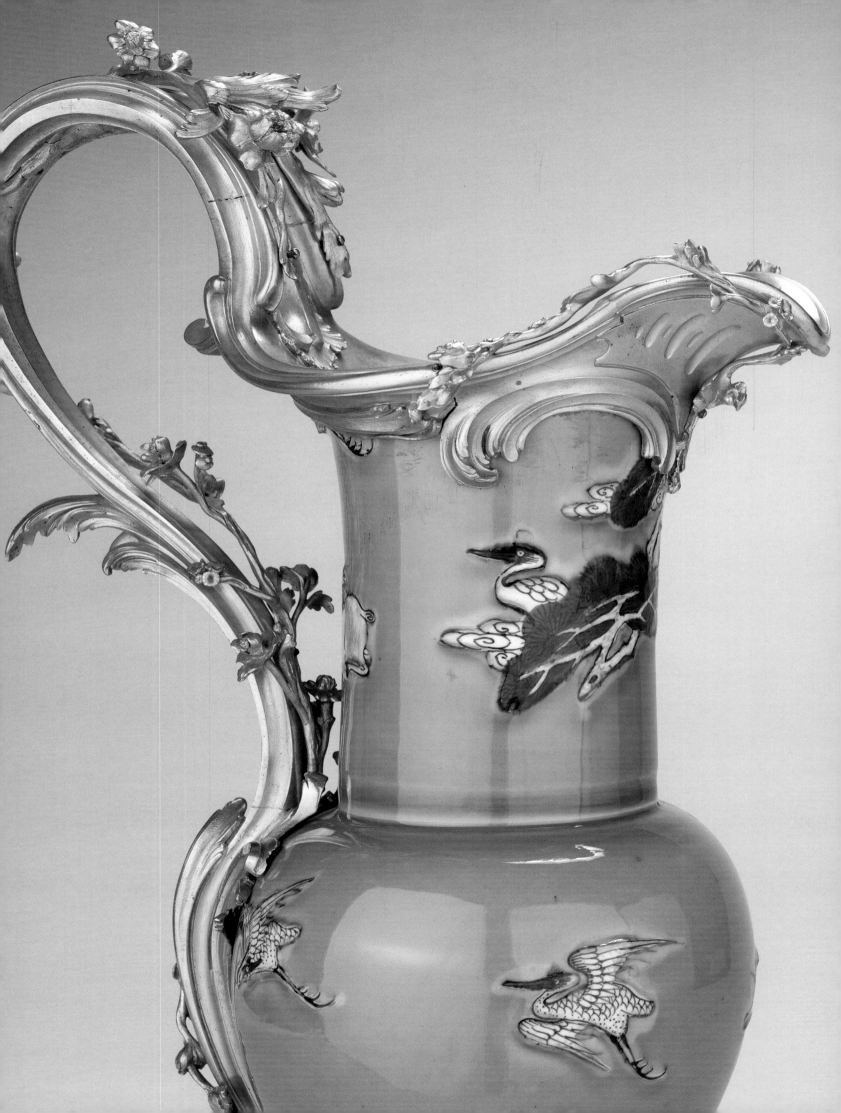

Mounted Oriental
PORCELAIN
in the J. Paul Getty Museum

Revised Edition

Gillian Wilson

Introduction by Sir Francis Watson

The J. Paul Getty Museum

Los Angeles

Christopher Hudson, Publisher
Mark Greenberg, Managing Editor

Project staff:
Shelly Kale, Editor
Kurt Hauser, Designer
Anita Keys, Production Coordinator
Jack Ross, Photographer

Typography by G&S Typesetters
Printed by Gardner Lithograph

Library of Congress Cataloging-in-Publication Data

J. Paul Getty Museum.
 Mounted oriental porcelain in the J. Paul Getty Museum / Gillian Wilson ;
introduction by Sir Francis Watson. — Rev. ed.
 p. cm.
 Includes bibliographical references and index.
 ISBN 0-89236-562-5
 1. Porcelain, Chinese—Ming-Ch'ing dynasties, 1368–1912 Catalogs.
2. Porcelain, Japanese—Edo period, 1600–1868 Catalogs. 3. Porcelain—
California—Los Angeles Catalogs. 4. Mounts (Decorative arts)—France—
History—18th century Catalogs. 5. Mounts (Decorative arts)—Califor-
nia—Los Angeles Catalogs. 6. J. Paul Getty Museum Catalogs. I. Wilson,
Gillian, 1941– . II. Title.
NK4565.5.J24 1999
738.2'0951'07479493—dc21 99-25298
 CIP

CONTENTS

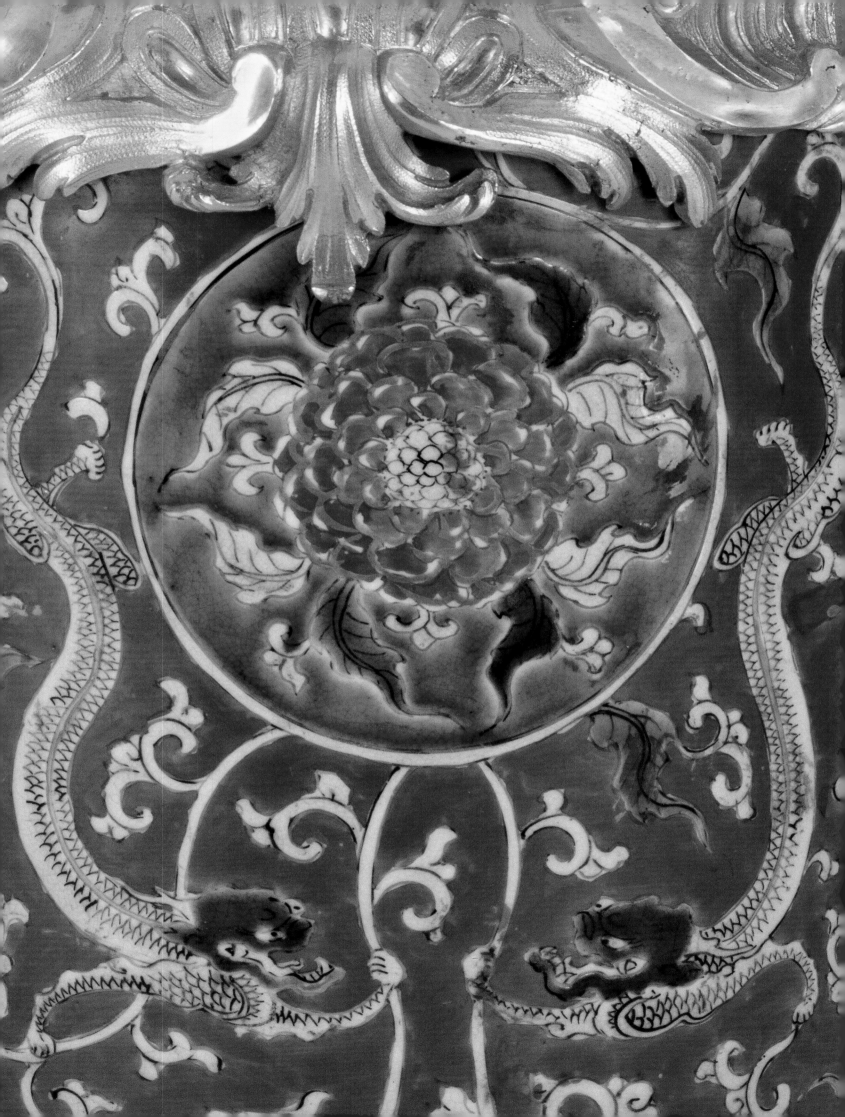

FOREWORD

This catalogue is a revised and expanded edition of *Mounted Oriental Porcelain in the J. Paul Getty Museum*, which was published in 1982. Oriental porcelain with Parisian gilt-bronze mounts forms a small but significant part of the Getty Museum's collection of decorative arts. These objects provide tangible evidence of cultural contact in the eighteenth century between China and Japan and the West.

The practice of embellishing oriental porcelain with silver or gilt-bronze mounts marks a period in history during which a growing awareness of the Far East inspired taste and fashion in Europe. Adorning Chinese and Japanese porcelain with European-made mounts familiarized and elaborated the exotic, adapting it to the character of contemporary French interiors.

J. Paul Getty began collecting decorative arts in the 1930s but did not start to form a collection of mounted porcelain until shortly before his death in 1976. Since then, the collection has grown considerably under the sure eye of Gillian Wilson, Curator of Decorative Arts, whose discrimination is evident throughout the galleries. This book and the other catalogues of her collection reflect her accomplishments; to her, and to all who assisted in the production of this volume, I express my admiration and gratitude.

Deborah Gribbon
Deputy Director and Chief Curator

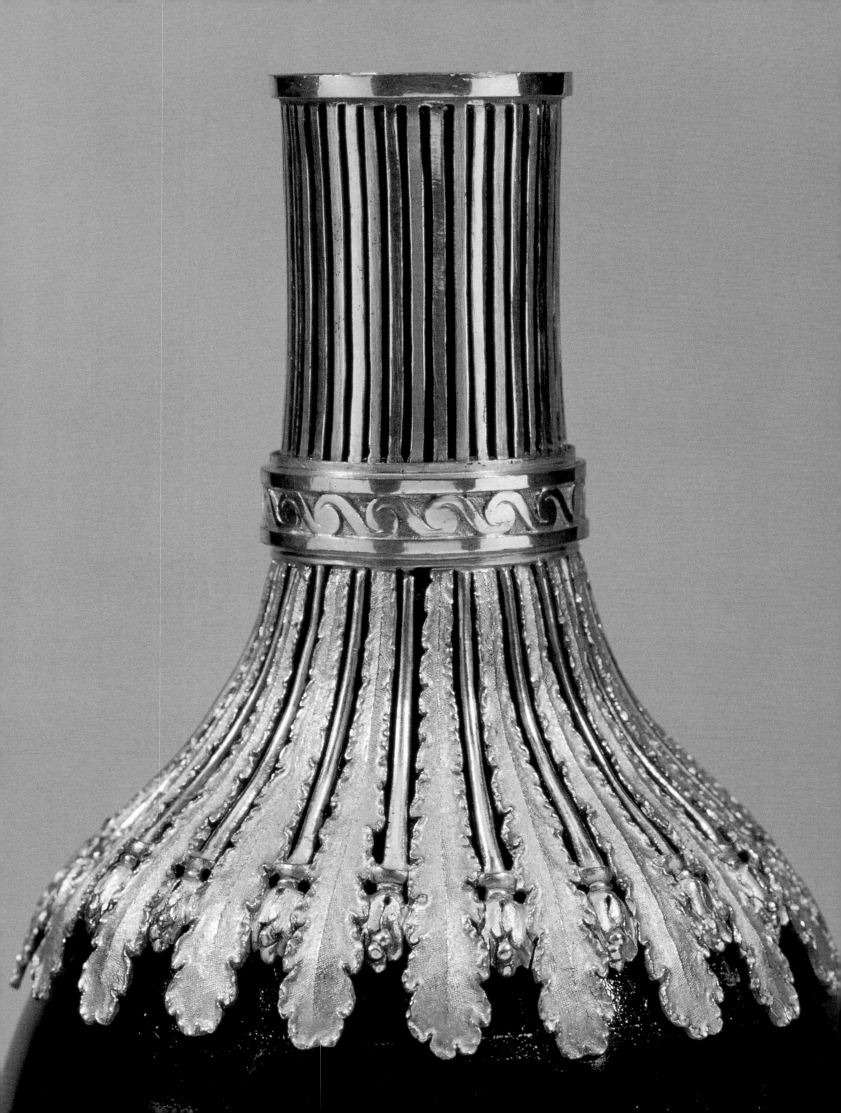

ACKNOWLEDGMENTS

This catalogue describes and discusses thirty-two items of mounted porcelain arranged in twenty-two entries. The collection was formed between 1972 and 1991, with the exception of catalogue number 21, which was acquired by J. Paul Getty in 1953. The gilt-bronze mounts and the porcelain that they embellish range in date from circa 1665 to 1785.

Sir Francis Watson's original introductory essay has been retained, and an appendix, glossary, bibliography, and index are provided. Edgar Harden has written catalogue entries for five of the objects (catalogue nos. 1, 8, 17, 20, and 22). Li He of the Asian Art Museum, San Francisco, afforded extensive assistance with the dating and description of the Chinese porcelain.

The photographs were taken by Jack Ross, and the book designed by Kurt Hauser. The production of the book was coordinated by Anita Keys. With great patience, Nina Banna and Dana Gorbea-Leon typed and retyped the manuscript, which was edited by Shelly Kale.

I would like to express gratitude for help of various sorts to the following: Stacey Pierson, The Percival David Foundation of Chinese Art, London; Roger Keverne, London; Adrian Sassoon, London; Clare le Corbeiller, the Metropolitan Museum of Art, New York; Christian Baulez, Musée de Versailles; Jean Nérée Ronfort, Paris; Jean Dominique Augarde, Paris; Anthony du Boulay, England; and Theodore Dell, New York.

I would also like to thank Charissa Bremer-David, associate curator, and Jeffrey Weaver, assistant curator, of the Getty Museum's Department of Decorative Arts for their help and assistance.

Gillian Wilson
Curator of Decorative Arts

LIST OF ABBREVIATIONS

In notes and bibliographies, frequently cited works are identified by the following abbreviations.

BEURDELEY AND RAINDRE 1987
Beurdeley, Michel, and Guy Raindre. *Qing Porcelain: Famille Verte, Famille Rose, 1644–1912*. New York, 1987.

BREMER-DAVID ET AL. 1993
Bremer-David, Charissa, with Peggy Fogelman, Peter Fusco, and Catherine Hess. *Decorative Arts: An Illustrated Summary Catalogue of the Collections of the J. Paul Getty Museum*. Malibu, 1993.

DE BELLAIGUE 1974
de Bellaigue, Geoffrey. *Furniture, Clocks, and Gilt Bronzes. The James A. de Rothschild Collection at Waddesdon Manor*. 2 vols. Fribourg, 1974.

DONNELLY 1969
Donnelly, P. J. *Blanc de Chine: The Porcelain of Têhua in Fukien*. London, 1969.

GETTYMUSJ
The J. Paul Getty Museum Journal.

HUGHES 1996
Hughes, Peter. *The Wallace Collection: Catalogue of Furniture*. 3 vols. London, 1996.

JARRY 1981
Jarry, Madeleine. *Chinoiserie: Chinese Influence on European Decorative Art, Seventeenth and Eighteenth Centuries*. New York, 1981.

LANE 1949–50
Lane, Arthur. "Queen Mary II's Porcelain Collection at Hampton Court." *Transactions of the Oriental Ceramic Society* 25 (1949–50), pp. 21–31.

LIVRE-JOURNAL DE LAZARE DUVAUX 1873
Livre-journal de Lazare Duvaux, marchand-bijoutier ordinaire du roy, 1748–1758. Edited by Louis Courajod. 2 vols. Paris, 1873.

LUNSINGH SCHEURLEER 1980
Lunsingh Scheurleer, D. F. *Chinesisches und japanisches Porzellan in europäischen Fassungen*. Brunswick, 1980.

SARGENTSON 1996
Sargentson, Carolyn. *Merchants and Luxury Markets: The Marchands Merciers of Eighteenth-Century Paris*. Malibu, 1996.

WATSON 1980
Watson, Francis. *Chinese Porcelains in European Mounts*. New York, 1980.

WATSON 1981
Watson, Francis. "Chinese Porcelain in European Mounts." *Orientations* 12, no. 9 (September 1981), pp. 26–33.

WATSON 1986
Watson, Francis. *Mounted Oriental Porcelain*. Washington, D.C., 1986.

WATSON 1987
Watson, Francis. "Mounted Oriental Porcelain." *Magazine Antiques* 131 (April 1987), pp. 813–23.

WATSON AND DAUTERMAN 1966–70
Watson, Francis, and Carl Dauterman. *The Wrightsman Collection.* 4 vols. New York, 1966–70.

WILSON 1977
Wilson, Gillian. *Decorative Arts in the J. Paul Getty Museum.* Malibu, 1977.

WILSON 1979
Wilson, Gillian. "Acquisitions Made by the Department of Decorative Arts, 1977 to Mid-1979." *The J. Paul Getty Museum Journal* 6–7 (1979), pp. 37–52.

WILSON 1980
Wilson, Gillian. "Acquisitions Made by the Department of Decorative Arts, 1979 to Mid-1980." *The J. Paul Getty Museum Journal* 8 (1980), pp. 1–22.

WILSON 1982
Wilson, Gillian. "Acquisitions Made by the Department of Decorative Arts, 1981." *The J. Paul Getty Museum Journal* 10 (1982), pp. 63–86.

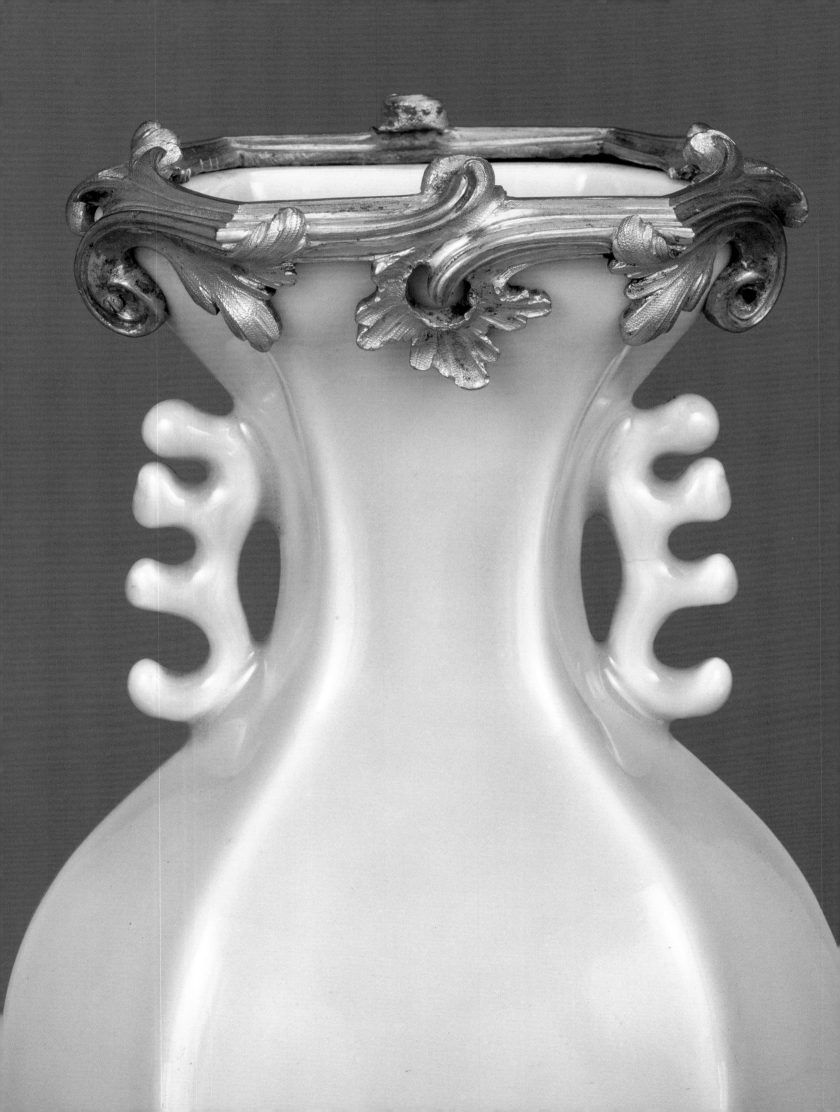

INTRODUCTION

A wide variety of ceramic wares—English, French, German, and Italian—from the Near and Far East, as well as vessels of glass, rock crystal, and hardstones, have been enriched with metal mounts in the course of European history. However, the collection catalogued here consists almost exclusively of Chinese and Japanese porcelains mounted in Paris during the reigns of Louis XIV (1643–1715) and Louis XV (1715–1774). In the majority of cases, the mounts date from around the two middle decades of the eighteenth century. These facts call for some explanation.

The practice of mounting oriental porcelain in Europe dates back at least to the Middle Ages, and pieces so mounted survive from the early Renaissance. These mounts were a tribute not so much to the beauty of the porcelains as to the extreme rarity of the material.[1] When, in the second half of the seventeenth century, oriental works of art began to reach Europe in considerable quantities, they continued to be mounted in precious or semiprecious metals (generally silver or silver-gilt), but it was their exotic character rather than their rarity that now excited interest. By the middle of the eighteenth century, *lachine*[2] was the height of fashion in Paris, the generally acknowledged focal point of European taste at the time. Without question, more oriental porcelain was set in metal mounts (by this date, generally of gilt bronze) of European design, in Paris, between 1740 and 1760 than at any other period in the world's history. Consequently, more examples from this period have survived into the modern world.

Pieces mounted during the Middle Ages are virtually nonexistent today; we know of them only from descriptions in early inventories. A few pieces mounted during the Renaissance survive, but they are exceedingly rare; only a handful are found in the United States. Even the porcelains which were mounted in silver in considerable quantity during the reign of Louis XIV (see catalogue nos. 4 and 6) are rare. Probably the mounts of many of these oriental pieces were removed and melted down when such things had ceased to be fashionable.[3]

Far Eastern porcelains were also mounted in countries other than France. In Holland, much porcelain was enriched in this way during the seventeenth century (though much less in the following centuries) and is sometimes depicted in Dutch paintings of the period. Mounts were also applied to porcelains in Germany, more frequently to copies of oriental pieces. Nevertheless, more Meissen porcelain was in fact mounted in Paris than in Saxony itself. Examples of Chinese porcelain with Venetian mounts are known, but they too are very few. In England, mounts were occasionally applied to Chelsea and other native wares and, though rarely, to Chinese and Japanese porcelain (see catalogue no. 1).[4] Englishmen such as Lord Bolingbroke, who collected such things, mostly purchased their mounted porcelain in Paris.[5] In effect, the history of mounted oriental porcelain in the eighteenth century, which might justly be called the golden age of mounted porcelain, is, for all practical purposes, the history of porcelain mounted in Paris.

Whatever may have been the intention in earlier epochs, during the eighteenth century the main reason for setting these oriental objects in mounts of European design was to naturalize them to the decoration of French interiors of the period; i.e., to modify their exotic character by giving them a quasi-French appearance.[6] The men who devised these pretty things for the rich, extravagant, and sophisticated society of eighteenth-century Paris were, to some degree, the equivalent of modern interior decorators, but they were not the makers of the

mounts. These men belonged to one of the city's oldest trade guilds, whose history dates back to the twelfth century, and were known as *marchands-merciers*.

The word *marchand-mercier* is untranslatable, for the profession itself did not exist either in England or in any country other than France. Literally translated, the term is tautological; it means "merchant-merchant," which does not tell us very much. The *marchands-merciers* combined the roles of antique dealer, jeweler, frame maker, supplier of light fittings and hearth furniture, dealer in new and old furniture, and interior decorator.[7] They often were picture dealers as well. They created nothing themselves but employed other craftsmen to work on their ideas and their designs. Diderot called them *faiseurs de rien, marchands de tout*. As inspirers of taste and fashion, their role was to provide the world of fashion with the chic and the up-to-date, what the English of the day called "kickshaws." A contemporary, writing of the *marchand-mercier* Hébert, wittily remarked, "*Il fait en France ce que les Français font en Amerique; il donne des colifichets pour des lingots d'or.*"[8]

To embody their ideas and designs, the *marchands-merciers* employed furniture makers (*ébénistes*), bronze casters (*fondeurs*), gilders (*doreurs*), and so on. They themselves merely marketed the results. The *marchands-merciers* were exceedingly ingenious in devising ways of adapting rare and exotic materials, especially those from the Far East, to the decoration of the houses of the rich. It was the *marchands-merciers* who first thought of cutting up lacquer screens and cabinets from the Orient and veneering panels from them onto furniture of purely European design. It was they too who purchased writing boxes and other items of Japanese lacquer found on the Dutch market and employed goldsmiths like Ducrollay to cut them up and mount the fragments as *tabatières, bonbonnières, cartes de visite, étuis, navettes,*[9] and other expensive toys that formed so essential a part of the social intercourse of Parisian society of the day. The *marchands-merciers* also encouraged the brothers Martin to devise what was by far the most successful European attempt to imitate oriental lacquer, a type of very hard varnish patented in 1744 and known by the name *vernis Martin*, after its inventors. Even so essentially French a device as the practice of mounting wooden furniture with gaily colored plaques of Sèvres porcelain was the result of the *marchands-merciers*' interest in the use of oriental materials. The earliest experiments in this field were made with plaques of Sèvres porcelain imitating Cantonese enamels.[10] As far as mounted porcelain was concerned, these middlemen bought the porcelain (mostly on the Dutch market) and employed *fondeurs* and *doreurs* to create the mounts, which the *marchands-merciers* probably designed.[11] We may note in passing that from time to time lacquer, generally Japanese lacquer bowls, boxes, etc., was also mounted.[12]

We are fortunate that the *Livre-journal*, or sales ledger, of the *marchand-mercier* Lazare Duvaux has survived.[13] It covers the decade of 1748 to 1758, the peak years of the fashion for mounted oriental porcelain. Literally hundreds of examples of mounted porcelain, both European and oriental, passed through Duvaux's hands during this period. He was an important figure in the commerce in such things, a *marchand suivant la Cour* (the equivalent of a tradesman "by Royal Appointment" in London today), and all the most important figures in Parisian society came to his shop, *Au Chagrin de Turquie*, in the fashionable rue Saint-Honoré. The marquise de Pompadour, one of Duvaux's most regular clients, purchased more than one hundred and fifty pieces of mounted oriental porcelain from him during the period covered by the *Livre-journal*. Louis XV patronized Duvaux's shop; so did the queen. Many of the most important members of the court of Versailles were his clients, as were foreign royalty and visiting Englishmen and, in fact, the entire European world of fashion; and most of them bought mounted porcelains.

The *Livre-journal* is a mine of information on the subject of mounted porcelain, as shown in the quotations in this catalogue. The ledger describes a wide variety of types of mounted porcelain and their prices, as well as the price of unmounted porcelain and the cost of the mounts. From this book we learn who collected mounted porcelain (practically every one of Duvaux's clients), and occasionally even the names of the craftsmen who actually made the mounts (see p. 16).

Ingenious and inventive as the *marchands-merciers* were, they did not invent the idea of setting oriental porcelain in metal mounts of European design. They simply developed this practice and gave it fresh life. Emphasizing the rarity (and sometimes the beauty) of small and exotic objects by mounting them in precious or semiprecious metals has a very long history. Certain great cathedral treasuries included pieces of this kind, but none have come down to us; we know them only from inventory descriptions. The greatest surviving assemblage of this type is in the Treasury of St. Mark's in Venice, where the visitor can still see bowls and goblets of classical and Byzantine origin that were mounted in gold, silver, and silver-gilt, partly to emphasize their rarity but also to adapt them for ecclesiastical use as chalices, patens, and so on. Amongst them one bowl of opaque green glass, mounted with silver-gilt and set

with jewels, was long thought to be of Chinese porcelain (fig. 1). Today it is generally agreed to be glass of Persian origin created under Chinese inspiration.

Those Far Eastern porcelains that occasionally passed into secular hands during the late medieval and Renaissance periods were mounted and treasured as great rarities. Thus as early as 1365, Louis duc d'Anjou is known to have possessed a bowl of blue-and-white porcelain of Yuan dynasty ware which was particularly richly mounted with silver-gilt and enamel. It was an object of some size, for it is described in an inventory of 1379–80 as an *escuelle pour fruiterie.*[14] The mount had a distinctly ecclesiastical flavor, since the foot was surmounted by six busts of apostles. The silver rim, however, was secular and enameled with hunting scenes. From this rim depended three rings with enameled shields displaying the duke's arms, which were attached by gilt knobs set with pearls and garnets. Less than a decade later we learn from the will of Jeanne d'Evreux, queen of Navarre, that she possessed: *"Un pot a eaux de pierre de purcelleine a un couvercle d'argent et bordée d'argent pesant un marc iiii onces, prisiee iiij francs d'or."*

Porcelain must have been becoming a little less rare, for a little later, the duc d'Anjou's brother, the great Maecenas Jean duc de Berry, possessed several pieces of both mounted and unmounted Chinese porcelain. In the inventories of his possessions drawn up between 1401 and 1416, we find mention of:

730. Item un pot de pourcellaine, a un ance d'argent blanc et le demourant avec le couvercle garni d'argent dore; et dessous le couvercle a un esmail de pelit, pesant i marc v onces xv sterlins.
731. Item un autre pot de pourcellaine, avec l'ance de memes garnie d'argent d'ore; et dessus le fretelet un roze d'argent doree; pesant i marc i once.[15]

Perhaps of an even earlier date than these was a ewer given the duke in November 1410 (as the inventory tells us) by the anti-pope John XXIII (of Gibbonian fame): *"Item une aiguiere de pourcellaine ouvree, le pie, couvercle et biberon de laquelle sont d'argent doré."*[16] This piece was evidently not of blue-and-white porcelain but of the white Yuan ware with incised or applied reliefs, which was exceedingly rare in Europe during this period. It may be compared with the Gaignières-Beckford vase mentioned below.

A century later such things were still rare and highly prized in France. Thus we find listed amongst François I's possessions at the château de Fontainebleau: *"Une petite vase de porcelaine avec son couvercle, avec le pied et le biberon d'argent doré."*[17]

It was the same in Italy. Amongst the pieces mentioned in the inventory of Piero de' Medici's *Gioie e Simile Cose,* there are several pieces of Chinese porcelain including: *"Una choppa de porcellana leghata in oro,"*[18] although we do not know at what date this piece entered the Medici collection.

FIGURE 2. Bottle-shaped vase of white Chinese porcelain of the Yuan dynasty. This is the same porcelain object as that shown in Figure 3 but now stripped of its mounts. Note the hole pierced in the body (one of several) for the attachment of the missing mounts. *Dublin, National Museum of Ireland. Photo: Courtesy of National Museum of Ireland.*

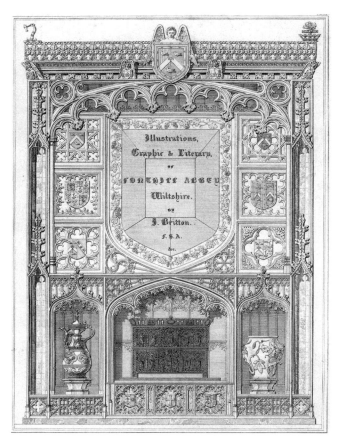

FIGURE 3. Detail of the frontispiece of John Britton's *Graphical and Literary Illustration of Fonthill Abbey, Wiltshire* (1823), showing the Gaignières-Beckford mounted ewer displayed in a niche of Gothic design at Fonthill.

A piece of the rare Yuan period ware mentioned in the inventory of the duc de Berry is the most important example of the practice of mounting Chinese porcelain to survive from this period. This is the so-called Gaignières-Beckford ewer, a white porcelain pear-shaped bottle made at Jingdezhen early in the fourteenth century and converted into a handled ewer of European design by means of silver-gilt mounts that were partly enameled, like the duc d'Anjou's *escuelle* mentioned above, with the armorial bearings of a former owner. The mounts are by inference probably of Hungarian origin, for the piece was presented by Louis the Great of Hungary to Charles III of Durazzo on the occasion of the latter's succession to the throne of Naples in 1381. Today the vase alone may be seen in the National Museum of Ireland[19] (fig. 2); unhappily, it has been deprived of its mounts, which were certainly in position as late as 1844. The appearance of these mounts, however, is familiar from two sources: a detailed drawing made in 1793 for Roger de Gaignières, a famous *archéologue* and its former owner, and an engraving (fig. 3), published in 1823, when it was in the possession of the equally famous English collector William Beckford at Fonthill Abbey in Wiltshire.[20]

The earliest piece of Far Eastern porcelain to survive intact with its European mounts is a celadon bowl of the Sung period mounted with silver-gilt as a covered cup, which is today in the Staatliche Kunstsammlungen at Kassel (fig. 4). The bowl is known to have been brought back from the Far East by Count Philip von Katzenellenbogen, who traveled in the Orient between 1433 and 1444. The armorial bearings on the mounts make it certain that these were applied to the bowl no later than 1453.[21]

With the opening up of sea communications between Europe and the Far East in the sixteenth century, Chinese porcelain became a good deal less of a rarity. Japanese porcelain, however, did not begin to arrive in

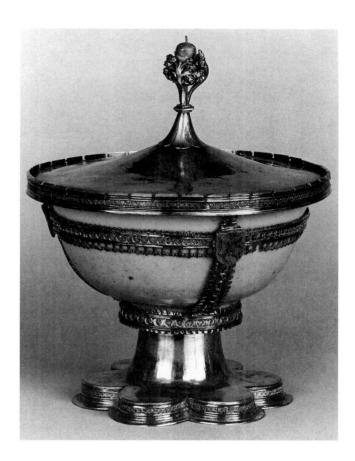

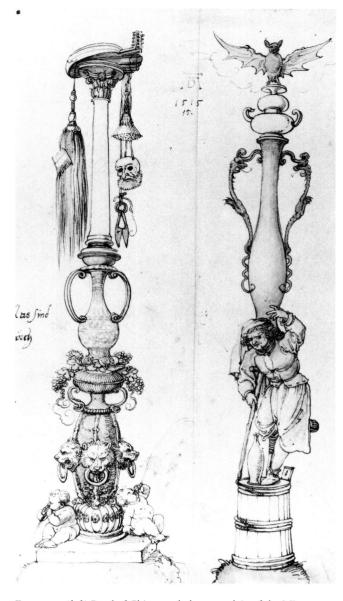

any quantity until much later, the first large cargo docking at Amsterdam in 1659.[22] The blue-and-white wares of the Ming dynasty reached Europe in considerable quantities in Portuguese and Spanish carracas.[23] A curious drawing in pen and ink by Dürer, dating from about 1510 to 1515 and now in the British Museum, shows two elaborately complex columns whose tall shafts each incorporate a Chinese vase with metal mounts of European design (fig. 5). Although Dürer himself had purchased oriental porcelain in Antwerp, these are clearly fantastic creations of the artist's imagination rather than records of anything he had seen. Nevertheless, they suggest that mounting oriental porcelain had already taken a firm hold on men's minds.

In England particularly, mounted porcelain was highly prized during this period. The earliest recorded Chinese porcelain to have reached that country was presented by Philip of Austria to Sir Thomas Trenchard in 1506 in gratitude for the entertainment of his wife and himself when they were shipwrecked off the coast of Dorset. One of these pieces was mounted in silver-gilt later in the century.[24]

In 1530, Archbishop Warham presented New College with a celadon bowl of the Ming period that had been mounted in silver (fig. 6). It is one of Oxford Univer-

FIGURE 4. (*left*) Bowl of Chinese celadon porcelain of the Ming dynasty mounted as a lidded cup. The mounts are of German silver-gilt and date from shortly before 1453. They bear the arms of Philip, count of Katzenellenbogen. This is the earliest example of oriental porcelain to survive complete with its European mounts. *Kassel, Staatliche Kunstsammlungen.*

FIGURE 5. (*right*) Albrecht Dürer (1471–1528). Drawing of a pair of fantastic columns, each incorporating a vase of Chinese porcelain with European mounts. Pen and ink, dating from 1510–1515. *London, © The British Museum.*

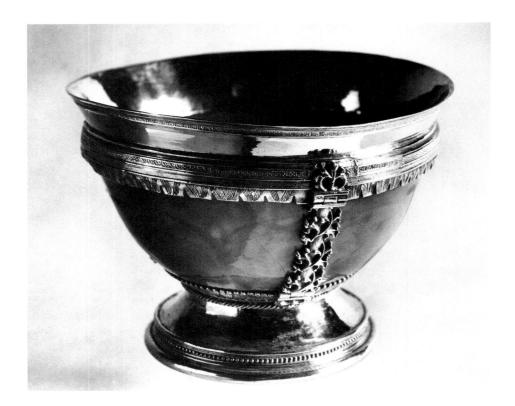

FIGURE 6. Cup of Chinese celadon porcelain of the Ming dynasty with English silver-gilt mounts, dating from the early sixteenth century. Given by Archbishop William Warham (circa 1450–1532) in 1530 to New College, Oxford, of which he had been a fellow. *By permission of the Warden and Fellows, New College, Oxford. Photo: J. W. Thomas.*

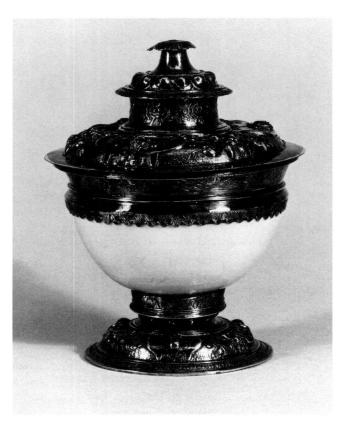

FIGURE 7. Bowl of grayish-blue Chinese porcelain of the late sixteenth century mounted with silver-gilt as a communion cup for Samuel Lennard, a London merchant. The mounts are struck with the London date-mark for 1569–70 and were made by the silversmith using the mark FR. It is the earliest known fully marked piece of oriental porcelain mounted in London. *London, Percival David Foundation, University of London.*

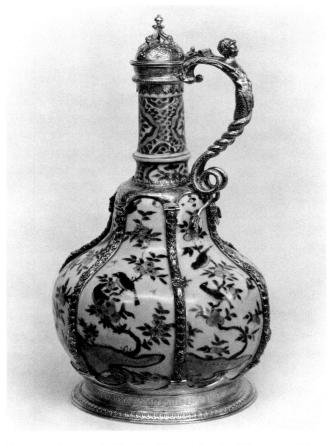

FIGURE 8. Long-necked bottle of blue-and-white Chinese porcelain of the Wanli period with English silver-gilt mounts of around 1580, converting it into an ewer. It is one of a group of Wanli porcelains mounted at this time for William Cecil, Lord Burghley. *New York, The Metropolitan Museum of Art, Rogers Fund, 1944 (44.14.2).*

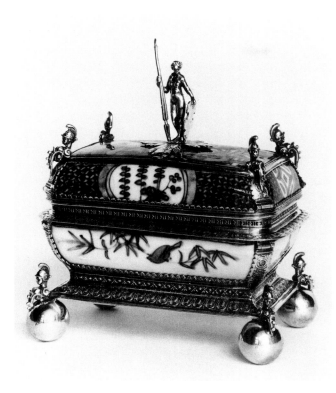

FIGURE 9. Casket of blue-and-white Chinese porcelain of the Wanli period with English mounts of silver-gilt, dating from 1570–80. *Photo courtesy of the Royal Ontario Museum, © ROM.*

sity's most prized treasures. Forty years later, a porcelain cup with a grayish-blue glaze came into the possession of a certain merchant, Samuel Lennard, and was mounted by him with silver-gilt bearing the London hallmark for 1569–70 and the mark of an unidentified silversmith with the initials FR. Believed to be the earliest fully marked piece mounted in England (fig. 7), it is known as the Lennard cup, from the name of its original owner, and is today in the collection of the Percival David Foundation of the University of London. A particularly notable group of blue-and-white porcelains of the Wanli period was mounted in London with silver-gilt for William Cecil, Lord Burghley, Queen Elizabeth's Lord Treasurer; it remained in the possession of his descendants at Burghley House until the beginning of the twentieth century. The entire group was purchased by J. P. Morgan and later acquired by the Metropolitan Museum of Art, New York (fig. 8).[25] On New Year's Day 1587, Lord Burghley presented his sovereign with a bowl of white Chinese porcelain mounted with gold, a rare reversion to medieval practice. An unusual example of mounting is the blue-and-white Ming porcelain mounted with silver-gilt as a hinged box with a classical figure surmounting the lid, which is in the Lee collection at the Royal Ontario Museum (fig. 9). The mounts are of English work and date from around 1570.

England was by no means the only country to mount Chinese porcelain enthusiastically during this period. In the Museo Civico at Bologna, for example, there is a Ming bowl with silver-gilt mounts, probably of Portuguese origin[26]; other examples could be given.[27]

After the founding in 1602 of the highly successful Dutch East Indies Company, a great deal of the trade in oriental materials of every sort gradually passed from Portuguese hands into those of Hollanders, and Dutch silversmiths began to practice the technique of mounting porcelain. Dutch mounts were usually a good deal simpler and less imaginative than contemporary English designs. A typical bowl would be given a simple rim of silver, linked to the plainly molded foot by means of strapwork of a simple pierced design. A certain number of blue-and-white pieces mounted in this way have survived, and more (and usually grander) examples can be seen in still lifes by Dutch artists of the period such as Willem Kalf.[28]

It is thus clear that by the middle of the seventeenth century, the setting of oriental porcelain in mounts of metal of European design was practiced fairly widely. As early as 1611 oriental goods, including porcelain, began to appear at the popular *Foire de Saint-Germain* in Paris. Soon after this, a contemporary versifier wrote:

> *Mênez-moi chez les Portugais*
> *Nous y verrons à peu de frais*
> *Les marchandises de la Chine*
> *Nous y verrons l'ambre gris*
> *De beaux ouvrages de vernis*
> *Et de la porcelaine fine*
> *De cette contrée divine*
> *Ou plutôt de ce paradis.*[29]

Paradoxically, the greater accessibility of Chinese, and later Japanese, porcelain increased rather than diminished interest in this exotic material. It was collected widely. Well before the end of the seventeenth century, almost every European prince or great nobleman wished to have his china cabinet, or *Porzellanzimmer* (as it was called in German lands where a number of them survive). In such rooms the walls were entirely decorated with Chinese and Japanese porcelains displayed on brackets or overmantels, in cabinets, and along cornices and shelves, even sometimes on the floor along the baseboards (fig. 10). At Hampton Court Palace visitors can still see the remains of such a decorative scheme designed by Daniel Marot for Queen Mary II's apartments.[30] In 1978–79, just such an arrangement was shown in the United States when a replica of part of the *Porzellanzimmer* of Augustus the Strong of Saxony was constructed at the exhibition of works of art from Dresden.[31]

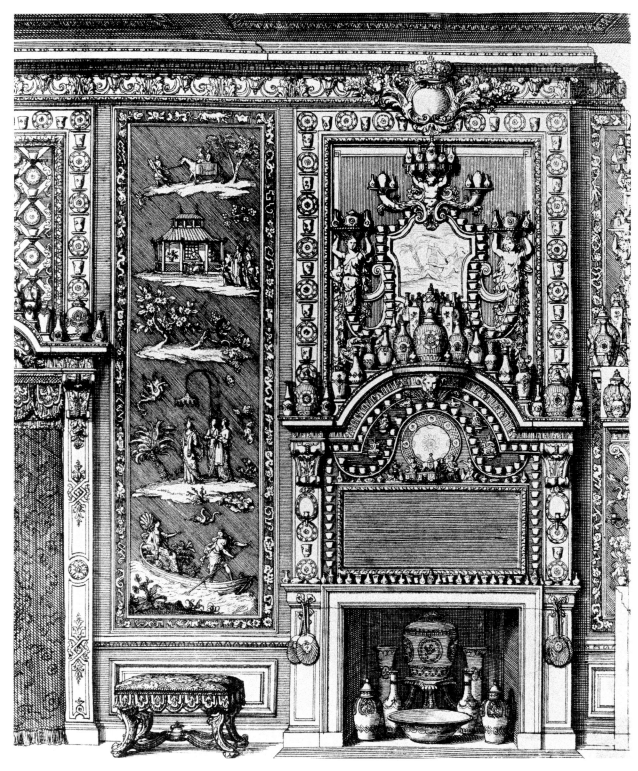

FIGURE 10. Daniel Marot (circa 1663–1752). Engraved design for the chimneypiece and part of the wall of a china cabinet. Note the ubiquity of the porcelains. Last quarter of the seventeenth century.

What Félébien described as *l'engoument pour la Chine* of the French was strikingly manifested by the so-called *Trianon de Porcelaine* erected in 1670–71 in the park at Versailles by Louis XIV for his reigning mistress, the redoubtable and witty marquise de Montespan.[32] This garden pavilion, though of purely European design (the only concession to Chinese architecture was a slight upturning of the corners of the roof), was faced with plaques of faience (porcelain had not yet been invented in Europe) painted to imitate Chinese blue-and-white porcelain. The blue-and-white color scheme was extended to the interior where the paneling of the rooms was similarly painted. A contemporary wrote enthusiastically:

Considerons un peu ce château de plaisance
Voyez-vous comme il est tout couvert de faience
D'urnes de porcelaine et de vases divers
Que le font éclater aux yeux de l'univers.[33]

Unhappily, the faience tiles of the exterior did not stand up to the winter climate of northern France, and the building had to be pulled down in 1677 after barely six years of use.[34]

If further evidence of the French admiration for Far Eastern porcelain in these early years of Louis XIV's reign is needed, it can be seen clearly in two examples. The king himself was accustomed to take the morning cup of *bouillon*, which comprised his breakfast, in a bowl of Chinese porcelain *"très fine . . . garnye par le pied d'un cercle d'or et par les le costez de deux ances de serpentes tortillez, aussi d'or."*[35] Perhaps of even greater significance is the fact that in 1678, when the Duchess of Cleveland wanted to dispose of her large collection of oriental porcelains, she sent them from London to Paris to be sold. *"Il s'en est vu cette année d'extraordinaires,"* we read in the *Mercure Galant* for that year, *"ce sont les porcelaines que Mme. la Duchesse de Cleveland y a fait vendre . . . Les plus rares étaient montées d'or ou de vermeil doré et garnies diversement de même matière en plusiers endroits."* This can only mean that mounted porcelains were in greater demand in the French capital than in London. The article ends with a long and interesting discussion of the origin of the word *porcelaine*.

The event, however, which elevated this *"engoument pour la Chine"* (a word that embraced Japanese and even Siamese works of art as well as Chinese) from a mere fashion to a veritable rage in French society, was the arrival in 1684 of the so-called Siamese "ambassadors" to the court of Versailles and their return two years later (fig. 11). In fact, neither group was strictly a diplomatic mission from the king of Siam. Both were trade delegations, arising from the great difficulties that the French government had encountered in its endeavors to set up a *Compagnie de la Chine* with a trading post in the Celestial Kingdom. As a second-best solution, it was decided to establish trade relations with the kingdom of Siam, a staging post on the trade route from China to Europe. The two missions which visited France for this purpose were organized under royal patronage by a Greek merchant, Constantinos Phaulkon, who had established himself as a trader in Bangkok and succeeded in seizing considerable political power there.

The first exploratory mission was a small one headed by two "mandarins" attended by twenty assistants and a group of young Siamese boys who were brought to France to learn the language and, if possible, receive training in certain Western crafts. The second mission was considerably larger and was solemnly received by Louis XIV in the Grande Galerie at Versailles on the first of September 1686.[36]

For the French, the most remarkable part of the visit was the large quantity of oriental goods—especially porcelains, lacquers, and textiles—that the "ambassadors" brought with them as gifts for the king, his family, and the principal court officials. Although a number of more or less detailed accounts of these presents

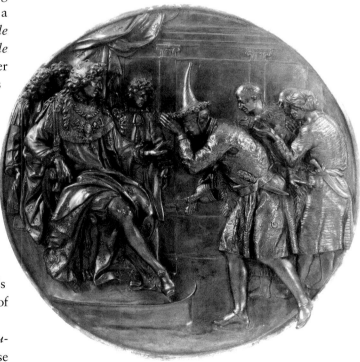

FIGURE 11. Jean Arnould (act. 1685–87) under the supervision of Martin van den Bogaert, called Desjardins (1637–1694). Circular bronze plaque showing the Siamese "ambassadors" offering gifts to Louis XIV in 1686. From the decorations of the destroyed equestrian monument to the king, formerly in the Place des Victoires. *Private Collection.*

survive, it is particularly unfortunate that the pages of the *Inventaire des Meubles de la Couronne de France*, in which these gifts were entered, is one of the rare sections of this invaluable document which is missing today.[37] We do know, however, from a note by the *Intendant* Fontanieu in charge of the royal *Garde Meuble*, who saw the now-missing pages when he was preparing a fresh inventory in 1718, that 1,416 pieces of oriental porcelain had been added between 1681 and the date of the revised inventory. We may safely assume that the bulk of the additional material included not only blue-and-white wares, but also large quantities of other types of Kangxi porcelains.

If details of the king's collection of oriental porcelains are lacking, the inventory of Monseigneur, his eldest son the Grand Dauphin, which was drawn up in 1689, survives.[38] This inventory includes an entire section on *"Porcelaines données par les Siamois"* under which sixty-four pieces are described in detail.[39] There is a puzzle about this. On Sunday December 8, 1688, the marquis de la Dangeau noted in his journal:

> *Monseigneur a fait ce matin une grande distribution de porcelaines et de tous les présents qui il a eu de Siam. Il en a envoyé presqu'à toutes les dames et à toutes les filles d'honneur des princesses.*[40]

It is possible that he was making a distribution on behalf of his father, who is known to have given many of the presents he received from the Siamese to court officials and favorites. On the other hand, it may be for this reason that there were only sixty-four items of porcelain *"Données par les Siamois"* mentioned in the Grand Dauphin's inventory drawn up in the following year. The presents given him (which were not all of porcelain) are known to have been on a most lavish scale.

The effect of the Siamese presents on public taste may be measured by the fact that by 1692, only six years after the departure of the "ambassadors," the *Livre Commode*, a sort of shopper's guide to Paris, lists nearly twenty dealers specializing in *lachinage*. Prior to the visit there had been only two. Dr. Lister, an English visitor to Paris in 1698, mentions in his diary a number of houses where he saw oriental collections.[41] He particularly singles out for praise the porcelain in the houses of Le Nôtre, the famous royal garden designer, and Du Vivier, an army officer living in the Arsenal whose large collection of Chinese porcelain was eventually left to his nephew, the vicomte de Fonspertuis. This man, Angran de Fonspertuis, was to become one of the greatest, if not the greatest, collectors of mounted porcelain of the entire eighteenth century, as we shall see below. He regarded the mounted pieces which he acquired at the sale

of the Grand Dauphin's collection as among his most prized possessions.

Monseigneur was a political nonentity. He is said to have expressed a political opinion, and that a very foolish one, only once in the *Conseil en Haut*, the supreme council of state on which he sat. His life was lived quietly in his small palace of Meudon, near Versailles, where he devoted himself to collecting. He was especially attached to *bijoux*—that is to say vessels of agate, rock crystal, lapis, and other semiprecious stones mounted in gold or gilt—and enameled mounts, as well as to mounted porcelain. In 1711, when Monseigneur died four years before his father, these *bijoux* were bequeathed to his younger brother, Philip V of Spain. With the aid of the inventory mentioned above,[42] many of these pieces can be identified in the Prado today. Unhappily, the same cannot be said of Monseigneur's porcelain collection, which was sold *"avec une indécence qui n'a peut-être d'example,"* according to Saint-Simon, to pay their deceased owner's debts. Consequently, only a single piece—the Gaignières-Beckford vase, which of course did not come from the Siamese—can be identified from the inventory now.[43] There were 304 pieces of oriental porcelain listed in Monseigneur's inventory, apart from the Siamese gifts, many of which were mounted in silver-gilt. We may take the opening item as typical:

> *Une grande Urne de Porcelaine bleüe garnie au pied d'un grand cercle à feüillages, de son couvercle de mesme terminé par deux pommes une grosse & une petite avec deux anses en festons, deux oiseaux dessus passées dans les musles de Lions; Le tout de vermeil doré, haut d'un pied & large de cinq pouces une ligne.*

It will be noted not only that the greater part of the description is devoted to the elaborate mounts, but also that it would certainly be impossible to identify the porcelain today if the changes wrung by cupidity, revolutionary puritanism, or merely time's decay had led to the disappearance of the mounts, as must have frequently occurred. Nevertheless, the memory of the great importance of the Grand Dauphin's collection lingered far into the eighteenth century. In the duc de Tallard's sale in Paris in 1756, a number of pieces from this renowned collection (nos. 1067–89) are recorded, for, as the sale catalogue declares: *"Tout le monde sait que ce Prince avait formé dans ce genre le plus rare qu'il soit possible d'imaginer."*

An item from the Grand Dauphin's inventory illustrates how quickly such pieces could lose their mounts or have them replaced. A group of porcelains of *"Ancien bleu & blanc de la Chine,"* claiming to have come from the same source, was included in the sale in 1782 fol-

lowing the death of the duc d'Aumont, *premier gentil-homme de la Chambre du Roi* and a famous collector of early porcelains. Amongst them no. 199 comprised: *"Une précieuse Garniture de trois grand Bouteilles . . ."* mounted in gilt bronze. To the catalogue entry the auctioneers Julliot and Paillet appended a note explaining: *" . . . il y a environ de trente années qu'on on a vu ces bouteilles garnis de vermeil relevé de fleurons d'or, ce qui constate bien le mérite qui leur avoit eté reconnu,"* presumably the original mounts made for Monseigneur. In fact, the validity of the auctioneers' assertion is open to question. It was rarer in the seventeenth century to mount porcelain with gilt bronze than with silver-gilt or even silver, exactly the opposite practice that was popular during the Louis XV and Louis XVI periods.

The Grand Dauphin did indeed possess a few pieces mounted with gilt bronze before 1689, as one or two entries in his inventory reveal:

> 307. *Une grande Urne bleüe & blanche ornée au corps d'une grande campane en broderie & d'une moyenne au bas, sur un pied en cul de lampe de cuivre doré à godrons, soutenu de trois consoles entre lesquels sont trois masques d'appliques, avec son couvercle orné d'une campane en broderie & d'autres petits ornemens, enrichi de deux cercles à moulure de cuivre doré & terminé par une pomme de pin dans une espece de vase à feüillages. Haut de seize pouces deux lignes & de diametre au corps deux pied trois lignes.*

This vase, the Dauphin noted, had cost him two hundred *pistoles*, a considerably larger sum than he had paid for many of the pieces mounted with silver-gilt. It would seem therefore probable that Monseigneur may have deliberately chosen gilt-bronze mounts for the choicest porcelains in his collection, the precise opposite of what Julliot and Paillet suggest. The use of gilt bronze for the late-seventeenth-century mounts of catalogue no. 2 below adds strength to this suggestion.

It is by no means easy to date the change in taste that resulted in the supercession of silver-gilt by gilt bronze for the mounting of oriental porcelain. At one time it was thought to be connected with the economic crisis of the later years of Louis XIV's reign and the sumptuary edicts of 1689 and 1709 which led to the melting down of almost all the nation's finest silver, even though small objects like mounts and snuff boxes were exempted. Certainly, porcelains with silver and silver-gilt mounts dating from the later years of the reign and from the Régence period survive, even if in smaller quantities than from the earlier part of the Sun King's reign (see catalogue nos. 4 and 6). Indeed, one of the few records of a piece of oriental porcelain being mounted in gold in the eighteenth century actually dates from

exactly this period and suggests that gilt bronze was not used for reasons of economics. It was a gift from the prince de Condé to Madame de Verrue, one of the Regent's mistresses and a famous art collector (the story is told in the 1748 sale catalogue of the Angran de Fonspertuis collection, where the piece itself reappeared as lot 52).

It is just possible that a factor contributing to the change was the appearance in France of Chinese cloisonné enamels. During the late Ming and Qing periods, particularly during the reign of the Qianlong emperor, the enamels produced in the palace workshops were often provided with gilt copper, bronze, or gold enrichments, sometimes even in the form of dragon handles and feet as well as moldings around the lips of vessels (fig. 12).[44] Cloisonné enamels were included amongst the Siamese presents[45] and appear occasionally in Paris sale catalogues of the eighteenth century.[46] It is likely that some of these had gilt metal mounts of Chinese origin.

The change must have come about gradually, but it can hardly be doubted that the principal reason for the choice of a golden rather than a silver tone for the color of the mounts was to make the still relatively unfamiliar forms of this exotic material conform more readily with the character of the French interiors of the period.[47] From 1720 onwards, with the development to the full rococo style, gilding was increasingly used in the interior decoration of Parisian houses on the walls, on the furniture, and for all sorts of decorative objects like clocks, barometers, etc. In Holland and Germany, where less attention was paid to the niceties of interior decoration, pewter was occasionally used to mount oriental porcelain. There is a scarcity of dated documented examples of mounted porcelain from the first forty years of the eighteenth century, even though certain examples (see catalogue nos. 2, 3, and 5) can be fairly safely assigned to the period on stylistic grounds. The late Seymour de Ricci asserted that the first time a piece of gilt-bronze mounted porcelain appeared in the sale room was in 1744. It has not been possible to trace an earlier instance, but the Grand Dauphin's inventory bears witness that such mounts existed half a century earlier. It is perhaps not without significance that such mounted porcelain began to be purchased for the French Crown for the first time in 1741. The generally conservative character of court taste (and not of the French court alone), and indeed of the king himself, makes such purchases unlikely before the taste was well established elsewhere in society.

The first actual purchase to be recorded is of no great significance except as providing a *terminus post quem* for the general acceptance of the taste for porcelain

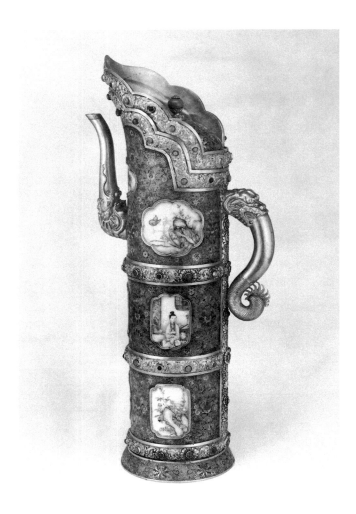

FIGURE 12. Ewer of Chinese cloisonné enamel of the Qianlong reign. Note the handle of gold in the form of dragons. *National Palace Museum, Taipei, Taiwan, Republic of China.*

mounted in gilt bronze. An entry in the *Journal du Garde Meuble* for April 22 of that year mentions: *"Un petit Lion de porcelaine bleu céleste garni en chandelier de bronze doré, avec petites fleurs de porcelaine."*

The flowers would almost certainly be of Meissen porcelain at this date (the Vincennes factory was not yet producing flowers), for the *marchands-merciers* never hesitated to combine oriental and Western porcelains in a single piece. At the end of the same year on December 16, Julliot, the *marchand* who had supplied the earlier piece to the Crown, again delivered: *"Deux pots pourris de porcelaine de Japon fonds blancs, à fleurs de couleur, garnie de bronze doré d'or moulu pour servir dans le Garderobe du Roy au Château de Choisy,"*[48] together with a pair of mounted porcelain candlesticks. From this time forward mounted porcelains appear with increasing frequency in the Crown inventories; invariably, the mounts are of gilt bronze. A large consignment, for instance, was purchased in June 1742 from Hébert, the only *marchand-mercier* to have an establishment

within the confines of the palace of Versailles itself. These, we learn, were intended *"pour servir dans l'appartement de Mlle la comtesse de Mailly"* at the Château de Choisy. Having regard to the fact that this beautiful young mistress of Louis XV is already known to have influenced taste in the matter of furnishings of her apartments,[49] it seems not unreasonable to assume she inspired the earlier Crown purchase of mounted porcelain. It may be supposed, therefore, that the rage (it was no less) for mounted porcelains, which obsessed French society in the middle years of the century, awoke rather earlier than 1741. The Angran de Fonspertuis collection, for example, dispersed at auction in 1748, included 120 lots of oriental porcelain, more than half of which were mounted in gilt bronze. Such an assemblage must have taken more than a decade to bring together. Dezallier d'Argenville, when discussing the collection of the *fermier* Blondel de Gagny in the 1752 edition of his *Voyage Pittoresque de Paris*, provides evidence of the high esteem in which mounted porcelain was held in the middle years of the century. He writes:

> *La peinture ne fait pas le seul ornament du cabinet de M. Blondel de Gaigny, on y voit avec plaisir une très grand quantité de porcelaines anciennes les plus parfaites, dont les monture semblent disputer le prix avec les pièces qu'elles accompagnent.*

The *Livre-journal* of Lazare Duvaux includes, as explained above, innumerable entries for the sale of mounted oriental porcelain in the years between 1748 and 1758, when the fashion was at its height. Interesting as is the light that this document throws on many aspects of mounted porcelain, it in no way explains the reason for the exceptional popularity of such pieces at this date. To understand this popularity it is necessary to consider for a moment the role played by China in European, and especially French, thought during this period.

The first impact Chinese art had on Europeans was, no doubt, to make them think of the Chinese people as remote and quaint, much like the *magots* or *pagodes* they saw painted on porcelain or lacquered on screens or like the head-nodding figures of porcelain that became so popular in France (note 71). Under the influence of the Jesuit missionaries who traveled to China in considerable numbers in the seventeenth century, this attitude changed rapidly and totally. Through the publications sponsored by the order, a wealth of more or less accurate information on the country and its inhabitants began to reach Europe. This was most valuable insofar as it provided, for example, the first adequate description of the manufacture of porcelain at the factories at Jingdezhen. But, in fact, the Jesuits laced their historical and scientific

information with a good deal of religious propaganda intended to bolster their somewhat unstable position as the religious order charged with the conversion of the Middle Kingdom to Christianity. Of the journal of Matteo Ricci (covering the period 1583–1610), the first and probably the most successful of the Jesuit missionaries to go to China, it has been said: "it probably had more effect on the literary and scientific, the philosophical and religious phases of life in Europe than any other historical volume of the period."[50] Ricci wrote of the government of the Middle Kingdom by the mandarin class under the Wanli emperor:

the entire kingdom is administered by the order of the Learned, commonly known as the Philosophers. The responsibility for orderly management of the entire realm is wholly and completely committed to their charge.

The appeal of such ideas to men of the Enlightenment, particularly in France, is all too clear. The *philosophes* in the century preceding the French Revolution certainly thought of themselves, and were increasingly thought of by others, as just the sort of elite to play the role of such mandarins.

It was the same with religion. Of Confucian beliefs Ricci remarked:

of all the pagan sects known to Europe, I know of no people who fell into fewer errors . . . From the very beginnings of their history it is recorded in their writings that they recognized and worshipped one supreme being whom they called the King of Heaven . . . One can confidently hope that many of the ancient Chinese found salvation in the natural law.

The appeal of such an interpretation of Confucianism to an age becoming increasingly sceptical of Christian revelation, an age in which many thinkers in France and elsewhere were seeking to replace theology with some form of natural religion, is evident.

No doubt the mandarin class, in the highest echelons of which Ricci moved at the court of the Wanli emperor, liked to present its empire as a monolithic Confucian state. The Jesuits likewise lapped up such ideas and were encouraged in their missionary task to think that Confucians were almost natural Christians without knowing it. But one has only to read the letters of contemporary merchants trying to trade with China to realize the almost unbridgeable gap between the Jesuit dream and the Chinese reality; the merchants had hardly any direct contact with the mandarin class except to corrupt them with bribes when they put obstacles in the way of trade.

Translations of Confucius appeared under Jesuit sponsorship quite early on and exercised a surprising influence on European thought. The English version of Confucius's works was, for example, the first thing that James Duke of York, later King James II, asked to be shown when he visited the Bodleian Library at Oxford in 1683.[51] A year earlier than this the German philosopher Leibnitz had written that he was deeply "immersed in the works of Confucius." A few years later he published his *Novissima Sinica*, in which he expressed the view that, owing to the general corruption of European morals, "Chinese missionaries should be sent to teach us the aim and practice of natural theology," a curious consequence of the missionary zeal of the Society of Jesus. The general impact of these writings on European intellectuals was to foster a belief that Confucianism was to some degree a purified form of the Christian religion—almost indeed that the Confucian Analects could be equated with the Beatitudes as a guide to conduct.[52] The main consequence of this sentimental idealizing of Chinese life was to produce what has been described as "a cultural misunderstanding on a wide scale . . . almost unique in the history of Western thought and institutions."

It is of course easy to understand the attraction of this explanation of Confucianism to an age in which many thinkers, in France and elsewhere, were seeking to replace Christian theology with some form of rationalistic Deism. To Voltaire it provided a particularly useful stick with which to further his crusade against the French church (*l'infame* as he called it). Confucius, he found, "appealed only to virtue; there is nothing [in his works] of religious allegory." Voltaire's most successful play, *L'Orphelin de la Chine*, had as its subtitle *Les Morales de Confucius en Cinq Actes*. He declared that the Far East was "the cradle of all arts to which the West owed everything." His *Essai sur les Moeurs* was designed as a reply to Montesquieu's *Esprit des Lois* and its unfavorable attitude toward the Orient. It opens with a chapter on China, and Voltaire's conclusion is that "the organization of their Empire is, in truth, the best in the world." In a sweeping condemnation of Western princes and peoples, this secular pope thundered out from *Les Délices* an anathema that, faced by the exemplary virtues of Chinese civilization, Europeans could do nothing but "admire, blush and, above all, imitate."[53]

Such deliberate imitation did indeed occur in particularly extraordinary fashion in 1756. At the spring sowing of that year, the physiocrat, François Quesnay (sometimes described as *le Confucius Européen*), supported by his patron Madame de Pompadour, carried his sinophile theories of agriculture so far as to persuade Louis XV to plow the first furrow in imitation of the age-

long ceremony carried out by the Son of Heaven at each vernal equinox before the Altar of Earth just outside the Forbidden City. The idea of this most sceptical of monarchs taking part in a fertility ritual that was intended to promote French crops is an ironical one. Against such a philosophical background, it is easy to understand the wide influence of China on the decorative arts of France during this period. The mounting of Chinese porcelain was only one manifestation, though an important one, of this influence.

There had always been, of course, a few contrary voices raised against this almost universal chorus of praise. As early as 1718 the Abbé Renaudot declared that the Chinese were in fact very little less barbarous than the American savages. There were a few others, amongst them thinkers of the caliber of Fenélon, Malebranche, and Montesquieu, who also raised objections. But it took the better part of a half a century for their protests to get any wide attention. The last time that the sentimentalized fertility ritual mentioned above was carried out was in 1769, when the Dauphin, the future Louis XVI, followed the plow.[54] Four years later the Society of Jesus, which had done so much to further the cause of China in Europe, was suppressed by Pope Clement XIV, and the appeal of Chinese thought and Chinese art began to decline. Ironically, the Jesuits themselves had provided the *philosophes*—and Voltaire in particular—with the very weapons that did so much to bring about their own downfall.

There were other and more purely aesthetic reasons, of course, for the waning of fashion for mounted porcelain, but it continued to be imported into France at the time of and after the Revolution. The impact of Far Eastern porcelains, Japanese and Chinese lacquers, and even Chinese paintings (though few of these were reaching Europe at this stage, and probably no paintings from Japan), with their use of non-European perspective and arbitrary distribution of figures and landscape details, had been a potent factor in the development of the rococo, which had made its earliest appearance little more than a decade after the arrival of the Siamese "ambassadors" in Paris.[55] For this reason, mounts in the rococo style seemed to be particularly well adapted to the character of oriental porcelain. The new neoclassical style, which was increasingly evident in France toward the latter end of the 1750s, did not accommodate itself nearly so well to Far Eastern styles and designs. In addition, at just this moment certain economic pressures encouraged the use of the relatively newly invented porcelain manufactured at Sèvres rather than foreign imports. This is clearly apparent in the *Livre-journal* of Lazare Duvaux,

who himself was attached to the Sèvres manufactory in an advisory capacity. Toward the latter part of the period covered by the sales ledger (1748–58), *porcelaine de France* appears with increasing frequency; often enough, it is mounted in gilt bronze. The Sèvres factory, as if to emphasize its determination to compete with oriental porcelains, began at just this period to produce monochrome vases of oriental shape. These pieces were marked with the interlaced L's of the royal manufactory. Their success may be judged by the fact that Brongniart, perhaps the ablest of all the directors of the Sèvres factory, confesses to having been deceived in the opening years of the nineteenth century into purchasing what he supposed to be a piece of Chinese porcelain, only to discover later that it was a product of the factory he directed.[56] The copies of Japanese lidded shells, generally with a blue céleste ground, were particularly deceptive models produced at Sèvres during this period (see catalogue no. 16).[57]

A certain amount of this pseudo-oriental Sèvres was set in severely neoclassical mounts of gilt bronze.[58] Nevertheless, in spite of this change of fashion, oriental porcelain set in rococo mounts continued to retain, to some degree, its popularity right down to the Revolution and even later.

Writing to Bentley from London on March 15, 1798, the English potter Josiah Wedgwood casts an interesting sidelight on the persistence of the taste:

> *Mr. Boulton tells me I sho*[d] *be surprised to know w*[t] *a trade has lately been made out of Vases in Paris. The artists have even come over to London, picked up all the old whimsical ugly things they could meet with, Carried them to Paris, where they have mounted & ornamented them with metal & sold them to virtuosi of every Nation . . . Of this sort I have seen two or three old China bowles, for want of better things, stuct rim to rim, which havd had no effect, but looked whimsical and droll enough . . .* (see catalogue no. 13).[59]

In addition to the evidence it provides on the continuance of the taste for such things at a time when Baron Grimm tells us that *"tout à Paris est à la greque,"* the letter reflects on two other matters. It makes it clear that the *marchands-merciers* sometimes sought their oriental porcelain for mounting at centers other than Amsterdam, and that potpourris similar to catalogue no. 13 below evidently continued to attract collectors, although they had been launched on the fickle taste of the Parisians at least two decades earlier.

Even later, such objects continued to command high prices in the sale room. For example, in the Gaignat sale in 1768, a single celadon vase with mounts fetched

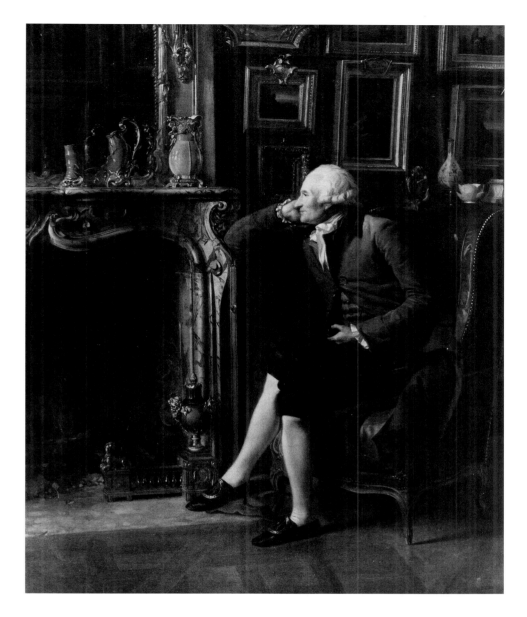

FIGURE 13. Henri-Pierre
Danloux (1753–1809). *Portrait
of Pierre-Victor, baron de Besenval
(1722–1791)*, showing him seated
beside a chimneypiece on which
is displayed a group of mounted
Chinese celadon porcelains. Further
mounted oriental porcelains (some
of them Japanese) are to be seen on
the top of a low cupboard behind
the sitter's head. Oil on canvas,
1790–91. *London, formerly Stair
Sainty Matthiesen Inc.*

2,489 livres (no. 91), and at the Randon de Boisset sale in 1777 two urns (no. 507) clearly mounted in the rococo style fetched 6,001 livres, some of which may have been accounted for by their elaborate marble plinths. Nevertheless, several other pieces in the same sale without marble supports attained prices in excess of 3,000 livres, a price beyond anything that Lazare Duvaux had charged twenty years earlier. However, even these prices were exceeded in 1782 by the sum of over 7,500 livres paid by Louis XVI for a pair of large celadon vases (no. 110),[60] but these were mounted in the neoclassical style by Gouthière.

Danloux's portrait of the baron de Besenval, painted in 1790–91 (fig. 13), when the French Revolution was in full progress, shows him seated beside a chimneypiece covered with celadon porcelain mounted in the style established fifty years earlier, but it must be remembered that the sitter was very much associated with the *ancien régime* and was a prominent member of the *vieux cour*, a close personal friend of Marie-Antoinette, and one whose taste might be expected to be retardant. During the last quarter of the century, the taste for oriental porcelain generally and mounted porcelain in particular was increasingly overwhelmed by the new enthusiasm for the world of antiquity.

It is difficult to trace the history of a taste for mounted oriental porcelains during the next fifty years: documentary evidence is far too scanty. In the sale room, prices were far lower than they had been during the previous century, but the taste must have continued, for porcelains with mounts clearly dating from the Louis-Philippe period are not uncommonly found today. They are identified not only by the coarseness of the gilt-bronze mounts, but also by the use of more richly decorated

porcelain than was general during the eighteenth century. Greater discrimination began to show itself with the return to fashion of French eighteenth-century furniture in the 1850s and 1860s. Here, as might be expected, Robert, twelfth Earl of Pembroke, was a pioneer as he was in the taste for French eighteenth-century furniture itself. At his sale in 1851, a pair of mounted cisterns of Chinese porcelain attained the then high price of 151 guineas, and at the sale of the contents of his house in the Place Vendôme in 1873, a pair of celadon vases mounted as potpourris attained the remarkable price of over 5,000 francs. But the only real collector of mounted porcelain at this date seems to have been the duchesse de Montebello, whose sale in Paris in 1857 included no less than eighty-seven lots of mounted Chinese porcelain, a number of which fetched remarkably high prices.

From that time forward, a steady upward trend in the popularity of mounted porcelain with collectors can be traced. In 1882, the *année miraculeuse* of the Hamilton Palace sale, a single celadon vase with rococo mounts fetched the astonishing price of £2,415 at the Leybourne Popham sale. This trend reached its culminating point in the years immediately preceding the outbreak of the First World War, when at the Oppenheim sale in 1913, Duveen paid £7,665 for a pair of "Mazarin blue" vases with mounts in the Louis xv style. At this auction, seven pieces of mounted oriental porcelain attained the surprising total of £17,220. This reorientation of taste gave rise to a demand that was met by the wholesale manufacture of reproductions. A number of Parisian firms, notably those of the two Beurdeleys, father and son, specialized in these copies. Although not intended to deceive, the quality of the workmanship of the Beurdeley mounts is so remarkable as to be exceedingly difficult to distinguish from genuine eighteenth-century products. At least one Beurdeley piece has received the accolade of entering a great museum piece as a genuine piece,[61] and it has been suggested that the piece which sold for a record price at the Leybourne Popham sale mentioned above[62] was in fact a reproduction made by this firm. Later still, deliberate forgeries appeared. A well-known American museum possesses a piece of oriental porcelain set in English seventeenth-century silver mounts, bought some forty years ago. A few years previously, the mounts had embellished a small Rhenish stoneware jug, an object of much less value.[63]

By a curious paradox, it is from the later eighteenth century, when the fashion for mounted porcelain was on the wane, that we know most about the *fondeurs* who actually created the mounts. Gouthière, of whose distinctive style we gain a fairly clear idea from the engravings of the works he created for his great patron the duc d'Aumont, a discerning collector of oriental porcelain, is a familiar example.[64] We also know a good deal about the style of Thomire during the pre-Revolutionary period from the documented work he produced for the Sèvres factory. However, he more usually executed the mounts for *porcelaine de France* than for oriental wares. Svend Eriksen and others have made us familiar in varying degrees with the styles of Caffieri, Felois, Duplessis, and Pitoin, the first of whom mounted a considerable quantity of porcelain. Duplessis, who as chief modeler at the Sèvres factory was particularly in demand for mounting Chinese porcelains, charged high prices for his work, as can be seen from these two entries in Lazare Duvaux's *Livre-journal*:

> *13 Septembre 1750*
> M. le Marq. de VOYER: *Deux gros vases de porcelaine céladon, montés par Duplessis en bronze doré d'or moulu . . . 3000 l.*
> *15 Juin 1754*
> Mme. la Marq. de POMPADOUR: *La garniture en bronze doré d'or moulu de deux urnes de porcelaine céladon modèles fait exprès par Duplessis, 960 l. La garniture en bronze doré d'or moulu d'un vase en hauteur de porcelaine céladon, à tête de bélier, nouveau modèle de Duplessis, 320 l.*

Attempts have been made, with very inconclusive results, to attribute certain types of mounts to the silversmith Thomas Germain,[65] but although signed objects of gilt bronze by *fondeurs* such as Osmond and Saint-Germain are reasonably familiar, no mounted porcelains bearing their signatures so far have come to light. The names of *fondeurs* such as Aze or Godille are recorded as specialists in *"les garnitures de porcelaines et autres vases précieux,"* but we have no means of identifying their work. There must have been many dozens of others doing work of high quality who are not even names today, for these craftsmen were not artists in the modern sense of the word but merely day workers who had no individual existence outside the quotidian labor of the workshop.

Designs for mounted porcelain are extremely rare. Such things, the mere detritus of the workshop, were no doubt frequently thrown away when they had served their immediate purpose. The best known design of this sort is the elegant drawing for a perfume fountain for Louis xv, in which a vase of oriental porcelain is supported by a pair of hounds of gilt bronze. This has been convincingly attributed to Michel-Ange Slodtz and is now in the Bibliothèque Nationale (fig. 14). It is unlikely that a group of watercolor drawings of mounted porcelain, now in the Metropolitan Museum of Art,[66] are

designs for craftsmen to follow but rather catalogue material issued by a *marchand-mercier*. The same probably can be said of certain drawings in the Berlin Kunstbibliothek.[67] Engraved designs for mounted porcelain are rare and not always distinguishable from mounted vases of other materials such as marble. No doubt these and the numerous series of engraved designs of vases produced throughout the eighteenth century in France played their part in influencing the style of mounts. Engraved designs for silver also influenced the design of gilt-bronze mounts.[68]

In France, the most popular types of porcelain for mounting at first were the blue-and-white wares that were arriving in great quantities well before the end of the seventeenth century.[69] In the eighteenth century, taste gradually changed and the celadons and other monochrome wares tended to be preferred for mounting.[70] Especially appreciated were the gray-crackled wares (referred to as *porcelaine truittée*, where the cracks in the glaze formed a minute network, and as *porcelaine craquelée*, where the cracks were larger). In the eighteenth century, the distinction between Chinese and Japanese porcelain was a good deal more blurred than it is today. Most celadons, for example, were believed to be of Japanese origin and were described in sale catalogues as *"porcelaines d'ancien céladon du Japon."* Because less Japanese than Chinese porcelain reached the European market, it was more highly prized than the Chinese.

It was not uncommon in the eighteenth century to combine oriental and European porcelain in a single piece. The desired effect in mounting porcelain at all was, after all, decorative rather than archaeological or scientific. Porcelain flowers of European manufacture, which were invented at Meissen and enjoyed a widespread vogue in 1730s and 1740s, when they were exported all over Europe, were frequently used for this purpose. After 1745, such flowers began to be made at Vincennes and tended to displace Meissen flowers, especially when combined with oriental porcelains mounted in Paris. Typical of this practice is a pair of candelabra sold by Lazare Duvaux to *"M. de FONTAINE Fermier général"* on March 13, 1756: *"Une paire de girandoles à terasse et brancages dorés d'or moulu sur des magots[71] anciens, bleu-celeste, garnis de fleurs de Vincennes assorties . . . 264 l[ivres]."*

Such pieces were functional, but they relate to another decorative use of oriental porcelain combined with porcelain of European origin. This is exemplified by catalogue no. 10, in which two or more different objects are united for a purely pictorial effect. In this piece, two quite disparate objects of Chinese porcelain, a figure of a boy, flower-covered rockwork, and a pierced porcelain sphere

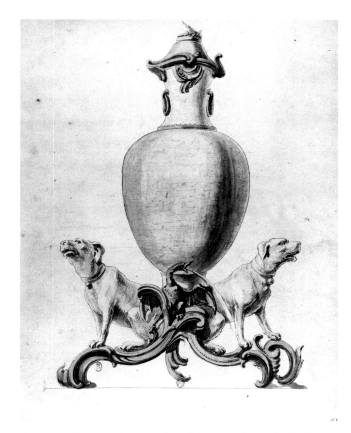

FIGURE 14. Drawing in pen and wash by a member of the Slodtz family (probably Michel-Ange Slodtz) for a perfume fountain, composed of a Chinese porcelain vase mounted with hounds, scrolls of gilt bronze, etc. Probably intended for use in one of Louis XV's hunting boxes. *Paris, Bibliothèque Nationale.*

have been combined to suggest a boy looking into a peepshow, a common enough sight in eighteenth-century France but with no direct equivalent in China. Much more elaborate effects were often produced in which Far Eastern and European porcelain were used together.[72]

The *marchand-mercier* Gersaint, whose shop *À La Pagode* specialized in orientalia of all sorts, tells us that the type of porcelain most frequently found in early-eighteenth-century Paris had a yellow ground, but that this porcelain was hardly ever mounted. His introduction to the sale catalogue of the famous Fonspertuis collection in 1748 gives a good summary of European views on Far Eastern porcelains at that date, and it seems worthwhile to quote it here in full as a coda to this introduction:

> *On en voit aussi de bleue, de rouge et de verte, mais ces couleurs sont difficiles à étendre également et rarement elles réussissent; ce qui en rend les morceaux fort chers quand ils sont parfaits. J'en ai vu même de noire, mais elle fort rare ici; elle ne pourrait plaire que par sa rarité cette couleur la rendant trop triste. Enfin la Porcelaine la plus ordinaire est à fond blanc, avec fleurs bleues, paysages, figures ou animaux.*

NOTES

1. The oldest surviving mounted object is almost certainly a blue glass cup mounted as a goblet on a foot of Chinese silver, probably of the eighth century. It is in the Shōsōin treasury at Nara in Japan, where it has been since the ninth century (*Shōsōin no garasu* [Glass objects in the Shōsōin] [Tokyo, 1965], p. iii, figs. 33–37). Some claim that the glass cup is of European origin, which would make the goblet the precise oriental equivalent of the European objects discussed here. This assertion, however, is questionable, and most authorities agree that the glass and silver are from China.

 Precedence has been claimed ("Bronzes dorés pour vases de Chine," *Connaissance des arts* 83 [April 1959], p. 52) for a cup of blue faience and gold found at Knossos (Sir Arthur Evans, *The Palace of Minos*, 4 vols. [London, 1921–25], vol. 1, p. 252, fig. 189a), but in fact the gold lining is enclosed within the faience, which reverses the European process.

2. The word *chinoiserie* was not used during the eighteenth century. It does not appear in any printed text before 1848 and was not admitted to the *Dictionnaire de l'Académie française* until the revision of 1878.

3. The classic instance is, of course, the removal of the late medieval silver mounts from the Gaignières-Beckford vase after William Beckford's death in 1844. Equally regrettable is the loss of the gold mounts of the antique onyx vase formerly belonging to Isabella d'Este (now in the Herzog Anton-Ulrich Museum, Brunswick). These, after surviving the sack of the Mantuan ducal palace in 1631, were stolen in 1831. The late Leonard Gow, a renowned collector of oriental porcelain, recounted toward the end of his life that he had always made a point of removing and throwing away the mounts of any porcelain he purchased. It may be some consolation that the porcelains enameled in the Chinese taste that comprised the greater part of his collection could only have borne mounts which were Second Empire pastiches.

4. Earl of Harewood sale, Christie's, London, July 1965, lot 46. The mounts are in the Adam style and quite un-French.

5. For Viscount Bolingbroke, and other English names, see *Livre-journal de Lazare Duvaux* 1873; also Eliza Meteyard, *Life of Josiah Wedgwood*, 1865–66, vol. 2, p. 78.

6. In France oriental porcelain was mounted almost exclusively for decorative purposes, even when it was given a seemingly functional form (see catalogue no. 12). In Holland and Germany, on the other hand, functional objects like beer mugs, coffeepots, etc., were created from oriental porcelains by the addition of mounts and were used.

7. Perhaps the nearest equivalents in England were the London "toy-shops," like that of Mrs. Chenivix, often referred to by Horace Walpole. Such establishments purveyed many more goods than just children's toys but not nearly so wide a range as handled by the Parisian *marchands-merciers*.

8. *Thermidore* (an anonymous novel published in 1748), vol. 1, p. 15.

9. See F. J. B. Watson, *Catalogue of the Wrightsman Collection*, vol. III (New York, 1970), p. 103.

10. Francis Watson, "A Possible Source for the Practice of Mounting French Furniture with Sèvres Porcelain," in *Opuscula in honorem C. Hernmarck* (Stockholm, 1966), pp. 245–54.

11. Mounts were attached to porcelain in a variety of ways. Sometimes they were designed to clasp the porcelain closely (see catalogue nos. 12 and 15). This was not always practical with porcelains of certain shapes, and other methods were adopted. Holes were drilled through the walls of the porcelain to accommodate lugs at the backs of the metal mounts. For knops and handles, the lugs were often threaded and secured on the interior with a screw nut (see catalogue nos. 3, 4, 11, and 13). Possibly some sort of adhesive was used when neither method was practical, but contemporary evidence for this is exceedingly scanty. The Japanese used *urushi* (lacquer) for this purpose as early as the eighth century; the Chinese may have used it also. In Europe it is possible that animal glue or some sort of cement was used for the same purpose.

 Quite often the original oriental porcelains had to be cut (see catalogue nos. 5 and 14). This was a tricky business and must frequently have resulted in cracking and even breakage. For the large cutting operations a bow and diamond or Carborundum dust were probably adopted. Small projecting elements such as spouts and knops could be removed (see catalogue no. 19) by scoring with a sharp instrument below the part to be taken away, bracing the body with string or similar material, and tapping sharply.

12. For reproductions of mounted lacquer, see Jarry 1981, pp. 214–19.

13. Or at any rate survived until 1873, when Louis Courajod edited and published it. Since then the manuscript has vanished.

14. The full inventory description is cited in Léon, marquis de Laborde, *Glossaire français du Moyen Age . . . précédé de l'inventaire des bijoux de Louis, duc d'Anjou* (Paris, 1872), p. 107: "*714: Une escuelle d'une pierre appelee pourcelaine, borde d'argent dore et esmaille Et a sur le dit bort 111 ecussons de not armes et y a iii fretelz d'argent dorez a perles a petit grenez, et sur chascun fretel une petite langue de serpent.*" I owe this reference to Clare Le Corbeiller.

15. *Inventaire de Jean de Berry, 1401–1416*, ed. Jules Guiffrey (Paris, 1894), p. 191. A small blue-and-white figure appears among the marginal illustrations of one of the duke's illuminated manuscripts. I am grateful to Elizabeth Beatson of the Princeton Index of Christian Art for this information. It has been suggested that one of the duke's mounted porcelains can be seen in the *Très riches heures du duc de Berry*, in the January miniature showing the duke feasting. But this seems extremely doubtful.

16. Ibid., p. 215, item 830.

17. Jean Charles Davillier, *Les origines de la porcelaine en Europe* (Paris, 1882), p. 10.

18. Eugène Müntz, *Les collections d'antiques. formées par les Médicis au seizième siècle* (Paris, 1895). Piero de' Medici possessed several other pieces of Chinese porcelain, but none were mounted. I owe this reference to Joseph Alsop.

19. For a full discussion of the vase, see Arthur Lane, "The Gaignières-Fonthill Vase: A Chinese Porcelain of about 1300," *Burlington* 103 (April 1961), pp. 124–32.

20. Ibid.

21. Lunsingh Scheurleer 1980, pl. 1. A detailed history of the bowl is given on p. 45.

22. T. Volker, *Porcelain and the Dutch East India Company, as Recorded in the Dagh-Registers of Batavia Castle, Those of Hirado and Deshima and Other Contemporary Papers, 1602–1682* (Leiden, 1954), p. 129.

23. For instance, Philip II of Spain is recorded as possessing no less than three thousand pieces of Chinese porcelain at his death in 1598.

24. Lunsingh Scheurleer 1980, fig. 16.
25. For this and other references to early mounted porcelain in England, see Yvonne Hackenbroch, "Chinese Porcelain in European Silver Mounts," *Connoisseur* (June 1955), pp. 22–29.
26. Lunsingh Scheurleer 1980, fig. 6.
27. Another example is a bowl of Jiajing date (1522–66) made for the Turkish market and acquired there by Count Eberhardt von Manderscheidt in 1583. He had the bowl mounted as a chalice on a silver-gilt stem of German workmanship. The Victoria and Albert Museum recently acquired it (Anna Somers-Cocks, "Savoir acheter: Un exemple du Victoria & Albert," *Connaissance des arts* 359 [January 1982], pp. 58–59).
28. Such paintings are reproduced in Lunsingh Scheurleer 1980, as are contemporary examples of blue-and-white porcelain with Dutch mounts.
29. The verses are by the poet Paul Scarron and are quoted by Henry Havard, *Dictionnaire de l'ameublement* (Paris, 1892), vol. 11, col. 836.
30. Lane 1949–50.
31. *The Splendor of Dresden: Five Centuries of Art Collecting*, National Gallery of Art, Washington, D.C., 1978.
32. Even earlier than this, in 1664, Louis XIV had granted a patent to Claude Reverend to establish *"une fabrique de porcelaine de Chine auprès de Paris,"* but nothing is known of its productions. They are unlikely to have been of porcelain (*Archives de l'art français*, 14 vols. [Paris, 1851–60], vol. 6, p. 360).
33. Quoted by L. Dussieux, *Le château de Versailles*, 2 vols. (Versailles, 1881), vol. 1, p. 32.
34. A good description of the Trianon de Porcelaine is to be found in H. Belevitch-Stankevitch, *Le goût chinois en France au temps de Louis XIV* (1910, reprint, Geneva, 1970). R. Davis, *La première maison royale de Trianon* (Paris n.d.) is a rare work on the same subject.
35. Jules Guiffrey, *Inventaire général du mobilier de la couronne sous Louis XIV*, 2 vols. (Paris, 1885–86), vol. 1, p. 32.
36. The most accessible account of the embassy, the events leading up to its visit to France, and its consequences is to be found in H. Belevitch-Stankevitch, *Le goût chinois* (1910/1970), pp. 10–48 and chap. 11. The scene in which the "mandarins" in their curious conical hats prostrated themselves at the foot of the throne was sensational and is recorded in several medals as well as in sculpture and engravings.
37. General lists (not inventories) of the presents brought for the king and his family are given in Alexandre Chaumont, *Relation de l'ambassade du Mr le chevalier de Chaumont à la cour du roy de Siam* (Paris, 1686) and are reprinted by H. Belevitch-Stankevitch, *Le goût chinois* (1910/1970), pp. 256–62.
38. It passed briefly through the London auction rooms some years ago and has since vanished again.
39. Monseigneur ordered special display cases built by André-Charles Boulle for his porcelain at Meudon. For his 1687 almanac Gerard Jollain engraved a scene of the Enfants de France visiting Monseigneur's cabinet to inspect the presents of the Siamese.
40. *Abrégé des mémoires du journal de Marquis de Dangeau* (Paris, 1817), vol. 1, p. 250.
41. Martin Lister, *A Journey to Paris in the Year 1698* (London, 1699), pp. 37–38.
42. Diego Angulo Iñiguez, *Catálogo de las alhajas del delfín* (Madrid, 1954).
43. See Daniel Alcouffe, "The Collection of Cardinal Mazarin's Gems," *Burlington* (September 1974), pp. 514–26.
44. Many of these enamels are in the Palace Museum, Taipei, Taiwan, and are illustrated in *Catalogue of Cloisonné Enamels from the Palace Museum* (Taipei, 1981).
45. *"6 assiettes de bois verny avec du cuivre emailé"* given by Constantine Phaulkon to the king.
46. For example, Angran, vicomte de Fonspertuis, sale, Paris, March 4, 1748, nos. 340–41, and Randon de Boisset sale, Paris, 1777, nos. 861–62. In the former sale the expert Gersaint describes such objects as *"cuivre emaillé aux Indes."* At the beginning of the reign of the Yongzheng emperor (r. 1723–35), the governor-general of Guangxi and Guangdong provinces requested that enamels which were then being sent in great numbers to far-away countries be painted with the imperial reign mark so they might redound to the prestige of the emperor's reign. The request was sharply rejected, but the incident suggests a brisk export trade in enamels, which, at that date, must have been largely with Europe (see also Liu Liang-yu, *Chinese Enamel Ware: Its History, Authentication, and Conservation* [Taipei, 1978]).
47. In the first half of Louis XIV's reign, familiarity with the silver furniture in the royal palaces and, to some extent, in the private houses of the nobility must have made the use of silver mounts for porcelain more acceptable than it was later.
48. Julliot's shop in the fashionable rue Saint-Honoré was under the sign *Aux curieux des Indes* to indicate the nature of the wares in which he dealt. The catalogue of his stock in trade sold by auction after his death in 1777 tells us that he specialized in *"porcelaines, anciennes, modernes, nouvelles du Japon, de la Chine, d'effets d'anciennes laques."*
49. Pierre Verlet, *Le mobilier royal français*, 4 vols. (Paris, 1945), vol. 1, pp. 6–7.
50. Nicolas Trigault [1577–1628], *The China That Was: China as Discovered by the Jesuits at the Close of the Sixteenth Century*, trans. from the Latin, Louis-Joseph Callagher (Milwaukee, 1942), p. xix.
51. *The Life and Times of Anthony à Wood*, ed. Andrew Clark (Oxford, 1891–1900), vol. 3, p. 36.
52. An even more curious, if frivolous, instance of the wish to interpret Christianity in Confucian terms, quoted by Hugh Honour (*Chinoiserie: The Vision of Cathay* [London, 1973]), was the binding by Mournier of a copy of the 1690 edition of *De Imitatio Christi* by Thomas à Kempis. The entire surface of the morocco binding has been embossed with Old Testament figures dressed in Chinese costumes and surrounded by a landscape of pagodas, dragons, and dromedaries.
53. Something of the same sort, though on a much smaller scale, arose over French attitudes to the Inca kingdom of Peru. Jean-François Marmontel in his novel *Les Incas* (1777) drew a eulogistic picture of the government of that country largely based on the highly tendentious account given in Garcilaso de la Vega's *Commentarios reales que tratan del origin de los Incas* (1609), a translation of which was published in Paris 1633. But as the Inca kingdom had been extinguished for some two hundred years, it provided a much less forceful example than the still powerful empire of China.
54. By curious chance, the first portrait of her future husband that the Archduchess Marie-Antoinette saw before meeting the future Louis XVI in France showed him performing this ceremony. It is reproduced in Philippe Huisman

and Marguerite Jallut, *Marie Antoinette* (New York, 1971), p. 60.

55. See Fiske Kimball, *Le style Louis XV: Origine et évolution du rococo* (Paris, 1949), pp. 59–111.

56. Earlier "experts" were not so easily deceived. Cataloguing the "Porcelains de France" in the Gaignat collection in 1769, Pierre Remy wrote the following entry: "*144: Quatre autres Vases de même porcelaine & même couleur, blue céleste, d'une forme imitée de Japon*" (Pierre Remy, *Catalogue raisonné des tableaux, groupes, et figures de bronze* [Paris, 1769]). The best oriental monochrome porcelains were then believed to be of Japanese and not Chinese manufacture.

57. In the late eighteenth century there was a tendency to replace the fantasy world of chinoiserie by a closer attempt to imitate oriental styles. This may be seen in a pair of black ground Sèvres *seaux à bouteille* dated 1792 in the J. Paul Getty Museum (acc. no. 72.DE.53). The decoration in gold and platinum is evidently an attempt to imitate the decoration of certain types of Japanese lacquer. Something of the same sort is to be seen in Charles-Nicolas Dodin's painting on the so-called "Dudley vases" in the Getty Museum (acc. no. 78.DE.358), which clearly imitate either Canton enamels or perhaps Chinese silk paintings.

58. For the two mounted Sèvres vases in the James A. de Rothschild Collection at Waddesdon Manor, see Svend Eriksen, *The James A. de Rothschild Collection at Waddeson Manor: Sèvres Porcelain* [Fribourg, 1968], pp. 232–33, no. 79. When he was in Paris in 1765/66 Horace Walpole purchased a garniture of three *bleu du roi* vases of this type with mounts in the high neoclassical style and gave it to his friend John Chute. One is reproduced in *Horace Walpole . . . Essays on the 250th Anniversary of Walpole's Birth*, ed. Warren Hunting Smith (New Haven, 1967), between pp. 192 and 193.

59. Meteyard, *Life of Josiah Wedgwood*, 1865–66, vol. 2, p. 78.

60. They are now in the Louvre. One is illustrated in color in Jarry 1981, fig. 23. The mounts are there described as "*attribuée à Gouthière*," but, in fact, the sale catalogue asserts positively that they are by him.

61. See de Bellaigue 1974, vol. 1, p. 758.

62. See de Bellaigue 1974, p. 758, where it is identified as a vase now at Anglesey Abbey, Cambridgeshire.

63. For a more extended discussion of the evolution of the taste for mounted porcelain, see Watson and Dauterman, 1966–70, vol. 4, pp. 375–91.

64. Sale, Paris, December 1–21, 1782. A facsimile of the catalogue with a long introduction by Baron Charles Davillier was published in 1880.

65. See Hughes 1996, vol. 3, nos. F115–16, pp. 1361–65.

66. Watson 1980, nos. 32a–c.

67. *Die Französischen Zeichnungen der Kunstbibliothek Berlin* (Berlin, 1970), no. Hdz. 42. These drawings are attributed to Jean-Claude Duplessis but are doubtfully by him, and OZ 81 Blatt 6.

68. See Hughes 1996, vol. 3, nos. F115–16 (see note 65).

69. From the opening of the eighteenth century, shiploads of blue-and-white porcelain were arriving in Antwerp from China. The first large consignment of Japanese porcelain reached a Dutch port in 1659 (see Volker, *Porcelain and the Dutch East India Company*).

70. The more highly decorated wares of the *famille verte* and *famille rose* were rarely mounted in eighteenth-century Paris. They were much favored in the nineteenth century when they became more accessible.

71. The word *magot* strictly means a deformed figure or person, but it was often applied to Chinese or Japanese porcelain figures. An alternative name, specifically applying to oriental figures of porcelain or lacquer, especially those with nodding heads, was *pagode* or *pagoda*: "*Le caractère soit naif, soit force des Pagodes, leurs attitudes & leurs expressions sont ce qu'on recherche le plus dans ce genre de curiosité, celles mêmes qui sont les plus difformés ont des attitudes tout-à-fait plaisantes, pourvu qu'elles ne soit pas décharnées; alors elles n'inspiront que le degout & l'effroi*" (descriptive passage by the auctioneer Pierre Remy in the sale catalogue of the Gaignat collection in Paris, 1768).

72. For example, the *blanc-de-chine* figure and cup with flowers of Vincennes porcelain combined in an elaborate "cage" of gilt bronze, from the Walters Art Gallery, Baltimore, reproduced in Watson 1980, p. 29. This is a purely decorative object with no practical use.

CATALOGUE

MOUNTED ORIENTAL PORCELAIN

1. PAIR OF LIDDED BOWLS

THE PORCELAIN: Japanese (Arita), late seventeenth century
THE GILT-METAL MOUNTS: English (London), circa 1680
HEIGHT: 1 ft., 1⁹⁄₁₆ in. (34.5 cm); WIDTH: 1 ft., 3 in. (38 cm); DEPTH: 10¹⁄₁₆ in. (25.5 cm)
85.DI.178.1–.2

DESCRIPTION

These deep circular lidded bowls are painted with underglaze decoration in cobalt blue. The scene on each bowl and its lid shows a classical Chinese mountainscape with houses, temples, and foliage veiled in mist. The centers of the lids and the bases of the bowls are decorated with a band of stylized chrysanthemum petals encircling a band of lotus petals. The porcelain has not been cut or ground down.

On the lid, a finial of four upturned oak leaves clasps the knop and a gadrooned band lined with stylized leaves is attached to the rim with clips. Pierced bands of larger stylized leaves encircle the lip and foot of the bowl. On the sides of the bowl, gilt-metal cartouches are attached to these bands with pinned hinges. The cartouches have mistakenly been mounted upside down. At each side of the cartouche are scallop shells flanked by paired acanthus leaf scrolls. From the scrolls depends a beribboned wreath of bell flowers centered by a cluster of berries. Each scrolled handle supports a greyhound, its tail wrapped around its body and its neck craned to the side (fig. 1B). The foot mount is decorated with opposed acanthus scrolls and leaves, held in at the cardinal points by clasps. At the base is a gadrooned band applied to a plain rim.

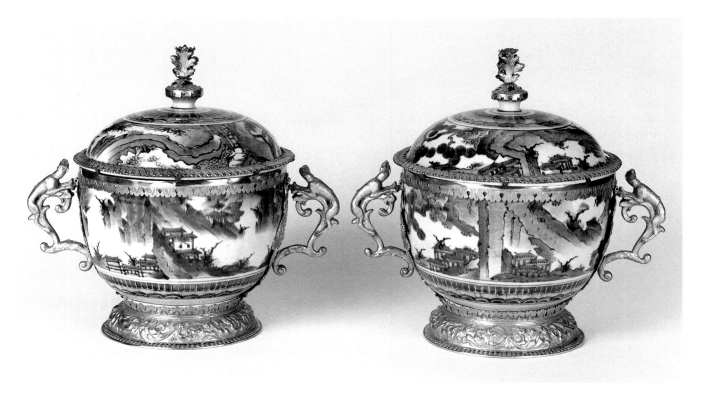

FIG. 1A

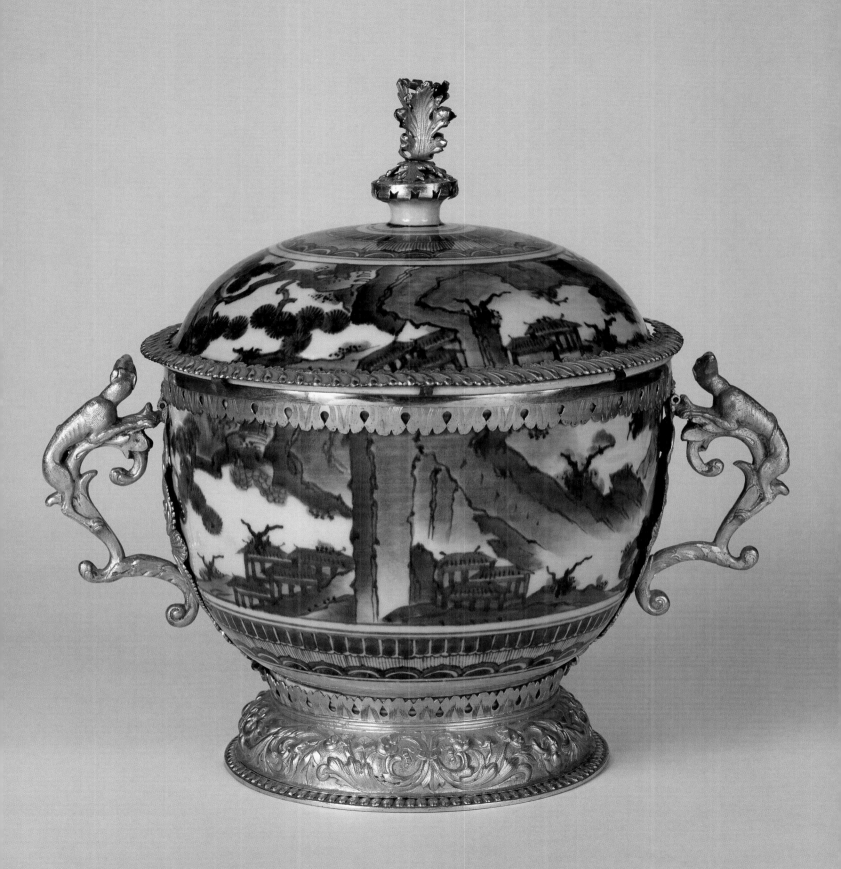

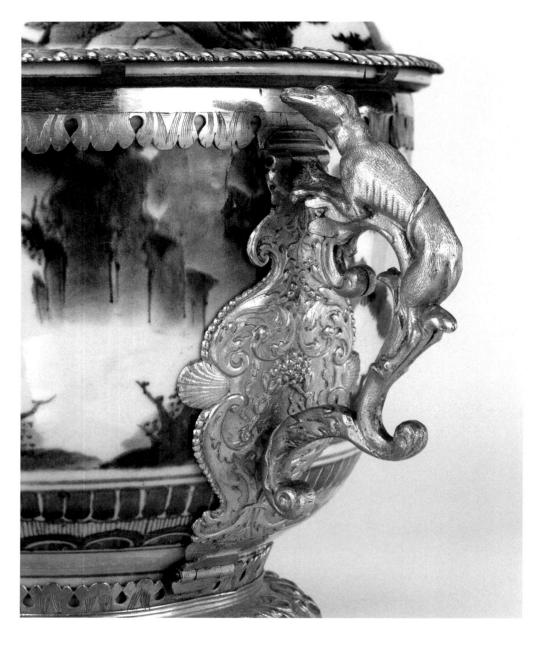

FIG. 1B

MARKS None.

COMMENTARY

One leaf has been lost from the finial of one lid.

A very similar pair of lidded bowls, said to be of porcelain of the Kangxi dynasty (1662–1722) and mounted in neoclassical mounts probably of Viennese origin, is in the collection of the prince of Liechtenstein.[1]

The hinged and pinned joints on the mounts of these bowls were a traditional method of attachment in early metalwork. They remained in use until the mid-eighteenth century when they were superseded by screws, which were easily hidden by the curvilinear features of rococo mounts. The mounts are not cemented to the porcelain, as was the practice in Paris.

Given their unusual design the mounts on these bowls can be attributed to a known maker. Greyhounds of the same form appear on the silver-gilt mounts of a Chinese blue-and-white brush holder (circa 1630–40) in the Victoria and Albert Museum, London.[2] These mounts date to about 1665–70 and bear the maker's mark WH (for Wolfgang Howser) above a cherub. The greyhounds reappear on the silver-gilt handles of a red glass bowl in Anglesey Abbey, Cambridgeshire, mounted as a two-handled cup and stamped with Howser's mark.[3] Another hound of similar form with its tail wrapped around its body appears on the handle of a silver ewer in a still life painted by Meiffren Comte (circa 1630–1705) at the Château de Versailles.[4]

Wolfgang Howser was active in England from about 1660 to 1688. A member of a Zurich goldsmithing

family, he was trained by his father, Hans Jacob Howser II, and became a freeman in 1652. The date of Howser's arrival in London is not known but he was active there by 1660–61, when he furnished Bishop Cosin's Chapel at Auckland Palace, County Durham, with a large set of plates, including a gilt and embossed communion flagon and alter basin.[5] Other commissions included the Moody salt of 1664–61 in the Victoria and Albert Museum, a pair of standing cups of 1669 and 1672 at Gray's Inn, a pair of firedogs and bellows of 1674 at Burghley House, and altar dishes for Saint George's Chapel at Windsor Castle and the Chapel Royal at Whitehall Palace. In 1664 Howser presented a letter from Charles II to the wardens of the Goldsmith's Company instructing them to assay and mark his work. After 1664 he received his mark, WH above a cherub.[6]

It is not known whether Howser worked in base metals, and it is possible that the mounts on the lidded bowls were made by some other metalworker. The person most likely to have worked in Howser's style was his nephew, Hans Heinrich, who came to London to work with Howser in 1681. Heinrich does not appear to have become a master silversmith, and, therefore, was not obliged to mark his work. No mention of Wolfgang Howser appears after 1688. It is assumed that he died in London. There is no record of what happened to his workshop at his death, nor to whom his models might have been sold.

Embossing was frequently used to decorate English silver during the second half of the seventeenth century.[7] The foot mount and the handle cartouches of the Getty Museum's lidded bowl have been cast to imitate embossing, perhaps to give the mounts the cachet of precious metal. The embossed work on the foot of Howser's silver-gilt communion flagon for Bishop Cosin is of similar design.

The small dish supported by the four oak leaves that make up each finial may once have held an acorn, now lost. The Victoria and Albert vase has a dog mounted on the lid as a finial, and the Anglesey Abbey bowl has a bird taking flight. Like these two-part finials, on which the dog and the bird are raised up on a base, the finials on the lids of the Getty bowls may once have been the base for a second element.

These lidded bowls are among the earliest examples of their type mounted in Europe and are almost contemporary with their mounts. The practice of mounting Chinese and Japanese porcelain in England at this date is extremely rare. Before the Civil War (1642–52), blue-and-white porcelain was mounted in silver in London. The Parisian fashion for mounting oriental porcelain in gilt bronze that began in the last decades of the seventeenth century was not taken up in the fashionable circles of post-Restoration London. It is possible that these rare objects were made for an aristocrat in the court of Charles II (1630–85, reigned 1660–85), who may have been in exile with him and picked up such a taste for the luxurious in Europe. It is also possible that the mounted bowls were made for the infamous Duchess of Portsmouth, Louis-Renée de Penencouet de Kéroualle (1649–1734), maid of honor to Henrietta Stuart, duchesse d'Orléans. A reputed spy for Louis XIV, she became a favorite of Charles II and set herself up in grand style in Saint James's.

PUBLICATIONS

Watson 1968, pp. 46–47, no. 9; "Acquisitions/ 1985," *GettyMusJ* 14 (1986), p. 240, no. 185; Watson 1987, pp. 813–23; Bremer-David et al. 1993, p. 151, no. 251.

EXHIBITIONS

Mounted Oriental Porcelain, The Frick Collection, New York, 1968, no. 9.

PROVENANCE

Joseph Downs, Winterthur, Delaware; William Heere (sold, Christie's, New York, October 29, 1983, lot 32); Aveline et Cie, Paris; acquired by the J. Paul Getty Museum in 1985.

NOTES

1. Metropolitan Museum of Art, *Liechtenstein: The Princely Collections* (New York, October 26, 1985–May 1, 1986), p. 169, inv. 1822 a–b, illus. See also Christie's, London, June 17, 1997, lot 385, for a lidded bowl of Japanese porcelain of similar size and decoration.
2. C. D. Rotch Bequest, acc. no. M.308-1962. For illustrations, see Charles Oman, *Caroline Silver, 1625–1688* (London, 1974), pp. 33–44, pl. 75; Lunsingh Scheurleer 1980, p. 225, fig. 108.
3. R. A. Crighton, *Cambridge Plate* (Oxford, 1975), p. 21, no. MTD 11. When this bowl was exhibited at the Fitzwilliam Museum in 1975, the mark was published in the catalogue as WH and a scallop. The bowl was dated to 1660. The mark of the cherub was probably misread, and the mounts were given too early a date.
4. *Still Life with Silver Candlestick and Ewer*, Château de Versailles (MV 8555).
5. Oman, *Caroline Silver* (1974), pls. 43A–B.
6. Oman, *Caroline Silver* (1974), p. 33. At issue was Wolfgang Howser's alien status in England and his removal of business from native smiths. The wardens agreed, and the king required Howser to employ only Englishmen in his shop. All information about Howser is taken from Oman, *Caroline Silver* (1974), pp. 33–34, 36, 47, 59.
7. Relief decoration on metal produced by hammering from the underside.

2 . EWER

THE PORCELAIN: Chinese (Kangxi), 1662–1722
THE GILT-BRONZE MOUNTS: French (Paris), circa 1700–10
HEIGHT: 1 ft., 6⅛ in. (46.1 cm); WIDTH: 1 ft., 1⅞ in. (35.2 cm); DEPTH: 5⅜ in. (13.8 cm)
82.DI.3

DESCRIPTION

The cylindrical body of the ewer is modeled with a shaped wall lip above a tall slender spout. The flat lid bears a porcelain knop at its center. Two pierced Buddhist lion masks form the places of attachment for the original pouring handle, which may have been of wire bound with cane. This has been replaced by one of gilt bronze that entirely covers the lower lion mask.

The body of the ewer is divided into three stages by four horizontally ridged triple bands that encircle it. It is enameled on the biscuit with pale aubergine, green, white, and yellow on a deep mottled-green ground penciled with black whirlpools and outcrops of white rockwork. The motifs include mythical carp dragons (mo zhe); horned chimerae and the eight horses of Mu Wang (the legendary queen mother of the West) flying over the ocean; loose prunus blossoms; and the eight Buddhist "precious things" (pa pao: the jewel, the cash, the open and solid lozenges with ribbons, the musical stone, the two books, the paired horns, and the artemesia leaf). The lip is enameled with a horned Chilong dragon with yellow and aubergine on a green ground scattered with aubergine clouds below a relief molded hatched border. The flat lid is decorated with the flying horse motif (fig. 2A).

The porcelain knop is partially encased in a cup of gilt-bronze acanthus leaves. The edge of the lid is encircled by a pierced flat gilt-bronze band that is hinged to the upper end of the handle. A band of the same design, below a gadrooned molding, is attached to the rim of the body of the ewer and to the edge of the wall lip. A similarly pierced band with gadrooning, of smaller scale, encircles the mouth of the spout, which is closed by a gilt-bronze bud-shaped stopper. The engraved stopper is attached to the mount of the wall lip by a six-link chain.

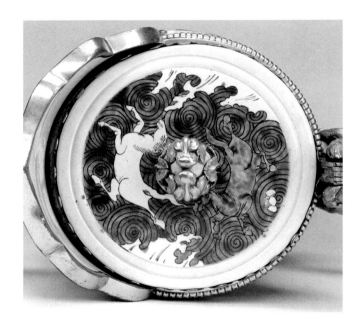

FIG. 2A

The large gilt-bronze handle, of rectangular cross section, is interrupted along its length by two clasps, decorated on their outer edges with rosettes. Above the bifurcate and scrolled upper end, the handle is held in a large acanthus leaf. It rests on the top of the small ceramic lion's mask; a drape is knotted to the scroll, its ends depending on either side of the mask. The scrolled base of the handle, clasped by an acanthus leaf along its outer edge, rests on a large gilt-bronze lion's mask (fig. 2B).

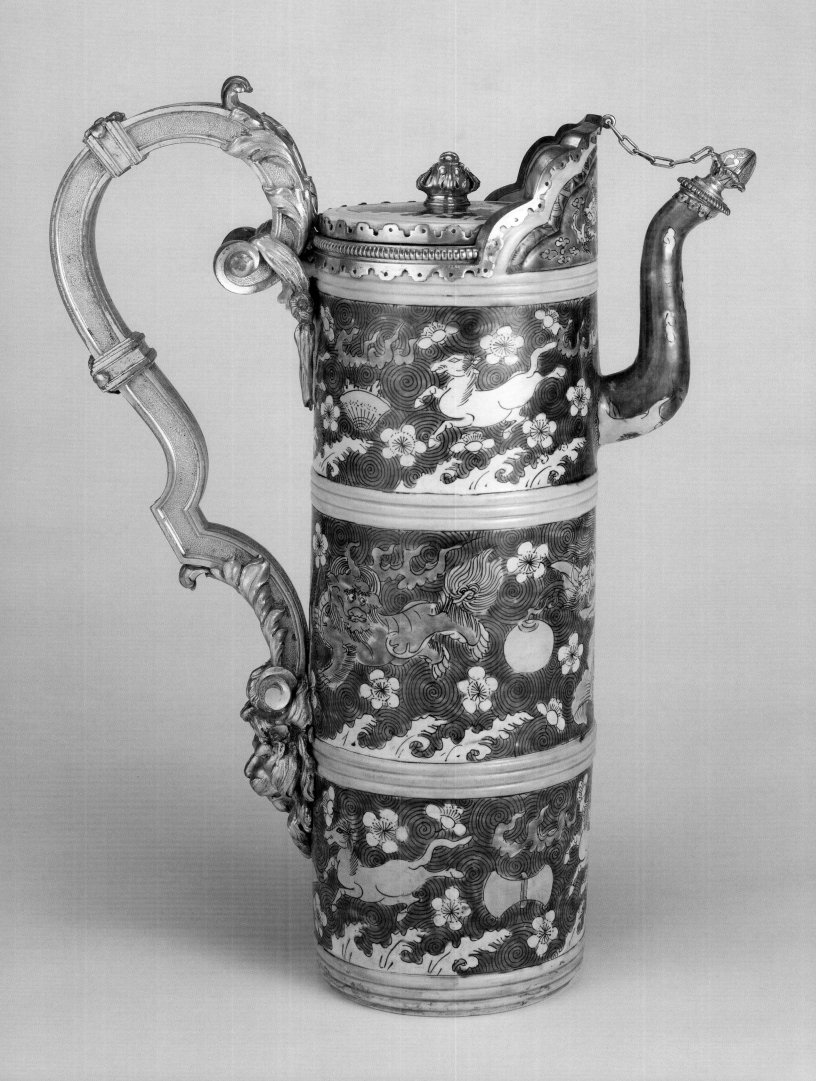

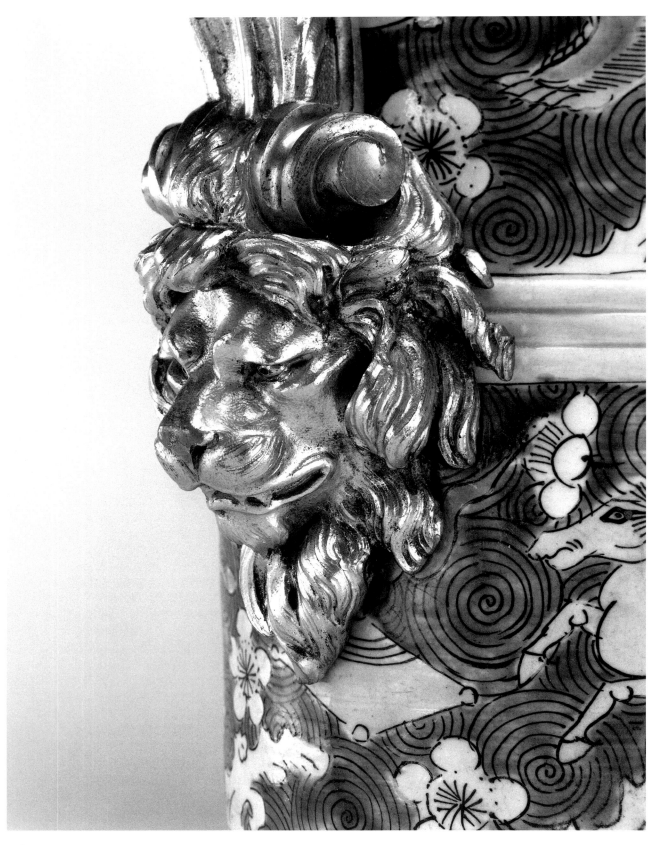

FIG. 2B

MARKS None.

COMMENTARY

Before acquisition by the Getty Museum, the ewer had been broken and poorly mended. It has now been restored. Apart from the replaced handle, the ewer is in its original form.

The tall cylindrical ewer with a wall lip, known in China as *Dou mu hu*, derives from a metal Tibetan prototype, *bay-lep*. Secularly used for beer, these jugs would have been used for milk tea in the Lamaist monasteries that flourished throughout China during the reign of the Kangxi emperor. Both simple metal bound wooden vessels and more elaborate damascened iron[1] or repoussé copper and brass[2] examples exist.

These vessels, used in China and Tibet, were made for domestic use and not for export. However, this example must have arrived in Paris within a few years of its manufacture. The French mounts date from the late seventeenth century, and the ewer is one of the earliest pieces of mounted oriental porcelain of the *grand siècle*.

A ewer of similar form and decoration appeared on the Paris market in 1996. The enameling of the porcelain was less elaborate: rockwork replaced scattered flowers; chimerae and dragons were absent; and the scattered objects meant to represent the eight Buddhist "precious things" were incorrectly drawn. It is possible that the porcelain and, consequently, the gilt-bronze mounts were of later date. The gilt-bronze lion's mask bears features dissimilar to those in the Museum's example (fig. 2B).

Chinese cloisonné examples of this form exist in the Imperial Palace Museum, Beijing,[3] and in the National Palace Museum, Taipei.[4] The form was rarely produced in the Qing period, but the following examples may be cited: a ewer enameled on the biscuit with "egg-and-spinach"-splashed glazes in the Imperial Palace Museum, Beijing[5]; a ewer enameled with *famille verte* in the Musée Guimet, Paris[6]; and another smaller ewer, similarly decorated, that was sold at auction in Paris in 1934[7] and in New York in 1982.[8]

The Grand Dauphin Louis (1661–1711) had a substantial collection of Chinese porcelain, some of which was given to him in 1686 by the "ambassadors" from Siam (see Introduction, page 9). The inventory taken of his possessions in 1689 lists 304 pieces in his *cabinet* at Versailles. Of these, thirty-eight were mounted in silver-gilt and fifteen with gilt bronze. Number 110 is described thus:

Une urne en forme de Buire de Porcelaine verdastre avec son gouleau fermé par un bouton tenant à deux chaisnes, garni d'une anse & d'un couvercle, sur son

pied à jour porté par trois petits Lions; le tout de cuivre doré, haute de quartorze pouces six lignes.[9]

The description of this mounted green ewer is strikingly similar to the Museum's ewer, with the exception of the foot mount. There is no indication that the latter was similarly mounted at its base, but the inclusion of such an object in the Dauphin's collection shows that such pieces were mounted at this early date.

Ewers of this form, but with purple glaze, are found, with neoclassical gilt-bronze mounts, in the sale of Gaignat in 1768, where they were acquired by the duc d'Aumont, and later passed into the ownership of Louis XVI.[10] Marie-Antoinette also possessed a pair of purple ewers, mounted by Pierre Gouthière, for her *cabinet intérieur* at Versailles (see catalogue no. 22).[11]

PUBLICATIONS

John Getz, *Catalogue of Chinese Art Objects . . . Collected by Edward R. Bacon* (New York, 1919), p. 31, pl. 12, no. 65, pl. XII[12]; Gillian Wilson, "Acquisitions 1981," *GettyMusJ* 10 (1982), pp. 85–86, no. 6; Bremer-David et al. 1993, p. 148, no. 246.

PROVENANCE

Edward R. Bacon, New York, circa 1919; Gaston Bensimon, Paris; acquired by the J. Paul Getty Museum after the sale of the collection of the late Gaston Bensimon, Hôtel Drouot, Paris, November 18 and 19, 1981, no. 103.

NOTES

1. Pratapaditya Pal, *The Art of Tibet* (New York, 1969), pl. 115, from the Bell collection in the Liverpool City Museum.
2. *Catalogue of the Tibetan Collection and Other Lamaist Articles in the Newark Museum*, 5 vols. (Newark, 1950–71), vol. 5, pl. 6.
3. *Selected Handicrafts from the Collections of the Palace Museum* (Beijing, 1974), pl. 76.
4. *Masterpieces of Chinese Enamel Ware in the National Palace Museum, Taipei* (Taiwan, 1971), pl. 17.
5. Li Jixian, "Qing Kangxichao ciqi chutan" (A preliminary study of the porcelain made during the reign of the Kangxi emperor of the Qing dynasty), *Gugong bowuyuan yuankan* (Palace museum journal), no. 4 (1979), pp. 63–71.
6. Musée Guimet, *Oriental Ceramics: The World's Great Collections* (Paris 1981), vol. 7, no. 132.
7. Galerie Jean Charpentier, Paris, June 7–8, 1934, no. 176.
8. Christie's, New York, June 23, 1982, lot 150.
9. Beurdeley and Raindre 1987, p. 266.
10. Their present location is not known.
11. Christie's, London, June 9, 1994, lot 35.
12. The ewer is illustrated with a nineteenth-century gilt-bronze foot mount, which was probably removed by its subsequent owner Gaston Bensimon.

3 · PAIR OF LIDDED JARS

THE PORCELAIN: Chinese (Kangxi), 1662–1722
THE GILT-BRONZE MOUNTS: French (Paris), circa 1710–15
HEIGHT: 1 ft., 3¾ in. (40 cm); WIDTH: 11½ in. (29.2 cm); DIAMETER: 11 in. (27.9 cm)
72.DI.50.1–.2

DESCRIPTION

Each jar is circular and tapering with rounded shoulders and a cylindrical lid. Each is enameled with vertical panels that extend the full height of the jar, with magpies, bees, butterflies, and dragonflies amongst scattered branches of lotus, gardenia, tree peony, pink magnolia, roses, prunus, chrysanthemum, and bamboo. These are enameled with green, coral, red, yellow, and aubergine, outlined in black.

The rim of each jar is encircled by a gadrooned molding of gilt bronze. This is linked to the foot mount at each side by vertical bands of pierced and scrolled strapwork surmounted by a shell and with a female mask at the center. This mount is attached at top and bottom by pinned hinges, with a drop handle depending from the shell (fig. 3A). The foot of the vase rests in a deep gilt-bronze molding gadrooned along the upper part.

The lid is encircled around its lower edge by a flanged molding. The original flat-topped cylindrical lid of porcelain is incorporated into the new lid. This is enameled with loose flowering branches between underglaze blue line borders. The lid has been mounted top and bottom with moldings of gilt bronze, the lower one being gadrooned. It is surmounted by a finial in the form of a cluster of berries in a foliate cup resting on a gadrooned base. This is attached by a long threaded pin that engages with an interior circular plate of gilt bronze chased with circles and *fleurons* against a matted ground (fig. 3B).

MARKS None.

FIG. 3A

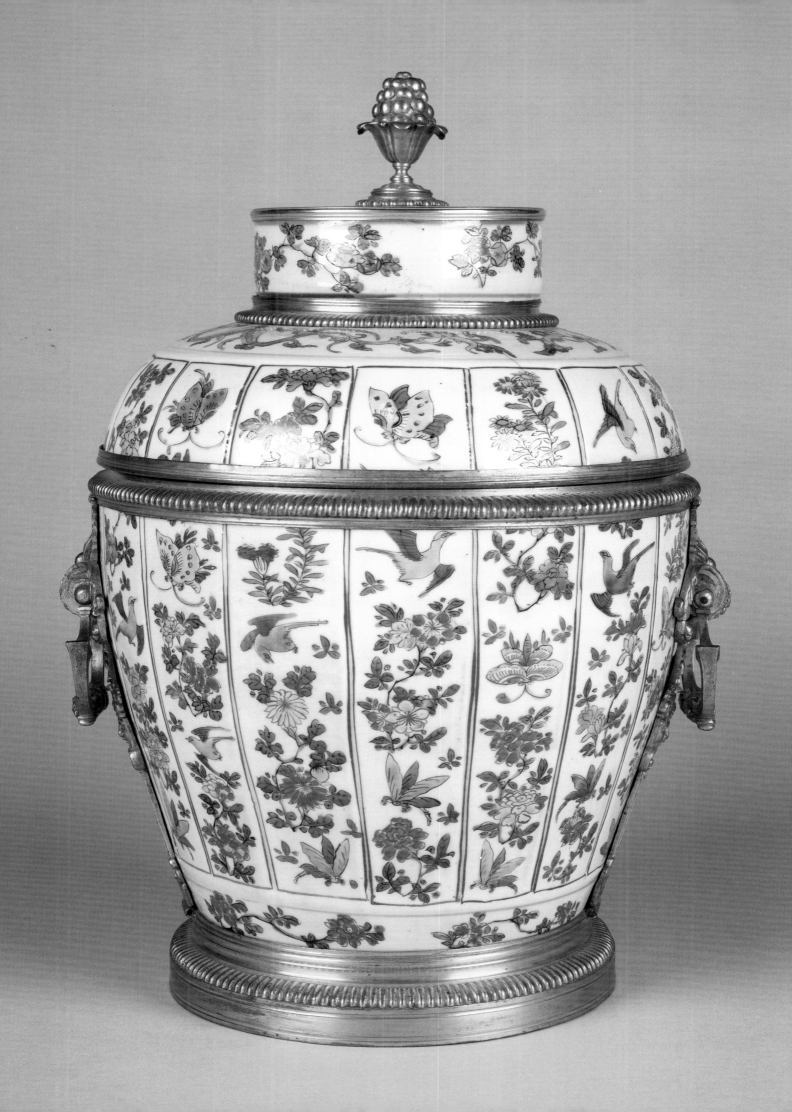

FIG. 3B. The underside of the lid.

COMMENTARY

Each jar has been made up from a complete lidded vessel. The lid has been formed by attaching the shoulder to the small original lid by means of a mount. The enamel decoration has peeled away in some small areas and has been retouched. This was probably done in Paris at the time the jars were being fitted into the mounts. The shape of the jars is based on traditional storage vessels that would have held tea, candy, rice crackers, or medicines. These jars were probably made for export as they are somewhat overdecorated to suit European taste. Traditionally such jars would have been painted with two, four, six, eight, or twelve panels, but these have sixteen panels each.

A similarly decorated complete jar with a domed lid—but unmounted—was sold in London in 1980[1]; a pair of similarly decorated rouleau vases is in the Devonshire Collection at Chatsworth.[2] Another pair of jars of similar shape and decoration, but converted into table lamps, was sold in New York in 1930.[3] A pair of Chinese jars in the Residenzmuseum, Munich,[4] has very similar mounts. Similar strapwork mounts with handles are found on a pair of cylindrical Kangxi vases sold in Paris in 1979.[5] Other similarly mounted jars have passed through the Paris auction rooms in the past century[6] and a pair of lidded bowls with mounts of this design is in the Musée Jacquemart-André, Paris.[7]

The practice of joining mounts with pinned hinges is traditional and dates back to the medieval period. It is to be found, for example, on the Warham Cup at New College, Oxford, which was mounted in silver-gilt between 1506 and 1516 (see Introduction, fig. 6).

PUBLICATIONS
Wilson 1977, p. 12, no. 10; Lunsingh Scheurleer 1980, pp. 60, 252–53, figs. 158a–b; Watson 1980, p. 38, no. 14; Bremer-David et al. 1993, p. 149, no. 247.

EXHIBITIONS
Chinese Porcelains in European Mounts, The China Institute in America, New York, 1980, no. 14.

PROVENANCE
Collection of Louis Guiraud, Paris; sold at the sale of Madame Louis Guiraud, Palais Galliera, Paris, December 10, 1971, no. 1; acquired by the J. Paul Getty Museum from Alexander and Berendt, London, in 1972.

NOTES
1. Christie's, London, April 28, 1980, lot 83.
2. *Treasures from Chatsworth: The Devonshire Inheritance* (Washington, D.C., 1979), p. 231, pl. 194.
3. American Art Association, Anderson Galleries, New York, February 28 and March 1, 1930, lot 75, property of Count Piero Venezze.
4. Res. Mu. KVb 286/87. See Lunsingh Scheurleer 1980, p. 253, fig. 159.
5. Palais d'Orsay, Paris, March 28, 1979, no. 19.
6. See, for example, a lidded blue-and-white Kangxi vase, sold from the collection of Jacques Doucet, Galerie Georges Petit, Paris, June 7–8, 1912, no. 209; a pair of lidded *famille verte* vases, sold from the collection of Madame Louis Burat, Galerie Jean Charpentier, Paris, June 18, 1937, no. 45; a single lidded *famille verte* vase, sold at Drouot-Montaigne, Paris, November 29, 1992, no. 16; a pair of *famille verte* lidded vases, sold at Ader Picard Tajan, Paris, March 15, 1993, no. 439; and a single lidded *famille verte* vase, sold at Christie's, Monaco, December 5, 1993, no. 155.
7. Acc. no. D.68.

4. LIDDED BOWL

THE PORCELAIN: Japanese (Imari), early eighteenth century
THE SILVER MOUNTS: French (Paris), circa 1720
HEIGHT: 11 in. (27.9 cm); WIDTH: 1 ft., 1⅜ in. (34 cm); DIAMETER: 10⅞ in. (27.5 cm)
79.DI.123

DESCRIPTION

The deep circular bowl is mounted with silver around the foot, the lip of the bowl, and the lid. There is a silver handle at each side and a silver finial surmounts the lid.

The exterior of the bowl is decorated with irregularly shaped overlapping panels of flowering chrysanthemum, prunus, and tree peonies in deep underglaze blue and overglaze iron red and gilt. The interior is similarly decorated with three sprays of flowers: chrysanthemum, peony, and prunus. They frame a central panel of a classical mountainous river landscape within a double circle of blue.

The lid is in two stages (fig. 4A), the lower consisting of an inverted shallow dish of Imari porcelain, decorated on its exterior with a loose chrysanthemum scroll with green and yellow enamels over underglaze blue, the base with prunus sprays surrounding a budding branch. The interior (fig. 4B) is richly decorated with a central formal chrysanthemum head—from which radiate panels of flowering branches and iron-red and gilt chrysanthemum heads scattered over gilt cell-patterned blue grounds—and with pale turquoise and green enamels. The upper stage of the lid is a domed lid taken from another vase, with its lip cut down. It is decorated with flowers and foliage of similar color; four of the flowers are molded in low relief and gilt, two with brocaded petals.

The lip of the bowl is encircled by a silver gadrooned molding, flanked at each side by a handle linked to the foot by a pierced mount of scrolled, foliate, and interlacing forms, attached above and below by a pinned hinge (fig. 4C). The rim of the foot takes the form of a simple gadrooned molding. The lower edge of the lid is surrounded by a deep band of silver chased with strapwork cartouches that enclose *fleurons* against a matted ground.

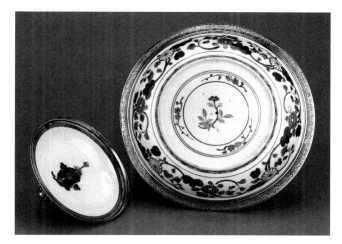

FIG. 4A. The lid disassembled.

A gadrooned molding encircles the domed lid midway, separating it from the inverted dish. The finial is in the form of a foliate cup heaped with berries; it is attached to a pin that passes through both components of the lid, securing them together with a nut.

MARKS None.

COMMENTARY

The elements of this piece—the bowl, plate, and small lid—were all made as export ware. The so-called "Imari" decoration was influenced by Chinese ceramics, where underglaze blue and overglaze red and gold appeared at a considerably earlier date than they did in the Japanese kilns.

The silver mounts are unmarked. An Imari bowl in the Bayerisches Nationalmuseum, Munich, bears silver mounts of the same design.[1] The Munich mounts are marked with a fleur-de-lys, the Paris mark for the years

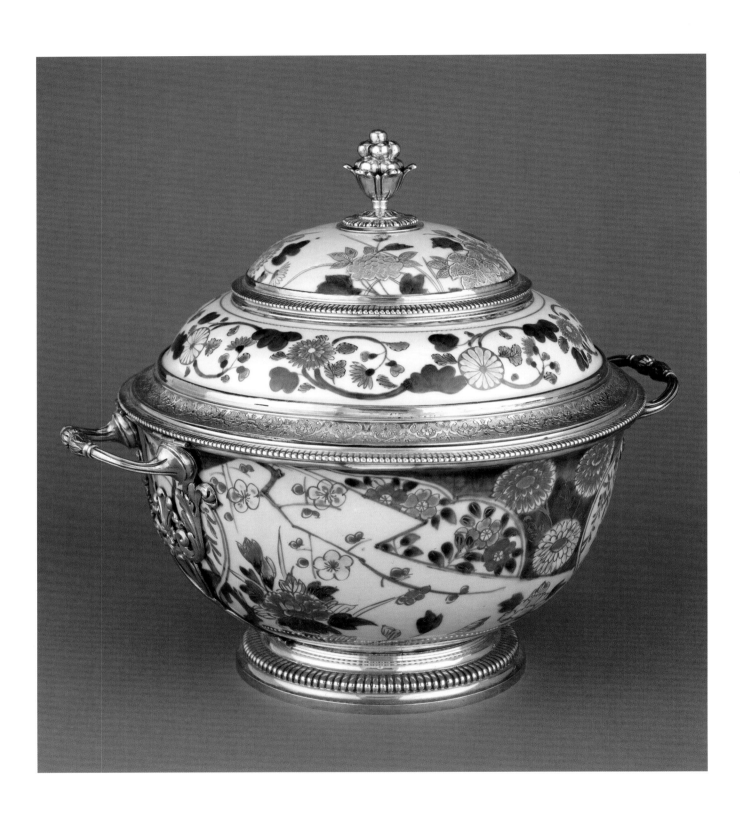

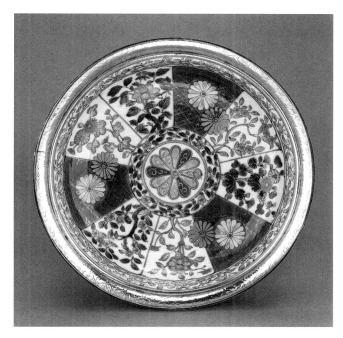

FIG. 4B. The underside of the lid.

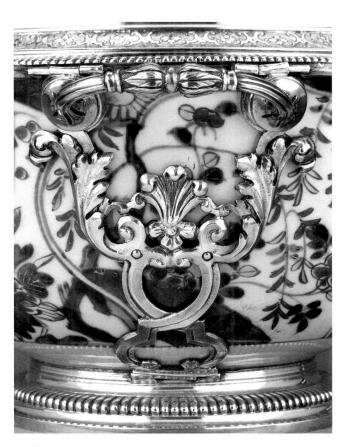

FIG. 4C

1697–1704 and 1717–22.[2] As the Imari porcelain of the Munich bowl would appear to date from around 1700, it seems likely that, allowing for a lapse of some years between its manufacture and its mounting in France, the fleur-de-lys mark is the one used between 1717 and 1722. The silver mounts of the Getty Museum's bowl may be given a similar date.

PUBLICATIONS

Wilson 1980, p. 8, no. 5; Watson 1986, pp. 54–55, no. 13; Bremer-David et al. 1993, p. 150, no. 249; *Three French Reigns (Louis XIV, XV, & XVI)* (London, 1933), no. 226; Sargentson 1996, p. 70, pl. 12, fig. 39.

EXHIBITIONS

Three French Reigns (Louis XIV, XV, & XVI), London, 1933, no. 226, lent by Mrs. Walter Hayes Burns; *Mounted Oriental Porcelain*, The Frick Collection, New York, 1986, no. 13.

PROVENANCE

Mrs. Walter Hayes Burns, née Morgan (sister of J. Pierpont Morgan), North Mymms Park, England; by descent to Major General Sir George Burns; acquired by the J. Paul Getty Museum at the sale of the contents of North Mymms Park, Christie's, September 24–26, 1979, lot 45 (illus.).

NOTES
1. Acc. no. Ker 1948 u. 1947.
2. I am grateful to Rainer Ruckert for this information.

5. PAIR OF LIDDED JARS

THE PORCELAIN: Chinese (Kangxi), 1662–1722
THE GILT-BRONZE MOUNTS: French, circa 1715–20
HEIGHT: 1 ft., 1½ in. (34.2 cm); WIDTH: 1 ft., ¾ in. (32.5 cm); DIAMETER: 1 ft., 1 in. (33 cm)
75.DI.5.1–.2

DESCRIPTION

Each of the circular and tapering lidded jars is composed of three pieces of porcelain cut down from two slightly larger jars and mounted with gilt bronze. The lid is in two stages, joined midway by a plain molding of gilt bronze. There is a handle at each side of the body (fig. 5A).

The body and lid are enameled in pale and dark green, aubergine, and iron red with lotus, prunus buds, and Buddhist "precious things." These are scattered over black-penciled waves that break against formal rockwork between double lines of underglaze blue. The foot is held in a simple circular mount of gilt bronze with a gadrooned shoulder between plain borders. This is linked at each side by pierced straps to a similar molding that encircles the rim of the vase. Each strap, which is attached above and below by pinned hinges, is of strapwork that incorporates acanthus leaves, C-scrolls, and husks. To the upper part of each side is attached a ribbed handle that is interrupted at the center with adorsed leaf cups.

The lower stage of the lid is the shoulder of the vase, cut at the original luted joint and with the cylindrical neck removed. It is joined to the reduced original lid, which has had the plain porcelain knop replaced with a gilt-bronze finial in the form of a foliated cup filled with berries that rest on a circular gadrooned base of gilt bronze. The two stages of the lid are joined by a bolt that passes from the finial through a circular plate of gilt bronze with matted design within the base of the dome, where it is secured by a nut (fig. 5C).

MARKS

The gilt-bronze mounts are struck with the crowned C mark nine times on each of the vases: once on the foot, lip, and two rim mounts, on each handle, and on the finial, its base, and the plate in the interior.

COMMENTARY

The shoulders of both lids have been broken and restored in a number of places. The original upper part of one of the lids (fig. 5D) has been almost completely overpainted; as this section of the lid is not broken, it is likely that the enamel overglaze decoration has peeled off and the losses repainted (figs. 5D and 5E).

The jars were probably made for export, although they are decorated with traditional motifs. They were made in a private, not imperial, kiln, and the products of such kilns were not always of the highest quality. A complete jar and lid, 1 foot, 2⅛ inches high but with an aubergine ground, is in the Musée Guimet, Paris.[1]

In March 1745 an edict registered by the French Parlement declared that a tax should be levied throughout France on all objects *"vieux et neufs de cuivre pur, de fonte, de bronze et autres de cuivre mélangé, fondu, battus, forgé, plané, gravé, doré, argenté, et mis en couleurs,"* and it was laid down that a mark should be struck on each piece of bronze at the time the tax was paid, much in the way that taxes had been levied on precious metals for many centuries. Henri Nocq,[2] the great authority on French silver, suggested that the mark probably took the form of a letter C (for *cuivre*, copper, the principal metal in bronze) surmounted by a crown, often found on works of gilt bronze. But he could not prove this, for the edict made no reference to the form of the

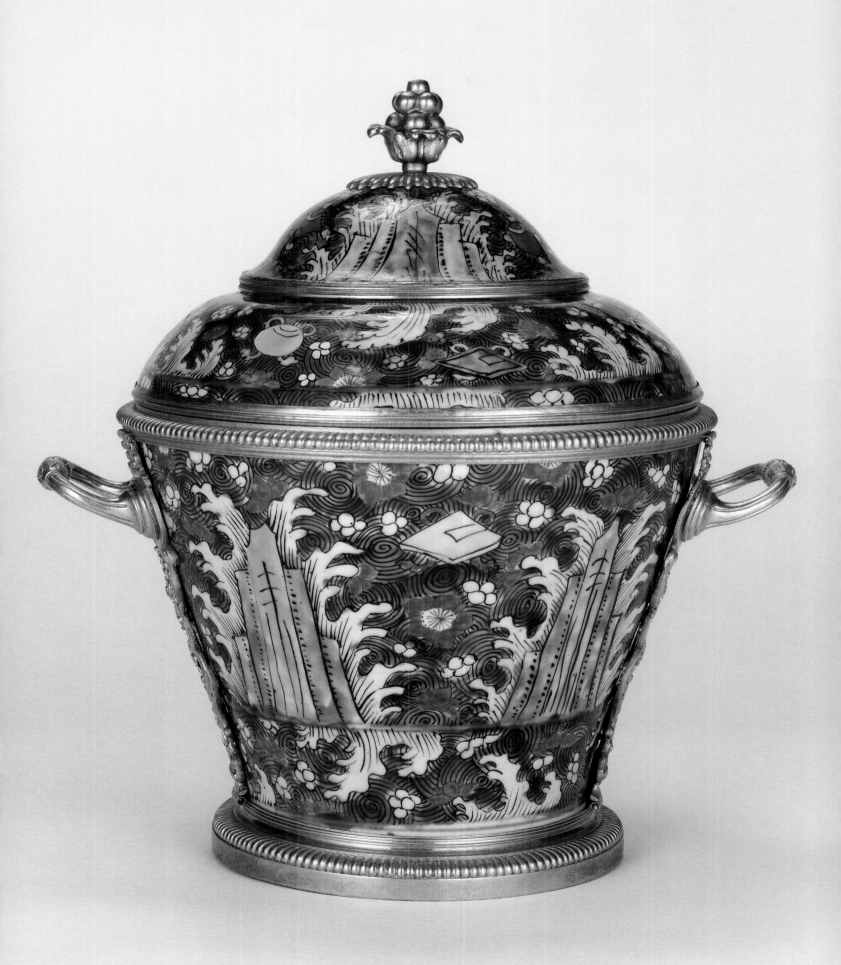

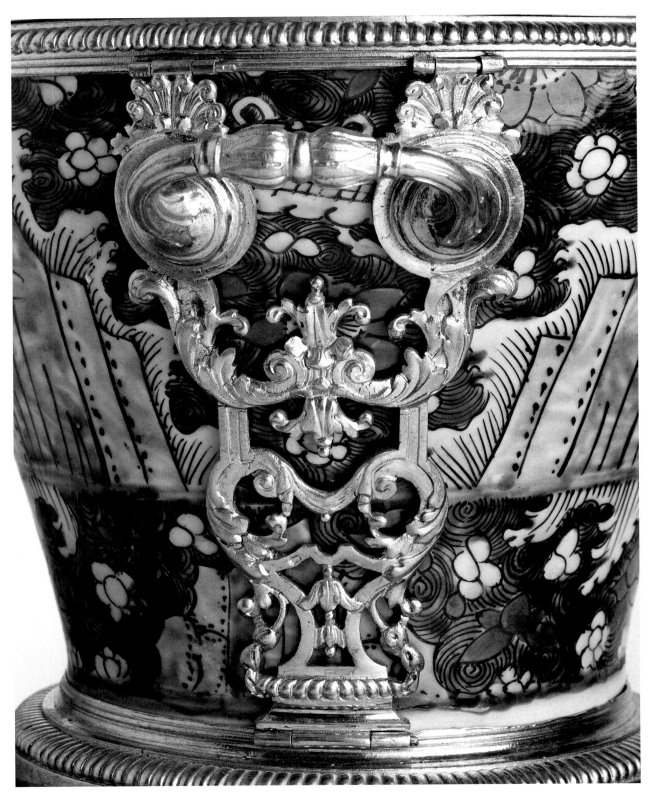

FIG. 5A

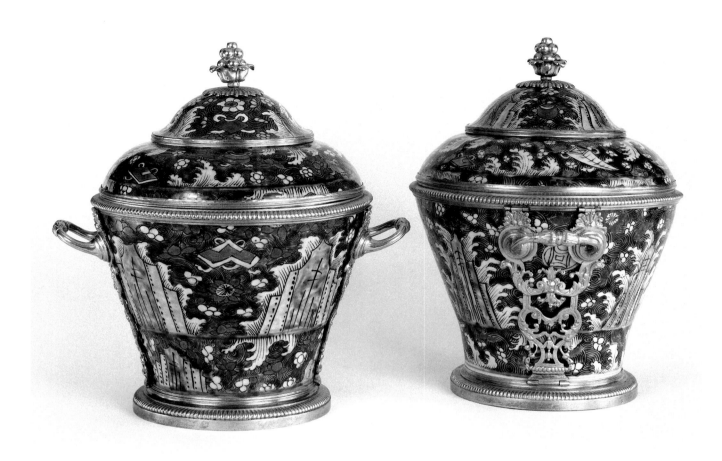

FIG. 5B

mark struck. It remained for Pierre Verlet to confirm this hypothesis by demonstrating that the familiar crowned C had been struck on the mounts of a chimney piece at Versailles that could be shown to have been ordered in 1748.[3] Earlier it had been suggested that the mark was a signature or a maker's mark, the names of Cressent and Caffieri being suggested amongst others.

The edict was canceled by the Parlement in 1749. It has often been supposed that the presence of such a mark indicates that the marked piece was actually made during the short span of four years when the tax was in force. It can, however, be seen from the wording of the edict that the tax was levied on old metalwork as well as on new. A chandelier in the Getty Museum,[4] stylistically datable to about 1710, is struck on each of its component parts with the tax stamp; and the gilt-bronze hinges of a late-seventeenth-century cabinet in the Wallace Collection[5] are also struck with the stamp.

A pair of lidded jars, of almost identical shape and mounting, was sold in Paris in 1978.[6] The strapwork mounts of these jars are similar in design to those of silver on the Imari bowls (see catalogue nos. 4 and 6). It is possible that they were designed by the same artist but made, necessarily, by craftsmen in different guilds using the same source of design.

A variant of this vertical mount including a female mask can be seen on a single lidded jar at the Château of Vaux-le-Vicomte[7] and on another in the Residenzmuseum, Munich.[8] A similarly mounted pair was sold in Paris in 1987,[9] and a single straight-sided vase was sold in London in 1999.[10]

PUBLICATIONS

Wilson 1977, p. 14, no. 14; Lunsingh Scheurleer 1980, p. 250, no. 151; Watson 1980, p. 27, no. 3; Bremer-David et al. 1993, p. 149, no. 248.

FIG. 5C. The underside of the lid.

EXHIBITIONS

Chinese Porcelains in European Mounts, The China Institute in America, New York, 1980, no. 3.

PROVENANCE

Bouvier collection, France; Jacques Seligmann, Paris, before 1938; Mrs. Landon K. Thorne, New York; acquired by the J. Paul Getty Museum from Matthew Schutz, Ltd., New York, in 1975.

NOTES

1. Musée Guimet, *Oriental Ceramics: The World's Great Collections* (Paris, 1981) p. 28. Similar complete unmounted jars were sold at auction: Christie's, London, November 24, 1932, lot 86, height 1 ft., 2½ in. (36.8 cm); Sotheby's, Monaco, February 12, 1979, no. 535, height 1 ft., 7⅝ in. (50 cm).

2. Henri Nocq, "L'orfèverie du dix-huitième siècle: Quelques marques: Le C. Couronné," *Le Figaro artistique* (April 1924), pp. 2–4.

3. Pierre Verlet, "A Note on the 'Poinçon' of the Crowned 'C'," *Apollo*, vol. 26, no. 151 (July 1937), pp. 22–23.

4. Acc. no. 76.DF.13.

5. Hughes 1996, vol. 2, p. 830. Its companion F61 is stamped I. DUBOIS. It is likely that both armoires were repaired by Jacques Dubois in the mid-eighteenth century.

6. Palais d'Orsay, Paris, February 21, 1978, no. 26, now in a New York private collection.

7. The porcelain is blue-and-white of the Kangxi period (1662–1722).

8. *Kurfürst Max Emanuel: Bayern und Europa um 1700*, 2 vols. (Munich, 1976), vol. 2, p. 330.

9. Drouot-Montaigne, Paris, November 22, 1987, no. 215. The jars were enameled in the *famille verte* style.

10. Sotheby's, London, March 11, 1999, lot 601.

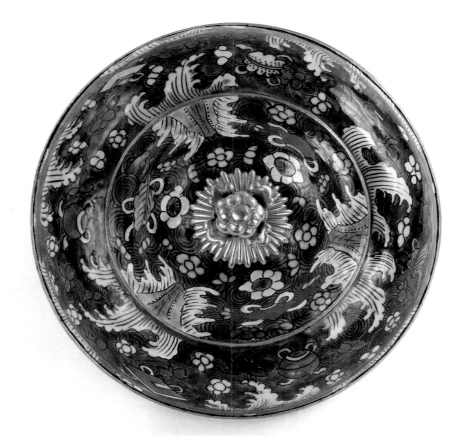

FIG. 5D. Lid, showing overpainting.

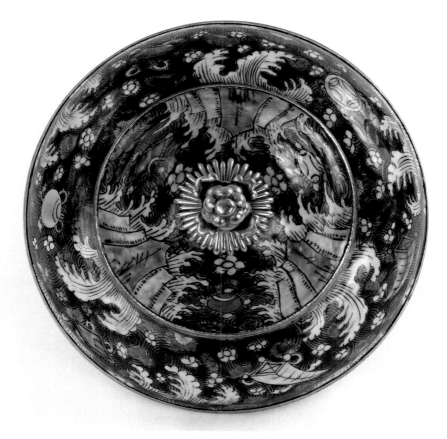

FIG. 5E

6. LIDDED BOWL

THE PORCELAIN: Japanese (Imari), early eighteenth century
THE SILVER MOUNTS: French (Paris), 1717–22
HEIGHT: 8¾ in. (22.3 cm); WIDTH: 10⅝ in. (27.1 cm); DIAMETER: 8⅜ in. (21.2 cm)
74.DI.27

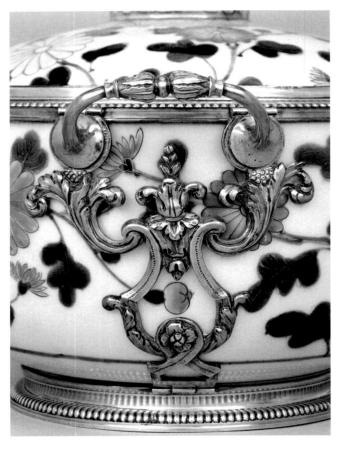

FIG. 6A

DESCRIPTION

The deep straight-sided bowl and shallow lid are enameled with iron red and gilt over underglaze blue with chrysanthemum branches on a white ground. Some of the flowers are molded in low relief, created by slip. The body is covered with a typical Imari blue-tinged translucent glaze. The foot of the lid (an inverted dish) is painted with a classic scroll in underglaze blue.

The bowl is mounted around the rim and foot with silver and fitted at each side with a silver handle attached to pierced strapwork that joins the rim to the foot. The lid is similarly mounted around its lower edge and is surmounted by a finial. The rim of the bowl is encircled by a simple molding, the foot by a larger gadrooned molding. The handle at each side springs from pierced, foliate, scrolled, and interlacing strapwork that is attached to the moldings above and below by pinned hinges (fig. 6A). The lid is encircled by a gadrooned molding around the rim and surmounted by a tall finial in the form of a leaf cup that contains a grape cluster set on a low cylindrical base of silver embellished with gadrooning and acanthus. This fits over the porcelain foot of the inverted dish, which functions as a lid.

MARKS

The silver mounts are struck with the following Parisian marks. On the base of the silver knop: a fleur-de-lys; on the rim of the lid: a fleur-de-lys, a butterfly, and a salmon's head (fig. 6B); on each handle: a fleur-de-lys and a butterfly; on the upper rim of the lid: a fleur-de-lys; on the rim of the bowl: a butterfly, a fleur-de-lys, and a dog's head (fig. 6C). A butterfly is the counter mark used between May 6, 1722, and September 2, 1727, under the *fermier* Charles Cordier. A salmon's head is

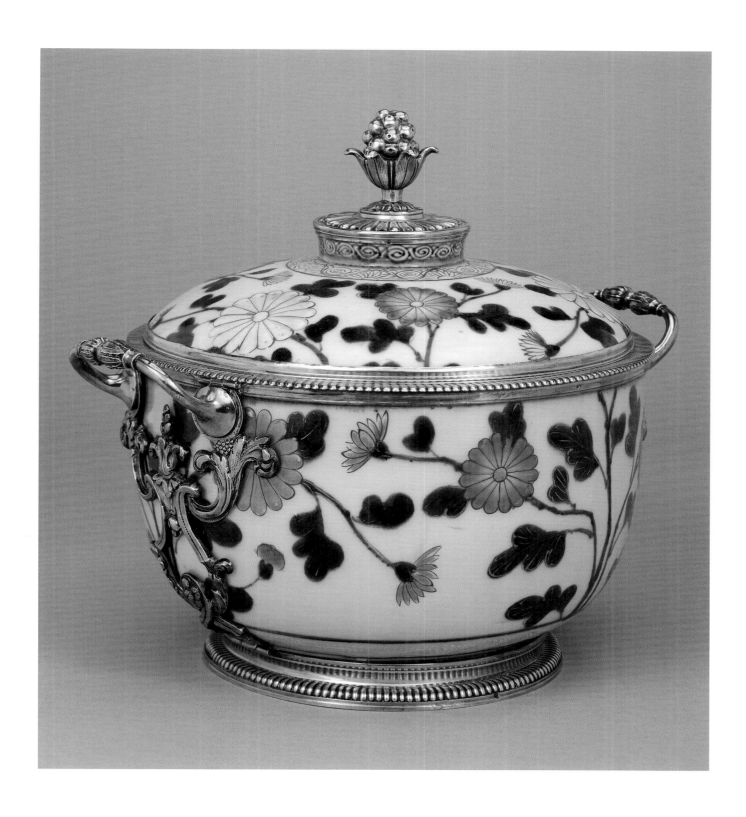

FIG. 6B. A salmon's head mark on the silver rim of the lid.

FIG. 6C. A fleur-de-lys, a butterfly, and a dog's head mark on the silver of the bowl.

PUBLICATIONS

Wilson 1977, p. 22, no. 26; Lunsingh Scheurleer 1980, p. 403, no. 439; Bremer-David et al. 1993, p. 150, no. 250.

PROVENANCE

Consuelo Vanderbilt (Mme. Jacques Balsan); acquired by the J. Paul Getty Museum from Matthew Schutz, Ltd., New York, in 1974.

NOTES

1. I am grateful to Clare le Corbeiller for her assistance in reading the silver marks.
2. Stéphane Faniel, ed., *Le dix-septième siècle français* (Paris, 1958), p. 94 (illus. only).
3. Photograph in Getty curatorial files, taken by John Whitehead.
4. One is illustrated in color in an advertisement published in *L'Oeil*, no. 132 (December 1965). They then belonged to J. Kugel, Paris.

the discharge mark for small silver used between October 13, 1744, and October 9, 1750. A dog's head is the discharge mark for small silver used between December 22, 1732, and October 3, 1738. A single fleur-de-lys with no crown would appear to be the discharge mark for small work, 1717–22.[1]

COMMENTARY

The bowl and the dish were made for export to the West. The decoration is not typically Japanese, but rather follows that of contemporary European textiles. They may have been part of a commission in which a European design was particularly specified.

Most of the gilding has been worn from the flowers in relief on the lid. A bowl with similar mounts was in the possession of Arturo Lopez-Willshaw.[2] Another Imari lidded bowl of similar dimensions and with silver mounts of similar design is in the Topkapi Museum, Istanbul.[3] A pair of Chinese lidded bowls with silver mounts of the same model was on the Paris market in 1965.[4]

7. LIDDED BOWL

THE PORCELAIN: Chinese (Kangxi), 1662–1722, and Japanese (Arita), circa 1660
THE SILVER MOUNTS: French (Paris), 1722–27
HEIGHT: 8 in. (20.3 cm); DIAMETER: 9⅞ in. (25.1 cm)
87.DI.4

DESCRIPTION

The circular lidded bowl is composed of three pieces of porcelain mounted with silver. The body is potted in a fine light gray clay and covered with a white glaze.

The white porcelain is painted with cinnabar-red overglaze enamel and gilded. The circular piece of porcelain forming the top of the lid is divided into sixteen panels that are alternatively painted with flowers and grasses (fig. 7A). The underside is painted in red, green, brown, and yellow with a flowering branch. It is encircled by a green band inside a band of alternating sections of trellis pattern and cloud collars (fig. 7B).

The main body of the lid is painted with the lower remains of a band of banana plant. Below, a band of "tortoiseshell" pattern is punctuated at the cardinal points with four of the eight "precious things": the pearl, the mirror, the artemesia leaf, and the musical stone.

A cloud collar design is painted around the shoulder of the bowl with the scrolling stems, leaves, buds, and flowers of a stylized chrysanthemum. Floral vines are painted at the cardinal points on the open field of the belly.

The bowl is mounted with silver around the foot and lip and on the lid around the rim and the top. The lid is surmounted by a silver finial that takes the form of a berry cluster in a six-leaf cup on a flat round base. It is secured to the lid with a threaded bolt and a four-petaled nut. The silver rim on the lip of the bowl is punctuated with four flanges that repeat the shape of the cloud collar they overlay. The foot mount has a gadrooned band at its center.

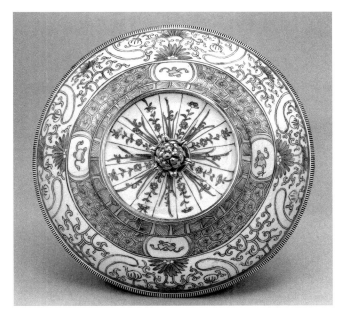

FIG. 7A

MARKS

The painter's mark of two concentric circles are painted in underglaze blue on the underside of the bowl.

Each silver mount is stamped with a dove (the Paris discharge mark for small silver works used between May 6, 1722, and September 2, 1727, under the *fermier* Charles Cordier) (fig. 7C).

COMMENTARY

The central section of the lid has been cracked in five places and the outer section of the lid in one place.

This type of cinnabar-red painted overglaze enamel decoration came into use during the Ming dynasty (1388–1644). Vessels decorated in this manner were

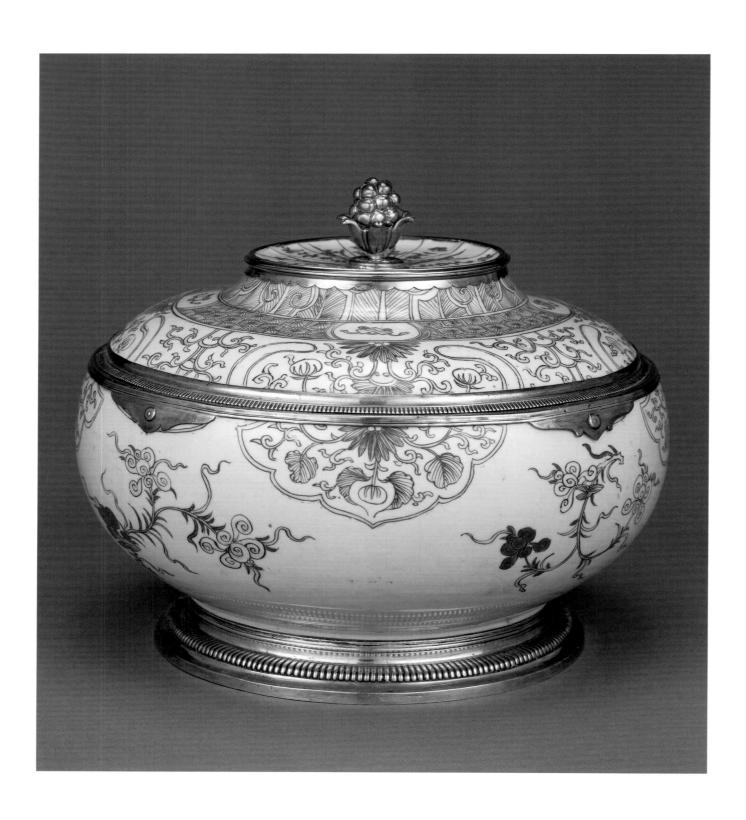

FIG. 7B. A detail of the underside of the lid.

FIG. 7C. A dove mark on the upper silver rim of the lid.

rare in Europe during the first quarter of the eighteenth century, when Dutch cargoes of porcelain consisted largely of Chinese blue-and-white, *blanc-de-chine*, and Japanese Imari.

The lidded bowl was once a long-necked vase that was made for domestic use. The neck of the vase was cut off and a second cut was made at the shoulder to form the lid. Cut from the base of a dish or a bowl, a disk of porcelain was inserted to fill the hole left by the removal of the neck.[1] The gilding of the Getty Museum's lidded bowl is worn and was originally more extensive. The network of double lines that defines all the painted forms was gilded.[2]

For reasons of economy and novelty Parisian dealer-decorators (*marchands-merciers*) adapted and reconfigured with metal mounts intact vessels and fragments from other pieces, perhaps broken during shipping, into decorative objects. The long neck of this vase may have been broken in transit. Given the inventive spirit of the *marchands-merciers* and the infancy of the study and appreciation of Asian ceramics at the end of the seventeenth century, no care or thought was given to the rarity of a vessel, and some were cut even if they had not been broken.

The central section of the lid is cut from the foot of a roughly contemporary Japanese Kutani-style dish or bowl from Arita.[3] Kutani-style wares were abundant in Europe at the end of the seventeenth century and were frequently adapted and mounted with pieces of other wares. The cinnabar-red overglaze enamel painting on the top of the lid is integral to the overall program of the bowl, but may not be original, having perhaps been added in Paris when the bowl was assembled. The decorative surprise on the underside of the lid may have been intended to delight its owner when the top was raised.

The use of silver mounts on Chinese porcelain was unusual in the eighteenth century. They were generally fitted for aesthetic reasons to Japanese Imari porcelains. The bowl may have been mistaken for a Japanese vessel. Regardless, elaborate gilt-bronze mounts would not perhaps have been suitable for this shape.

PUBLICATIONS

"Acquisitions/1987," *GettyMusJ* 16 (1988), pp. 178–79, no. 71; Bremer-David et al. 1993, p. 151, no. 251.

PROVENANCE

Acquired by the J. Paul Getty Museum from J. Kugel, Paris, in 1987.

NOTES

1. A pair of vases (Sotheby's, Monaco, June 15, 1996, no. 125) displays the original form and decoration that was adapted to make the Museum's lidded bowl. The necks of these vases have been slightly reduced in height.
2. Much of this network of gilding remains on the comparison vases mentioned in note 1.
3. I thank Oliver Impey for this information.

8. PAIR OF LIDDED VASES

THE PORCELAIN: Chinese (Kangxi), from Dehua, 1662–1722; circa 1700
THE SILVER MOUNTS: French (Paris), 1722–27
HEIGHT: 7⅝ in. (19.4 cm); WIDTH: 3⅜ in. (8.6 cm); DEPTH: 3 in. (7.7 cm)
91.DI.103.1–.2

DESCRIPTION

This pair of small vases is made of fine white clay and covered with a clear glaze. A molded lion's head has been applied to either side of each vase just below the shoulder, and a small hole has been drilled through the wall beneath.

Each vase is mounted with silver at the foot and lip, and the upper part has been pierced with holes set with star-shaped silver mounts (fig. 8A). A finial in the form of a bud set in a six-leaf cup surmounts each silver lid. The domed lids are pierced with a repeating motif of scrolling leaves and have gadrooned rims (fig. 8B). The lip of the vase is encircled by a silver band. The foot is set in a mount decorated with bead-and-chain on the stippled ground below a gadrooned band.

MARKS

Each lid and base mount is stamped with a dove (fig. 8C), the Paris discharge mark for small silver works used between May 6, 1722, and September 2, 1727, under the *fermier* Charles Cordier; a boar's head facing right (fig. 8D), the Paris discharge mark for small and old silver works used between December 23, 1768, and September 1, 1775, under the *fermier* Julien Alaterre; and the profile head of Minerva (fig. 8E), the mark for .800 silver works sold in France after May 10, 1838.

COMMENTARY

The porcelain of Dehua in the southern Chinese province of Fukien reached Europe in large quantities during the late seventeenth and eighteenth centuries. After the Ming dynasty (1388–1644), most Dehua wares were exported from the Chinese port of Xiamen to Ja-

pan, where they were bought by the Dutch.[1] The purity of these white wares appealed to collectors, and the porcelain manufacturers at Meissen, Saint-Cloud, and Chantilly sought to reproduce them. The finest Dehua vessels were made during the Kangxi dynasty. Since the mid-nineteenth century, porcelain of this type has been known as *blanc-de-chine*.

The form of these vases is familiar among Dehua wares. The presence of two larger vases of similar form, inscribed with characters in grass script and datable to 1683 and 1702, makes it possible to date the Getty Museum's pair of vases to between these years.[2] Vases of this type were originally meant to hold flowers during a religious ceremony. The Museum's pair was transformed to contain potpourri, the perfume of which escaped through the holes in the vase and the lid. Given the jewel-like quality of the mounts, these potpourris must have been made for use in a small cabinet or bed chamber, perhaps for the table carrying the silver boxes used for the toilette.

PUBLICATIONS

"Acquisitions/1991," *GettyMusJ* 20 (1992), p. 174, no. 75; Bremer-David et al. 1993, p. 151, no. 252.

PROVENANCE

Gift of Mme. Simone Steinitz, 1991.

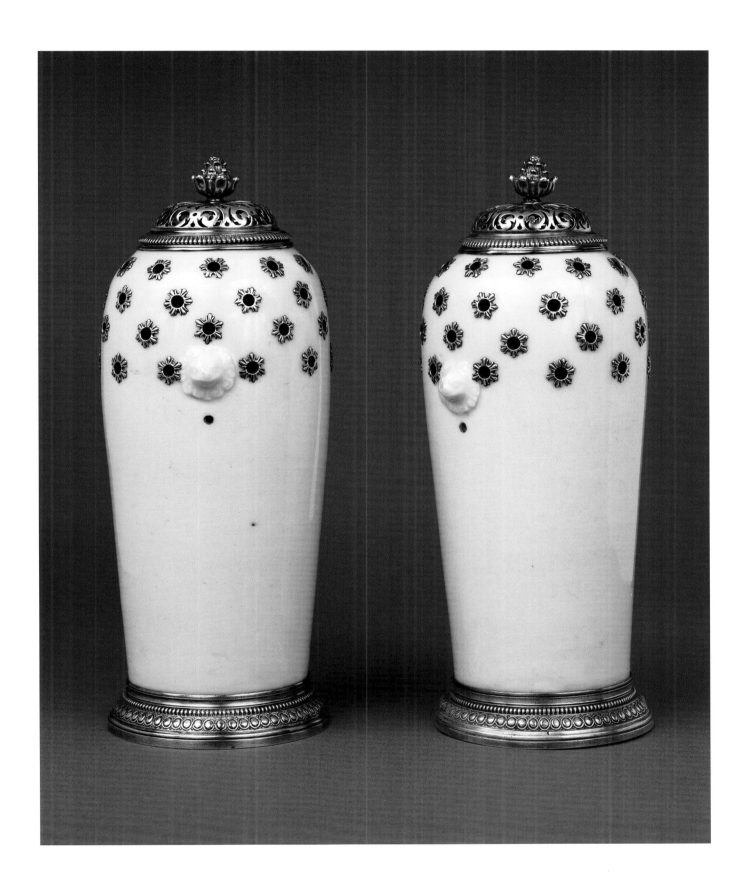

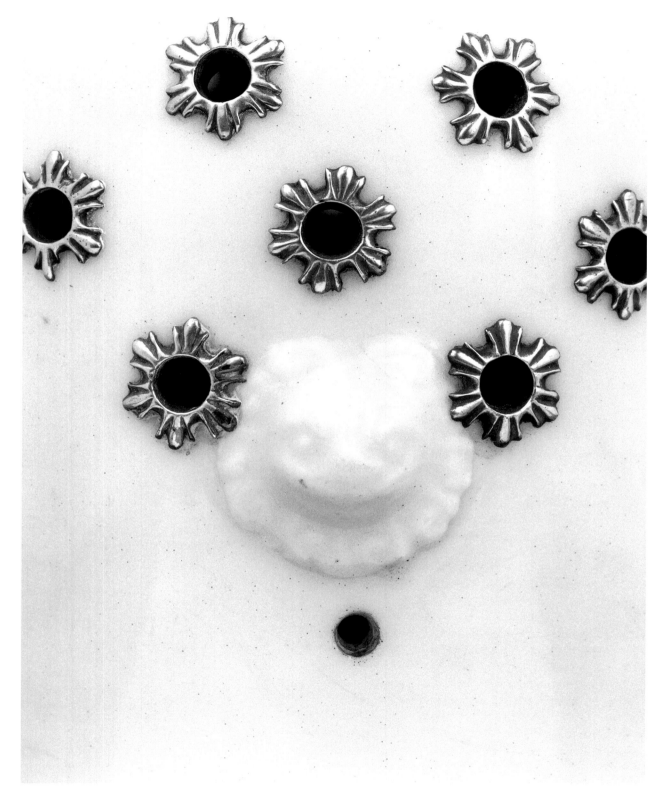

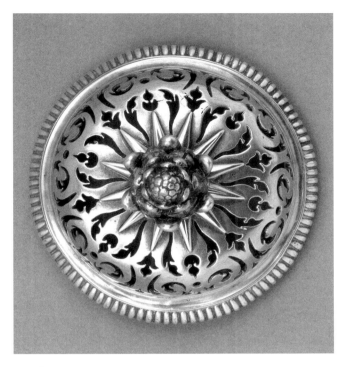

FIG. 8B

FIG. 8C. A dove mark on the silver rim of the lid.

FIG. 8D. A boar's head mark on the silver rim of the lid.

FIG. 8E. The mark of a profile head of Minerva on the silver rim of the lid.

NOTES

1. Ye Wencheng and Xu Benzhang, "The Extensive International Market for Dehua Porcelain" (in Chinese), *Hawai jiaotongshi yanjiu* 2 (1980), pp. 1–15, translated by Rose Kerr and reprinted in *Oriental Ceramic Society, Chinese Translations*, no. 10 (n.d.), n.p.
2. Christie's, London, June 8, 1992, lot 1, 18 in. (45.5 cm), and Pao-ts'an-shih, Hong Kong, 10 in. (25.4 cm). Dehua vases of this form range in height from 6 in. (15.2 cm) to more than 15 in. (38.1 cm). Donnelly 1969, pp. 51, 67, 69, 261, 264, 395, 402, pl. 8a.

9. BOWL AND STAND

THE PORCELAIN: Japanese (Imari), early eighteenth century
THE GILT-BRONZE MOUNTS: French (Paris), circa 1740
HEIGHT: 7⅜ in. (18.7 cm); DIAMETER: 7¾ in. (19.7 cm)
74.DI.28

DESCRIPTION

The deep circular bowl has a flared lip and is supported by three gilt-bronze dolphins on a three-legged stand of porcelain, also mounted with gilt bronze. The bowl is painted inside and out with underglaze blue and enameled with iron red and gilt, with floral lambrequin panels alternately painted with deep blue grounds. The center of the interior of the bowl is painted with an unidentified and fanciful European coat of arms (fig. 9A)[1] and surrounded by a composite bird and a foliate scroll with a plain thin molding of gilt bronze. The foot of the bowl is set in a similar molding which is clasped at three equidistant points by the tails of scaly dolphins whose heads rest upon the flat rim of the stand. The tripod stand is decorated with iron red and the deeper gray-blue typical of the period, with loose sprays of flowers. There are pierced panels in the shaped aprons between the cabriole legs. The legs are overlaid with gilt-bronze foot mounts of scrolling and floral character chased above the knees with cabochons. The three feet are linked by a tripartite stretcher of scrolling and foliate form, surmounted at the junction by a miniature vase.

FIG. 9A. Detail of the interior of the bowl, showing the coat of arms.

MARKS None.

COMMENTARY

An unmounted Japanese Imari stand, of the same form and decoration but supporting a teapot, was sold at auction in Holland in 1981.[2]

The bowl was originally intended for food and would have had a shallow domed lid to be used as an eating dish. A large dish with similar decoration and the same coat of arms is in the Residenzmuseum, Munich.[3]

PUBLICATIONS

Lunsingh Scheurleer 1980, p. 406, no. 451; Watson 1980, p. 33, no. 9; Bremer-David et al. 1993, p. 152, no. 254.

EXHIBITIONS

Chinese Porcelains in European Mounts, The Chinese Institute in America, New York, 1980, no. 9.

PROVENANCE

Anne Beddard, sold Sotheby Parke Bernet, London, June 15, 1973, lot 36; acquired by the J. Paul Getty Museum from Frank Partridge Ltd., London, in 1974.

NOTES

1. The coat of arms may loosely be described as: argent, 2 chevronels gules and or between 3 eagles or 2 counterdisplayed and a bezant and 1, in chief tenné 3 unidentified objects or (a mill iron? below 2 shackles?) encircled by a laurel wreath and surmounted by a pelican (?). As the coat of arms is painted with a certain amount of heraldic license, the orange-red is interpreted as red, and the white field as silver. I am grateful to Consuelo Wager Dutschke for reading the heraldry.
2. Sotheby's, Mak van Waay, Amsterdam, September 14–22, 1981, no. 2284, illus.
3. Res. Mu. KVb 411.

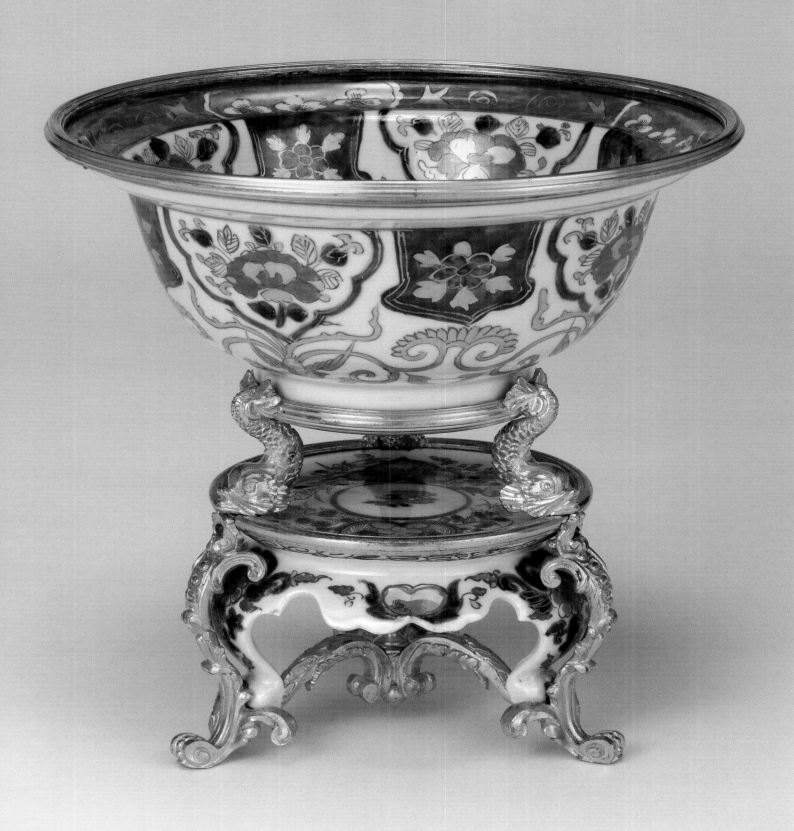

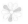

10. PAIR OF DECORATIVE GROUPS

THE PORCELAIN FIGURES, THE ROCKWORK, AND THE LION FINIALS: Chinese (Kangxi), 1662–1722
THE PIERCED SPHERES: Chinese (Qianlong), 1736–95; THE FLOWERS: French (Chantilly Manufactory), circa 1740
THE GILT-BRONZE MOUNTS: French (Paris), circa 1740–45
HEIGHT: 1 ft. (30.4 cm); WIDTH: 9 in. (22.8 cm); DEPTH: 5 in. (12.7 cm)
78.DI.4.1–.2

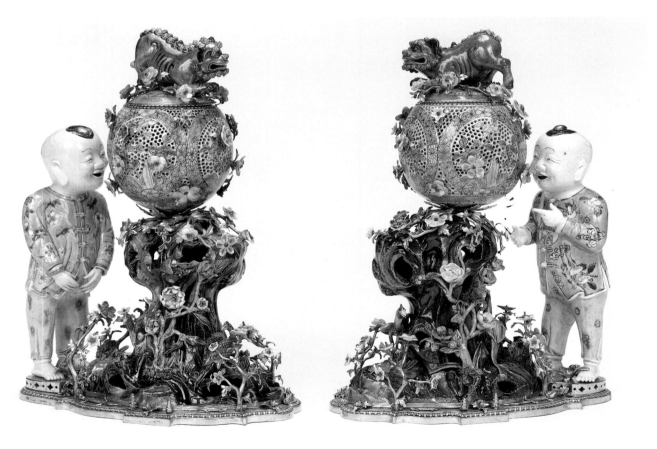

FIG. 10A

DESCRIPTION

Each group consists of three assembled porcelain objects: a figure, a pierced and lidded sphere, and a rocky outcrop. They have been combined into a picturesque composition of a boy peering into the pierced sphere. The main feature of each consists of an outcrop of pierced rockwork encrusted with peacocks (fig. 10C) amongst flowering branches that are enameled on the biscuit with dark aubergine and splashes of yellow and green. On this

rests a porcelain sphere with a lid, originally intended as a perfume ball, into which peers the Chinese boy. The lid of each sphere is surmounted by a lion finial.

The spheres are enameled with panels of landscapes and branches of flowers growing from rockwork in green, black, yellow, brown, and blue, surrounded by floral cell-patterned borders—all reserved on a pierced white ground. The lions are green, yellow, and brown. The standing boys wear yellow trousers and green coats.

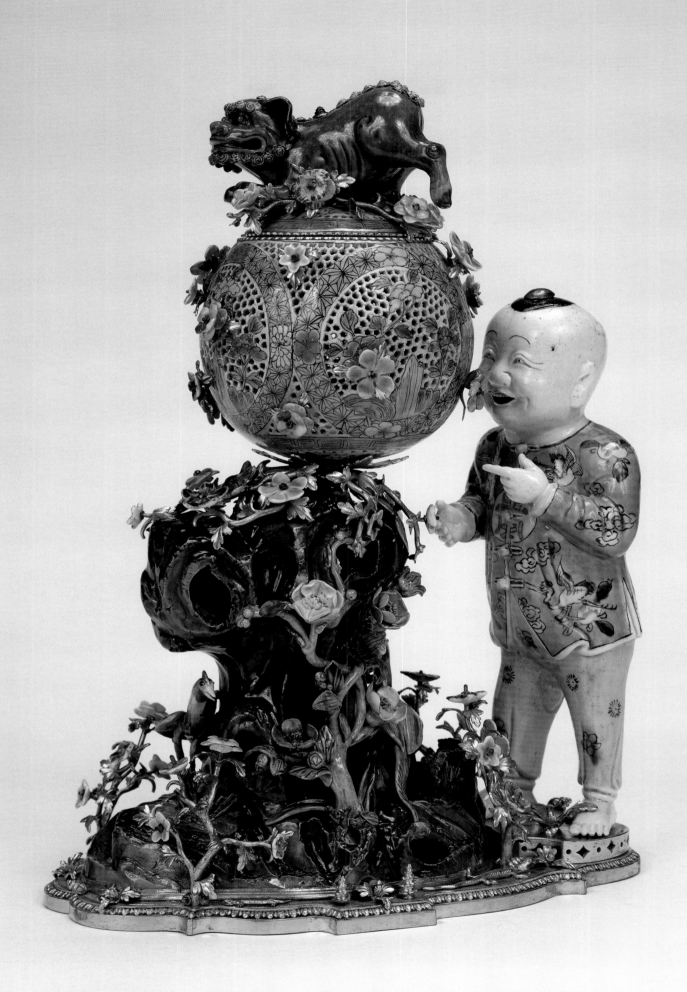

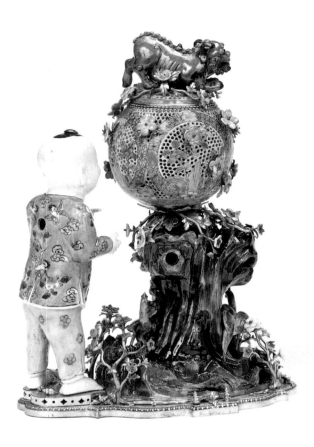
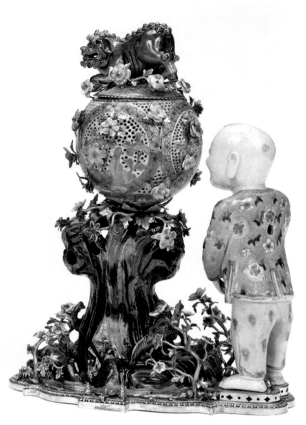

Fig. 10B

Each ensemble stands on a shaped base of gilt bronze with a repeating leaf motif around the edge. Upon the upper surface of this mount, around the border, are gilt-bronze lizards, snails, and small leafy twigs, irregularly placed (fig. 10D). The boy stands on a low open-work plinth of gilt bronze. The lid and the upper rim of the pierced sphere are framed with gilt-bronze moldings. Scattered porcelain flowers with gilt-bronze leaves are attached to the pierced sphere, which rests in a calyx of gilt-bronze leaves. Emerging from the leaves are leafy branches of gilt bronze to which porcelain flowers are attached. These overhang the top of the porcelain rock. Similar branches with porcelain flowers are placed between the lion and the lid of the pierced sphere.

MARKS None.

COMMENTARY

The lions, figures, and pierced spheres have been repaired.

The pierced porcelain balls have a prototype in the metalwork of the Tang dynasty (618–906), specifically the gold and silver incense holders of the eighth century. By the Qianlong reign they were used to hold potpourri and often had polychrome decoration. A single

sphere, suspended from a cord that passes through its body and ends in a tassel, is illustrated in Bushell's *Oriental Ceramic Art*.[1]

The two boys, when standing alone, represent happiness and longevity. The decoration on their clothes includes cranes, clouds, peaches, and bats, which symbolize these two aspects. The pine needles painted on the trousers of one of the boys also represent longevity, while the peacocks on the rockwork are associated with a lofty and virtuous disposition.

Itinerant entertainers are often shown in French paintings and engravings of the eighteenth century exhibiting portable magic lanterns or "peep shows" to village children; it is possible that these composite groups derive from an image of that sort.[2] Few such assemblages of mounted porcelain survive. This is partly due to their extreme fragility. They rarely, for example, appear in the great English collections formed shortly after the French Revolution. Many must have been broken and discarded during the course of the nineteenth and early twentieth centuries.

A pair of candelabra of somewhat similar conception was sold at Christie's in 1897, from the collection of Sir Charles Booth Bart:

FIG. 10C

FIG. 10D

A pair of small candelabra, formed as groups of rock with shrines and figures of fakirs of old Chinese coloured porcelain, mounted with ormolu foliage branches for two lights each, fitted with coloured Dresden flowers on plinths of ormolu chased with lizards and foliage in relief. 8½ inches high.[3]

A pair of similar rocky mounts with twining floral branches and birds and lions above, all unmounted, was in the possession of John Sparks, Ltd., in 1938.[4] A similar pair mounted as candelabra was sold in Berlin in 1937.[5]

Gilt-bronze bases decorated with lizards, snails, and shells are frequently found in conjunction with oriental porcelain. Chinese parrots in the Jones Collection at the Victoria and Albert Museum, London,[6] the Musée Nissim de Camondo, Paris,[7] and the Residenzmuseum, Munich, all rest on such bases, and other examples in public and private collections can be quoted. It is probable that they were all made in the workshop of the same *bronzier*.

PUBLICATIONS

Wilson 1979, p. 40, no. 5; Bremer-David et al. 1993, p. 152, no. 255.

EXHIBITIONS

Minneapolis Institute of Art, March–September, 1978.

PROVENANCE

H. J. King, sold Christie's, February 17, 1921, lot 13; Edgar Worsch, New York, 1928; Robert Ellsworth, New York (acquired in 1975); sold, Robert C. Eldred Co., New York, August 29–30, 1975, lot 151; Alan Hartman, New York; acquired by the J. Paul Getty Museum from Matthew Schutz, Ltd., New York, in 1978.

NOTES

1. Stephen W. Bushell, *Oriental Ceramic Art . . . from the Collection of W. T. Walters* (New York, 1899), p. 257, fig. 308.
2. Edgar Munhall, "Savoyards in French Eighteenth-Century Art," *Apollo* (February 1968), pp. 86–94.
3. Christie's, London, March 15, 1897, lot 114, bought by E. M. Hodgkins for £147. It is possible that these candelabra or others of similar design were sold again at Palais d'Orsay, Paris, June 13, 1979, no. 40.
4. See "The Antique Dealer's Fair and Exhibition," *Connoisseur* 102 (October 1938), pp. 203–4.
5. Emma Budge collection, Hamburg, sold at Paul Graupe, Berlin, September 27–29, 1937, no. 728.
6. Acc. no. 813, 813a-1882.
7. Acc. no. 219.

11. PAIR OF LIDDED JARS

THE PORCELAIN: Chinese (Kangxi), 1662–1722
THE GILT-BRONZE MOUNTS: French (Paris), circa 1745–49
HEIGHT: 1 ft., ½ in. (31.8 cm); WIDTH: 1 ft., ¼ in. (31.2 cm); DIAMETER: 8½ in. (21.6 cm)
72.DI.41.1–.2

DESCRIPTION

Each circular lidded jar consists of a body of bulbous shape; a composite domed lid with a flat top; and gilt-bronze handles, base, and finial.

Each has been slightly cut down at the shoulder luting. Each is decorated with underglaze blue and iron red and gilt on a white ground, with phoenixes flying amongst scrolling and flowering tree peonies.

The lip of the bowl is encircled by a gilt-bronze rim chased with an egg-and-leaf molding. On each side a scrolled and divided handle, of seaweed form, is attached by pinned hinges to the lip and foot mounts (fig. 11B). They clasp the lower part of the base. The foot of the jar is mounted with a plain molding that rests in an elaborately scrolled and foliated base with four pierced feet.

The lid is in two sections, the lower of which has been cut from the shoulders of the original jar. There is a molded flange of gilt bronze encircling the lower edge. The upper part is the original flat top of the cylindrical lid. It is surrounded by a molding similar to that which appears around the rim of the lower stage. The whole is surmounted by a complex gilt-bronze finial of shells, rockwork, coral, and fish eggs. This is fitted with a threaded rod that passes through a gilded plate in the interior and is held in position by a nut of gilt bronze.

MARKS

The mounts are struck with the crowned C in eight places on each jar: on the finial, on each of the two rims of the lid, on the interior plate, on the lip of the jar, on each handle, and on the foot. The same mounts, with the exception of the foot, of the other jar are also stamped.

FIG. 11A

COMMENTARY

This type of decoration is known as Chinese Imari. The Chinese, realizing that Japan was enjoying great success with its exported porcelain (typically and profusely decorated with underglaze blue and overglaze red and gold), decided to imitate their popular wares.

The mounts are not of the highest quality. Mounts in the form of seaweed are infrequently found, but a pair of lidded Sèvres bowls sold in Paris in 1978 bore handles similar to those that appear on these vases.[1] These lidded bowls reappeared on the market in 1989.[2] In 1990 an identically mounted pair of black Kangxi lidded jars was in the hands of a Paris dealer.

A pair of lidded jars of Kangxi porcelain of the same size and shape and with all the mounts of the same model was sold in Paris in 1988.[3]

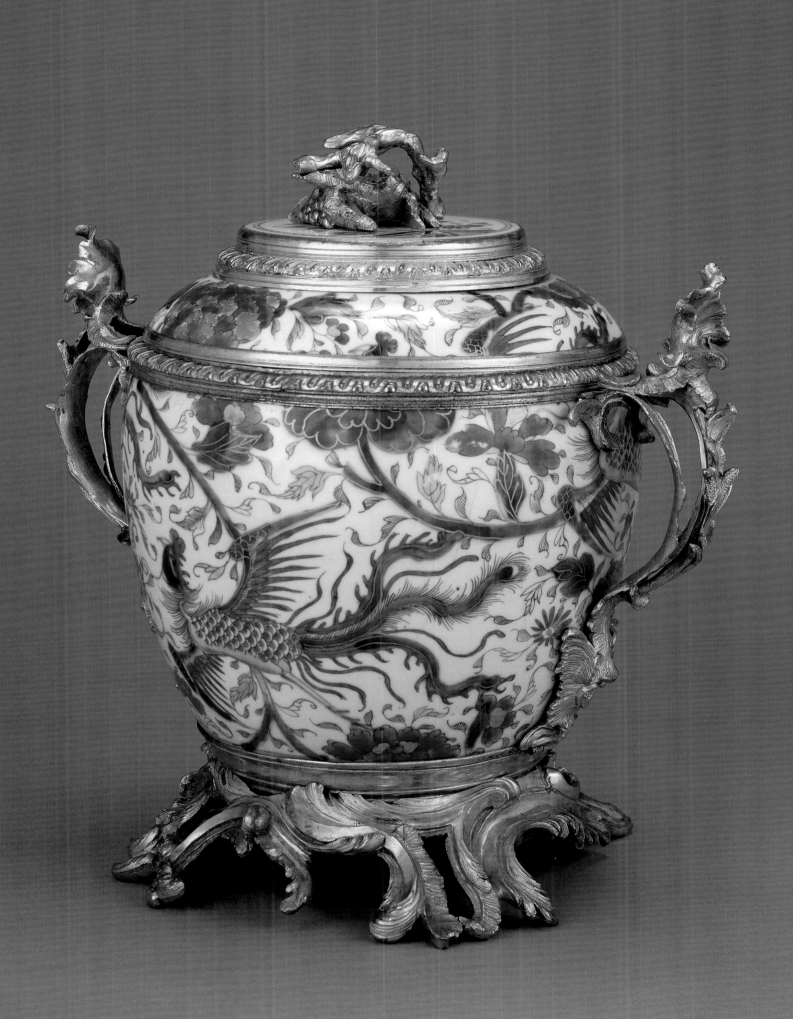

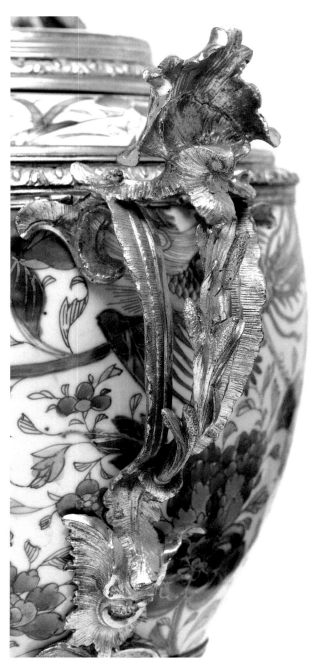

PUBLICATIONS
Lunsingh Scheurleer 1980, p. 260, no. 175; Watson 1980, p. 40, no. 16; Bremer-David et al. 1993, p. 153, no. 256.

EXHIBITIONS
Chinese Porcelains in European Mounts, The China Institute in America, New York, 1980, no. 16.

PROVENANCE
Baroness Marguerite Marie von Zuylen van Nyevelt van de Haar (d. 1970); sold, Palais Galliera, Paris, June 8, 1971, no. 42; Michel Meyer, Paris; acquired by the J. Paul Getty Museum from Rosenberg and Stiebel, New York, in 1972.

NOTES
1. Collection M.S., sold at Palais d'Orsay, Paris, February 21, 1978, no. 23.
2. Sale of Roberto Polo, Sotheby's, New York, November 3, 1989, lot 37.
3. Ader Picard Tajan, Paris, June 23, 1988, no. 47.

12. PAIR OF EWERS

THE PORCELAIN: Chinese (Kangxi), 1662–1722
THE GILT-BRONZE MOUNTS: French (Paris), 1745–49
HEIGHT: 1 ft., 11⅝ in. (60 cm); WIDTH: 1 ft., 1 in. (33 cm); DIAMETER: 8½ in. (21.5 cm)
78.DI.9.1–.2

DESCRIPTION

Each circular baluster-shaped vase with a trumpet-shaped neck has been mounted as a ewer. The vase is clasped between a raised foot ring and a pouring lip of gilt bronze, with a handle linking these two mounts.

The ground is a pale gray-green celadon painted with a thick white slip and underglaze copper red and blue, with deer and storks amongst fungus, pine, and stylized flowering trees below clouds.

The gilt-bronze pouring lip (fig. 12A) is of scrolled design with applied branches of flowers, seed pods, and leaves; its underside is chased with broad flutes. At the opposite side the rim is linked to the foot by a high scrolling handle, split at the top and entwined throughout its length by a branch of flowers and leaves. The handle (fig. 12B) clasps the lower part of the vase and is attached to the base mount by a pinned hinge. The foot of the vase is held by a deep molded ring of gilt bronze, entwined with floral sprays. This, in turn, is supported on four high open-work feet (fig. 12C) of scrolling acanthus leaves.

MARKS

The vase 78.DI.9.1 bears one indistinctly struck crowned C stamp on the foot mount, which is also stamped "Nº" and "Nº. 16." The base of the vase is painted with a double circle in underglaze blue and "B-27-a" in red paint. A small label is glued to the base, inscribed "Nº. 1" in ink. The vase 78.DI.9.2 bears two crowned C stamps on the foot mount, which is also stamped "Nº. 16." The base of the vase, thickly coated with opaque shellac, is painted "B-27-b" in red paint. These painted figures and stamps are certainly inventory numbers used by earlier owners of the vases.

FIG. 12A

COMMENTARY

The tall flaring lip of each vase has been cut down. Vase 78.DI.9.2 was cracked at the neck and poorly mended. This has been restored.

The fungus shown in the decoration is known as Lingzhi and is the mushroom of Immortality. The stork and the deer (fig. 12D) are the vehicles of the god Shoulao. The shape of the vase is known as a *Yen Yen*. A complete unmounted vase of the same shape was sold in London in 1980.[1]

Such ewers were intended purely for decorative use and not as pouring vessels. A similar pair of celadon vases mounted as ewers is in the Musée du Louvre.[2] A deep blue hexagonal vase in the James A. de Rothschild Collection at Waddesdon Manor, England,[3] bears very similar mounts, which probably were made by the same *fondeur-ciseleur*.

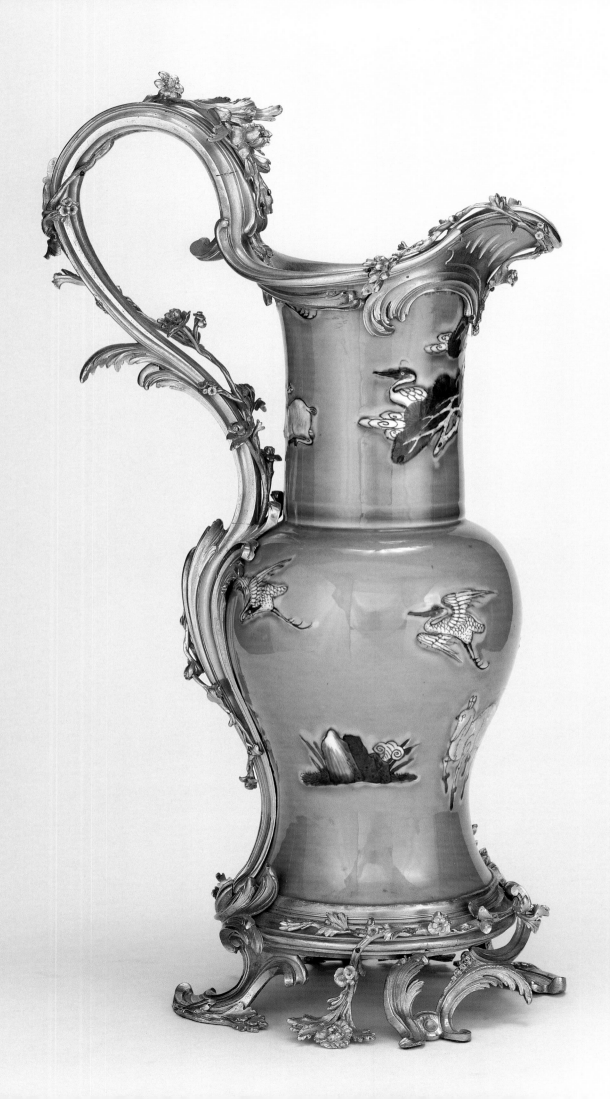

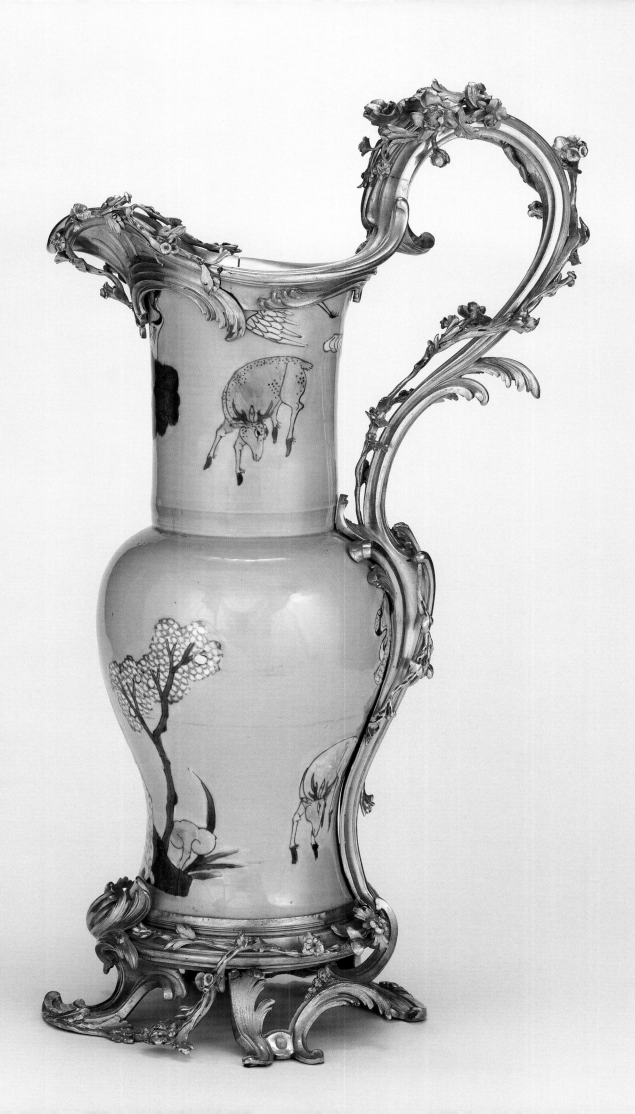

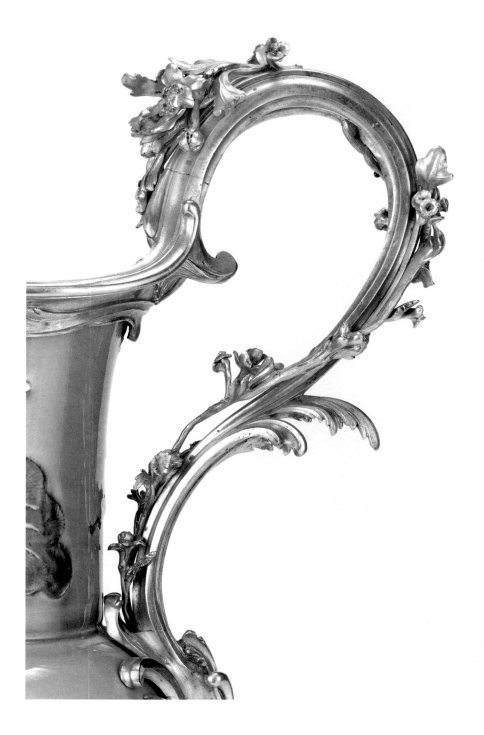

FIG. 12B

Another pair of deep blue vases, mounted as ewers, with very similar lip mounts, passed through the London auction rooms in 1924.[4]

Mounted porcelains of this type listed in the *Livre-journal* of Lazare Duvaux were invariably highly priced; a typical example is the sale to Madame de Pompadour on December 6, 1751, *"Deux autres vases en hauteur de porcelaine céladon ancienne, montés en forme de buire en bronze ciselé dorée d'or moulu . . . 1,680 livres."*[5]

Another entry in the *Livre-journal* provides evidence of the cost of transforming vases into ewers: on July 15, 1750, Duvaux sold to le Chevalier de Genssin

"La garniture en bronze doré d'or moulu de deux vases de la Chine, de quoi en fait deux buires . . . 288 livres."[6]

PUBLICATIONS

Wilson 1979, p. 42, no. 6; Watson 1980, p. 52, no. 28; Watson 1981, pp. 26–33; Watson 1986, no. 19; Bremer-David et al. 1993, pp. 153–54, no. 257.

EXHIBITIONS

Chinese Porcelains in European Mounts, The China Institute in America, New York, 1980, no. 28; *Mounted Oriental Porcelain*, The Frick Collection, New York, 1986, no. 19.

PROVENANCE

Ives, comte de Cambacérès, Paris (by repute)[7]; François-Gérard Seligmann, Paris; Jacques Helft, Paris; Hans Stiebel, Paris; Henry Ford II, Grosse Point Farms, Michigan; acquired by the J. Paul Getty Museum at the sale of the collection of Henry Ford II, Sotheby Parke Bernet, February 25, 1978, lot 56.

NOTES

1. Sotheby Parke Bernet, London, November 18, 1980, lot 13.
2. Acc. no. OA 5151.
3. de Bellaigue 1974, p. 750, no. 195.
4. Christie's, London, June 26, 1924, lot 93. They were bought by Sir Robert Abdy for the then large sum of 1,365 guineas.
5. *Livre-journal de Lazare Duvaux* 1873, p. 104, no. 967.
6. *Livre-journal de Lazare Duvaux* 1873, p. 55, no. 549.
7. These ewers do not, however, appear in the inventory of the contents of the Cambacérès *hôtel* made in 1807 nor in that taken after the death of Cambacérès in 1824. I am grateful to Christian Baulez for this information.

FIG. 12D

13. LIDDED BOWL

THE PORCELAIN: Chinese (Kangxi), 1662–1722
THE GILT-BRONZE MOUNTS: French (Paris), 1745–49
HEIGHT: 1 ft., 3¼ in. (40 cm); WIDTH: 1 ft., 3½ in. (39.3 cm); DEPTH: 11 in. (27.8 cm)
74.DI.19

DESCRIPTION

The potpourri bowl is composed of two thickly potted circular bowls of pale celadon glazed porcelain, each carved on the exterior in low relief with scrolls of flowering tree peony branches. One bowl is inverted over the other and is separated by a wide band of gilt bronze pierced with concave ovaloes, overlaid with a bunch of flowers and leaves at the center of the back and front (fig. 13A).

The lower bowl is supported on a base of gilt bronze resting on eight C-scrolls joined in pairs (fig. 13B). From each pair emerges a single flower with leaves and berries. At each side the lower half of the bowl is clasped by gilt-bronze straps from which spring trails of foliage, flow-ers, and berries that form the double-scrolled handles (fig. 13C), which are joined at the upper end to the central pierced band. A gilt-bronze finial in the form of a spiraling spray of leaves and flowers forms a handle for the upper bowl (fig. 13D). This is attached by two pins which pass through holes drilled in the porcelain; it is secured in the interior by flower-shaped nuts also of gilt bronze (fig. 13E). Though originally of identical shape and size, the upper bowl has been cut down around the rim by about an inch, removing a carved border of diamond key-fret, which appears inside the upper edge of the lower bowl. The foot ring has been ground off the inverted bowl to accommodate the finial.

FIG. 13A

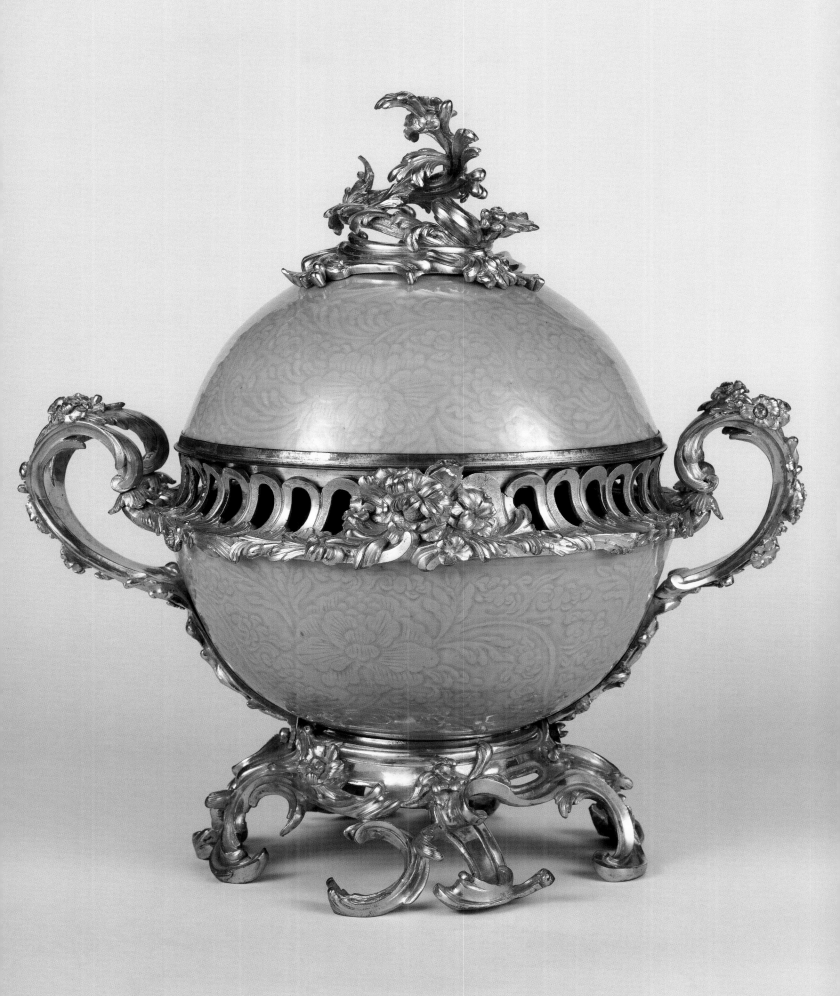

FIG. 13B

MARKS

The interior of each bowl is incised with a six-character mark reading *"daming Xuande nianzhi"* ("produced during the reign of Xuande in the great Ming dynasty") (fig. 13F). This is the reign mark of the Ming Xuande emperor (1426–35). It is a mark often used on porcelain made during the Kangxi period.[1] The base of each bowl is painted in underglaze blue with a two-character mark reading *"Tsen yu,"* which means "precious jade" (fig. 13G). This is probably a reference to the intended jade green color of the glaze.

The gilt-bronze mounts are struck with the crowned C in five places[2]: on the rims of the upper and lower bowls, on the straps below the handles, and on the foot.

FIG. 13C

FIG. 13D

COMMENTARY

The lower bowl is cracked.

The incised underglaze decoration, made by metal tools when the paste was leather hard before the first firing, is a technique that goes back to the Song dynasty (960–1278). The green color that resulted from the firing of the iron and titanium oxides was also revived during the Kangxi period.

The use of bowls of Chinese porcelain mounted together in gilt bronze of similar design is not uncommon. A pair of gray-crackled glazed bowls at Waddesdon Manor, England,[3] has very similar mounts that are also struck with crowned C's. Pairs of crackled bowls of differing shape, but all bearing mounts of the same form (with the exception of the finial), have passed through the London and Paris art markets in 1970, 1980, 1982, 1992, and 1998.[4] Perhaps the earliest description in an auction catalogue for lidded potpourri bowls of celadon porcelain is that found in the 1905 Christie's sale of E. H. Baldock Jr.'s "Old French Decorative Objects," most of which had been inherited from his father. Lot 105 reads:

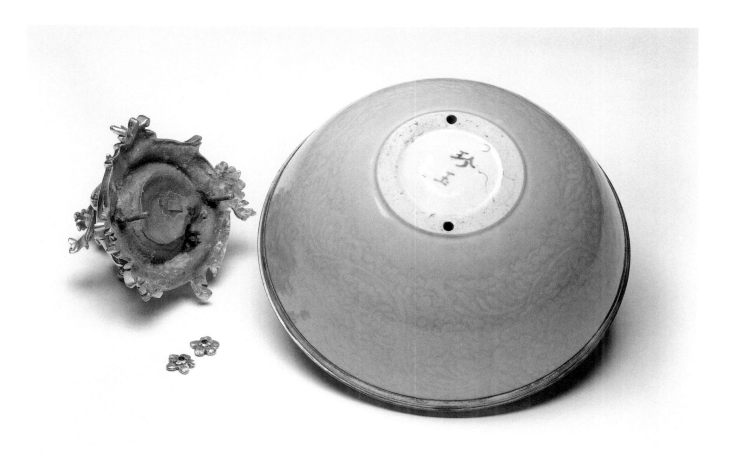

FIG. 13E. The lid with the gilt-bronze finial removed.

FIG. 13F. The six-character mark on the interior of the bowl.

FIG. 13G. The base of the bowl, painted with the two-character mark *"Tsen yu."*

A PAIR OF BOWLS AND COVERS OF CHINESE CELADON CRACKLE; each most elaborately mounted with composition of scrollwork, groups of fruit and flowers, of or-moulu; cast and finely chased in the manner of Caffieri 15 in. high.[5]

It is likely that all these mounts were made in the same *fondeur-ciseleur*'s atelier in the mid-eighteenth century, when the popularity of such objects was at its height. Accordingly, we find potpourris of oriental porcelain sold by the *marchand-mercier* Lazare Duvaux during this period, but the descriptions in his daybook are usually brief and unspecific, and the prices vary greatly. For instance, on December 15, 1756:

Mme. La Ctesse de BENTHEIM: Deux Pots pourris céladon, montés en bronze doré d'or moulu, 288 livres.

And on April 22, 1757:

S.A.S. Mgr. le Duc d'ORLEANS: Un grand vase en urne à dragons de relief, en porcelain truittée, monté en bronze doré d'or moulu; deux autres grand vases de même porcelaine, montés en pots pourris; & deux bouteilles à dragons, même porcelaine, montées en bronze doré d'or moulu, 2960 livres.[6]

An eighteenth-century watercolor design for a similarly mounted lidded bowl is in the Esmerian Collection at the Metropolitan Museum of Art, New York (fig. 13H).[7] The foot mount and the pierced mount centered by a cluster of flowers are of the same form, though the handles and finial differ. It forms part of a series of drawings for elaborate objects which may have been made for the *marchand-mercier* Dominique Daguerre and are linked with the decorations of the palace of Laeken for the Duke and Duchess of Sachsen-Teschen.

PUBLICATIONS
Bremer-David et al. 1993, p. 154, no. 258.

EXHIBITIONS
Chinese Porcelains in European Mounts, The China Institute in America, New York, 1980, no. 19.

PROVENANCE
Galerie Jean Charpentier, Paris, December 14–15, 1933, no. 107; Mme. Henry Farman, Palais Galliera, Paris, March 15, 1973, no. 25; Partridge (Fine Arts), Ltd., London, 1973; acquired by the J. Paul Getty Museum from Partridge (Fine Arts), Ltd., in 1974.

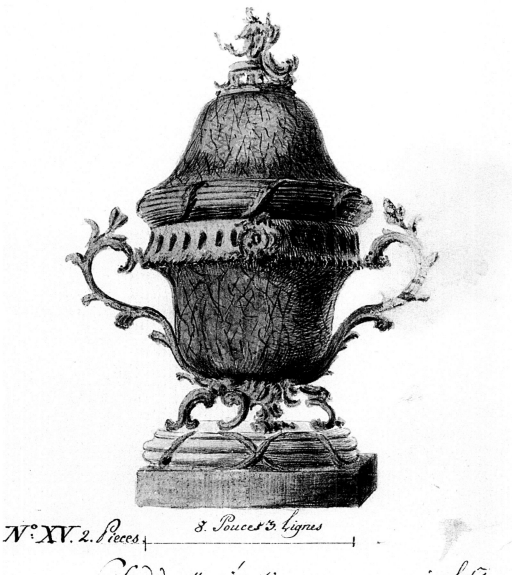

Pied 7. Pouces

N°: XV. 2. Pieces ⊢ ─── *8. Pouces 3. Lignes* ─── ⊣

Le fond de cette piéce tire un peu sur un gris plutôt bleuâtre que verdâtre, il est marqueté de beaucoup de petites rayes en fentes fines noirâtres et irregulieres.

FIG. 13H. Watercolor drawing of a similarly mounted lidded bowl. *New York, The Metropolitan Museum of Art, Gift of Raphael Esmerian, 1961 [61.680.1 (8)].*

NOTES

1. Both four- and six-character reign marks of the Chenghua emperor (r. 1465–87) are found on ceramics of a later date. In these cases, however, no attempt has been made by the maker to copy the porcelain of the fifteenth century and no deception was intended.
2. See commentary for catalogue no. 5.
3. De Bellaigue 1974, pp. 752–53, no. 196.
4. Christie's, London, November 26, 1970, lot 12, sold by order of the trustees of the late A. C. J. Wall, gilt-bronze mounts struck with the crowned C; Drouot Rive Droite, Paris, December 10, 1980, no. 74, mounts with the crowned C; Sotheby's, London, June 25, 1982, lot 59; Christie's, Monaco, December 5, 1992, no. 93; Christie's, London, December 10, 1992, lot 213. The last two pairs bore mounts struck with the crowned C; Sotheby's, London, December 16, 1998, lot 156 (without crowned C's).
5. Christie's, London, June 30, 1905, lot. 105.
6. *Livre-journal de Lazare Duvaux* 1873, p. 302, no. 2650, and p. 314, no. 2769.
7. Acc. no. 61.680.1(8); see M. Myers, *French architectural and ornament drawings of the eighteenth century* (New York, 1991), pp. 195–200.

14. PAIR OF VASES

THE PORCELAIN: Chinese (Kangxi), 1662–1722
THE GILT-BRONZE MOUNTS: French (Paris), circa 1745–49
HEIGHT: 1 ft., ½ in. (31.7 cm); WIDTH: 1 ft., 2 in. (35.5 cm); DIAMETER: 10½ in. (26.7 cm)
79.DI.121.1–.2

DESCRIPTION

Each vase is enameled with green, blue, and auber-gine and gilt with sinuous-horned dragonettes penciled in *grisaille* amongst flowering, scrolling tree peonies on an iron-red ground. Circular reserves enclose peonies above a base band of alternate panels of squared spiral and basket-weave patterns. These are on a green ground separated by four oval reserves that enclose camelias.

A rich flaring mount of gilt bronze chased with twisted fluting encircles the mouth of the vase (fig. 14A). At each side, an elaborately scrolled mount with an in-verted leaf at the center depends from the lip (fig. 14B). The lip is linked to the foot at each side by a scrolled handle from which bullrushes spring, clasping the lower half of the vase (fig. 14C). The foot is held in an elabo-rately scrolled and molded mount that rests on five tall C-scroll feet linked across each side by floral sprays (fig. 14D).

MARKS

The mounts of each vase are struck with four crowned C's: on the foot, each handle, and the rim. The bases of the vases are painted with double circles in underglaze blue.

COMMENTARY

Each vase is the lower half of a tall rouleau vase, the original height of which would have been about eigh-teen inches. A complete unmounted vase with an iron red ground and similar decoration is in the Salting Bequest at the Victoria and Albert Museum, London.[1] A pair of vases simply mounted at the rim and foot was sold at auction in New York in 1993.[2]

What would appear to be the upper half of one of the Getty Museum's vases is at Schloss Faisanerie, Fulda.[3] It is inverted and bears mounts of the same model at the rim and handles; it was certainly made by the same *bronzier*. It could be assumed that it was once part of a pair.

PUBLICATIONS

Wilson 1980, p. 9, no. 6; Watson 1981, p. 31; Bremer-David et al. 1993, p. 154, no. 259; Sargentson 1996, p. 69, pl. 37.

EXHIBITIONS

Chinese Porcelains in European Mounts, The China Institute in America, New York, 1980, no. 20.

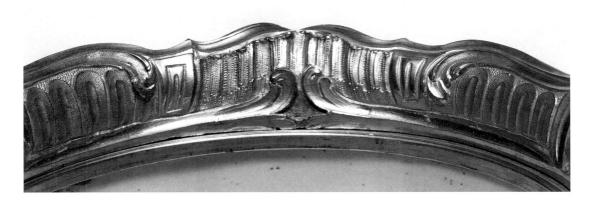

FIG. 14A

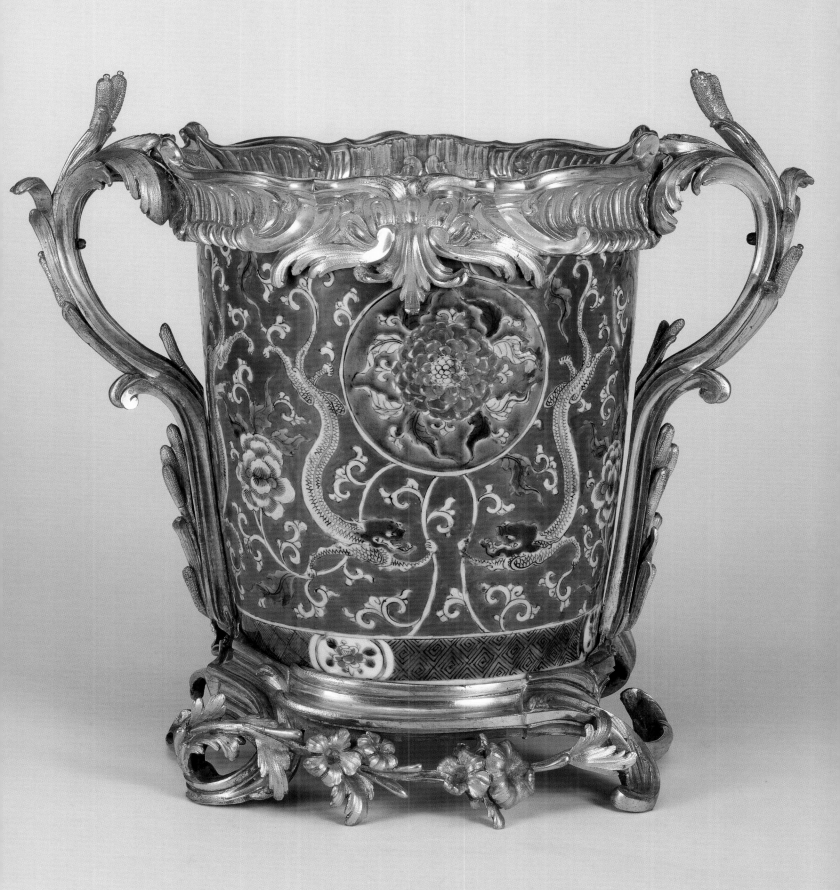

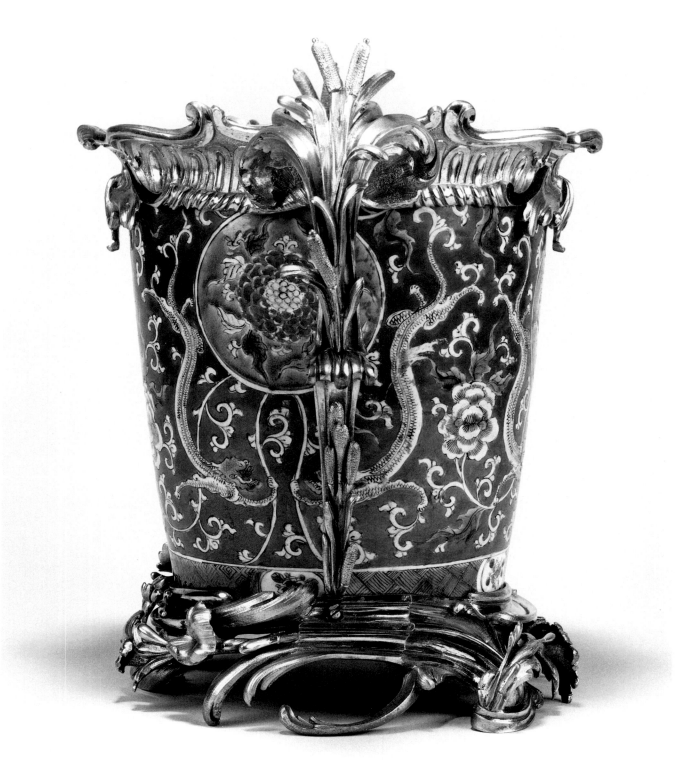

FIG. 14B

PROVENANCE

Galerie Georges Petit, Paris, December 20, 1932, no. 73; Mazurel family, France, sold in the late 1970s; Bernard Steinitz, Paris; acquired by the J. Paul Getty Museum from Alexander and Berendt, London, in 1979.

NOTES

1. Acc. no. C.13331-1910.
2. Sotheby's, New York, November 20, 1993, lot 117.
3. It was sold from the collection of Hermine Feist, Galerie Fischer, Lucerne, May 20–24, 1941, no. 41, height 1 ft., 4½ in. (42 cm). I am grateful to Theodore Dell for pointing this sale out to me. The father of the present Landgrave of Hesse apparently bought it at that sale. Adrian Sassoon saw the vase in 1998 and kindly provided photographs of it, which are in the Getty curatorial files.

FIG. 14C

FIG. 14D

15. VASE

THE PORCELAIN: Chinese (Qianlong), circa 1740
THE GILT-BRONZE MOUNTS: French, circa 1745–50
HEIGHT: 1 ft., 2½ in. (36.8 cm); WIDTH: 6 in. (15.2 cm); DEPTH: 4½ in. (11.5 cm)
75.DI.69

DESCRIPTION

The pale celadon vase has a flattened hexagonal baluster-shaped body on a tall flared foot. Hooked handles of porcelain are luted to either side of the short trumpet-shaped neck.

A gilt-bronze mount of scrolled and foliated design surrounds the lip of the vase (fig. 15A); the scrolls emerge from a cartouche at each side. The splayed foot rests in a high mount consisting of six foliate scrolls, from which emerge sprays of flowers and berries (figs. 15B and 15C).

A double-leaf motif marks the junction between the front and back scrolls. The foot mounts are joined at the base on each side by a gilt-headed screw.

MARKS

The undersurface of the vase is marked in pencil "3" and "4" in a modern hand. This may well indicate that the vase was originally one of a pair, or one of a larger group.

FIG. 15A

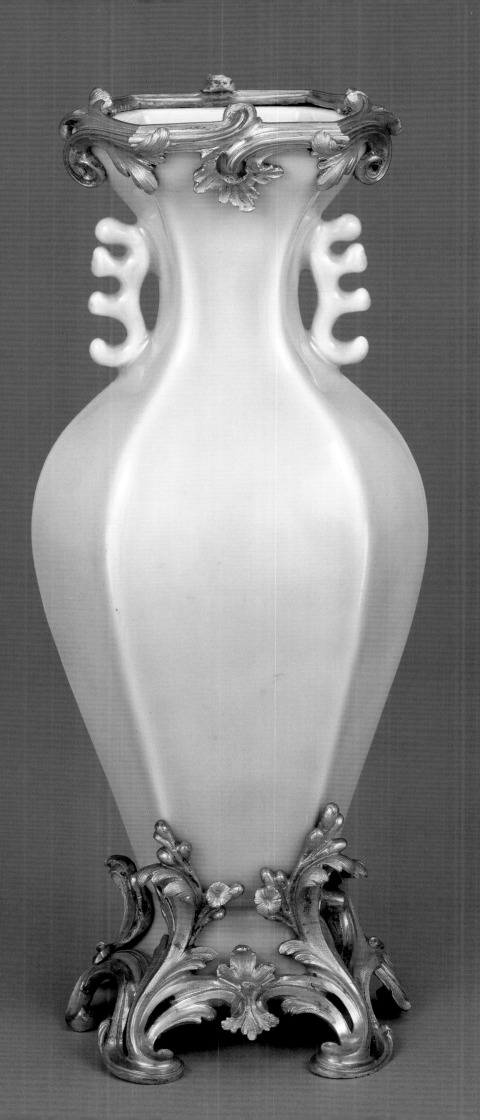

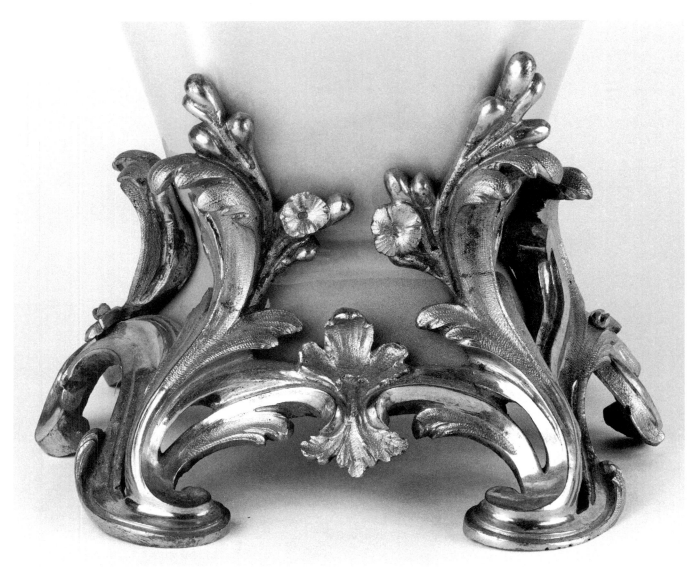

COMMENTARY

The form of the vase derives from an ancient bronze vessel. The four-"prong" motif of the handles is a stylized representation of a dragon in profile.

The bluish-green glaze color, a brighter tone than the traditional celadon, was first achieved in the Kangxi imperial ceramic studios. It was accomplished through a change in the traditional recipe and became typical of the eighteenth century.

A pair of celadon vases of the same design was in the collection of the Earl of Harewood at Harewood House, Yorkshire; it was sold in London in 1965.[1] Another pair, with plain gilt-bronze moldings around the lips and handle mounts in the form of laurel wreaths depending from the porcelain handles, is in the Musée Nissim de Camondo, Paris.[2] The mounts of the base are clearly from the same *fondeur-ciseleur*'s workshop as that of this vase, as are the mounts of the Harewood examples.

On December 30, 1758, Lazare Duvaux sold to the duchesse d'Orléans "*Une vase d'ancienne porcelaine, vert-céladon, orné de bronze doré d'or moulu . . . 600 livres.*"[3] This entry perhaps gives an idea of the price that a single vase of this type commanded in the eighteenth century.

PUBLICATIONS

Lunsingh Scheurleer 1980, p. 94, no. 330, fig. 318; Watson 1980, p. 42, no. 18; Bremer-David et al. 1993, p. 155, no. 260.

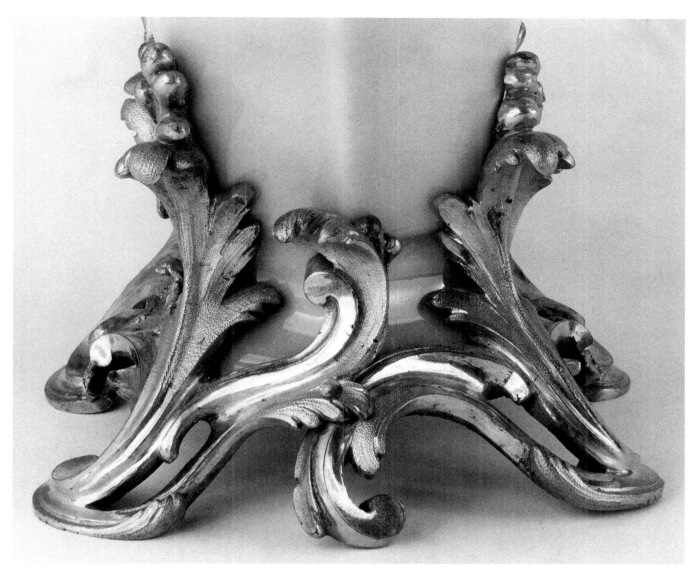

FIG. 15C

EXHIBITIONS
Chinese Porcelains in European Mounts, The China Institute in America, New York, 1980, no. 18.

PROVENANCE
Acquired by the J. Paul Getty Museum at the sale of the Trustees of the Swinton Settled Estates, Christie's, London, December 4, 1975, lot 46.

NOTES
1. Christie's, London, July 1, 1965, lot 47.
2. Acc. no. 222.
3. *Livre-journal de Lazare Duvaux* 1873, vol. 2, no. 3309, p. 383.

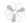

16. PAIR OF POTPOURRI BOWLS

THE PORCELAIN: Japanese (Arita), circa 1660–80
THE GILT-BRONZE MOUNTS: French (Paris), circa 1750
HEIGHT: 6 in. (15.2 cm); WIDTH: 7⅜ in. (18.7 cm); DIAMETER: 6½ in. (16.5 cm)
77.DI.90.1–.2

DESCRIPTION

Each bowl is of pale celadon glazed porcelain in the form of a univalve conch resting on three coral cluster feet of porcelain. The shells have fluted bodies encrusted with smaller shells, barnacles, and other marine forms. The interior of the serpentine lip of each shell is enameled with blue and iron red.

The slightly domed lid of gilt bronze is formed as a pierced leaf of coral. It is surrounded by a plain gilt-bronze rim. The semicircular handle, also of gilt bronze, is in the form of a branch of seaweed (fig. 16c). Each foot is shod with a gilt-bronze mount composed of shells, rocks, and branches of coral (fig. 16D).

MARKS None.

COMMENTARY

There are a number of casting flaws in the gilt-bronze lids.

The shells were probably intended for export to the West, since the shape is not found among native Japanese wares. In the Residenzmuseum, Munich, there is a pair of shells of the same model.[1] In place of the pierced gilt-bronze lids of the Getty vases, each has an oval lid of porcelain, surrounded by a gilt-bronze rim. A hole in center appears to have once been fitted with a handle. The porcelain feet are not shod with gilt bronze. Another pair of shells was on the London market in 1985. Completely unmounted, the lids were centered by small coral-red crabs. Another Japanese shell of almost identical form was sold at auction in 1979.[2] It was painted with polychrome colors and had a rough, spongelike surface. It possessed a porcelain lid and was elaborately mounted in gilt bronze with shells, seaweed, branches of coral, and rocks.

Pairs of shells, which, from their descriptions in the various sale catalogues could be those now in the Getty Museum, appear at least five times at auction in Paris in the second half of the eighteenth century.

In the 1767 posthumous sale of the cabinet of M. de Julienne, no. 1403 is described as:

Deux belles coquilles couvertes d'ancien & bon céladon uni, à rebords coloriés d'un beau fond rouge, elles sont de la plus grande perfection & garnie de bronze.[3]

Ten years later a similar or the same pair was sold at the auction of Randon de Boisset, where it appeared in the catalogue as no. 603:

Deux coquilles, couvertes, de belle sortie, à rebords coloriés d'un beau fond rouge, nuancé de bleu celeste foncé; elles sont de la plus grande perfection, & chacune garnie de gorge, & de trois petits pieds en rocaille de bronze doré.[4]

It was bought for 600 livres by the duchesse de Mazarin. The shells do not appear in her inventory of 1781, and it is likely that she gave the pair to her lover, Radix de Sainte-Foy. It is described as no. 55 in his sale of 1782:

Deux coquilles singulères, à rebords coloriés d'un beau fond rouge, nuancé de bleu celeste foncé, garnies de couvercles, avec entrelacs à jour, bouton de coquilles, & trois pieds en rocaille de bronze doré, Hauteur 6 pouces, largeur 7 pouces.[5]

The shells were sold for 130 livres to the *marchand-mercier* Jean-Baptiste-Pierre LeBrun. They appear again in the auction held after his death in 1791, where as no. 698 they are described in precisely the same way, with the added comment: *"Elles viennent de la vente de M. Saint-Foi."*[6] They were acquired by the *commissaire-priseur* Paillet for 120 livres.

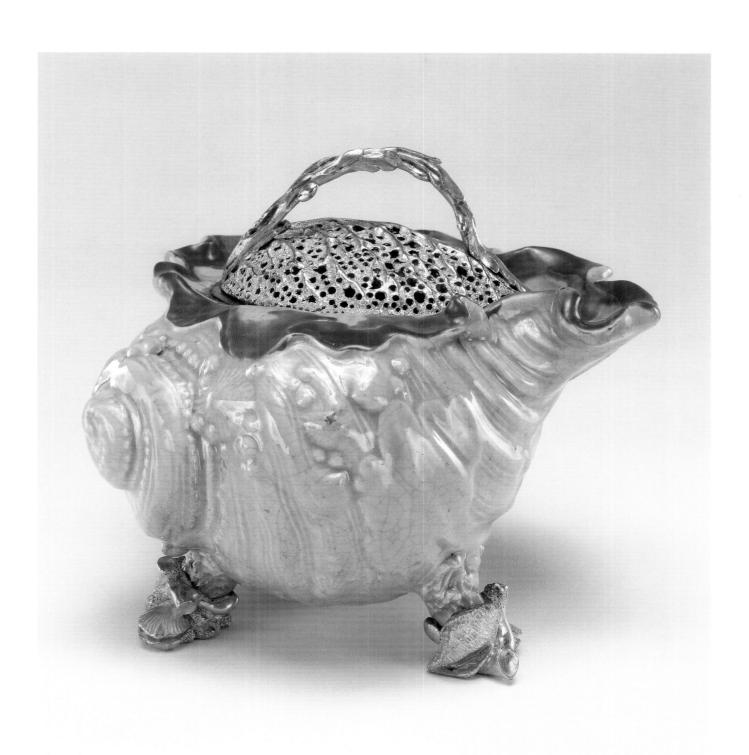

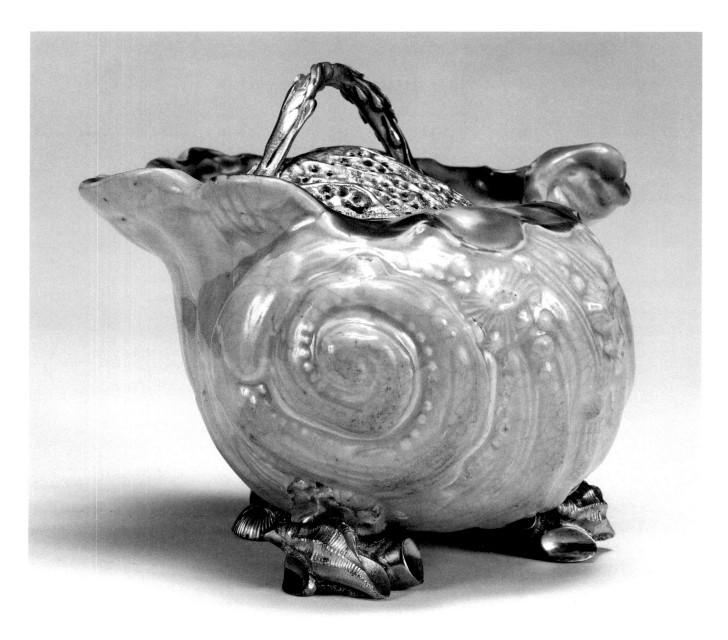

Another pair of celadon shells with a slightly varying description is listed in the catalogue of the sale of the *marchand* Julliot, held after the death of his wife on November 20, 1777:

> No. 331 *Deux coquilles, de genre singulier à rebord colorié d'un beau fond rouge, nuancé de bleu céleste foncé; garnies de couvercle, en feuille de corail, percé à jour & de trois petits pieds en rocaille de bronze doré.*[7]

This is the only description that includes the words " . . . *en feuille de corail, percé à jour.* . . ," which accurately describes the lids of the Museum's shells and may therefore be the only eighteenth-century reference to them.

Other types of Japanese ceramic shells were popular. A single mounted shell is listed in the inventory taken in 1740 after the death of the duc de Bourbon: "*Une vase de forme de coquille, de porcelaine ancienne du Japon, monture en bronze doré.*"[8] Chinese shells of the Kangxi period, in the form of cockle shells were also mounted with gilt bronze. A turquoise glazed pair is to be seen in the Walters Art Gallery, Baltimore.[9] This latter form was used by the Vincennes Manufactory as the inspiration for its *potpourri limaçon*, the plaster model for which appeared in 1752. A pair in *bleu céleste* is in the Forsyth Wickes Collection in the Museum of Fine Arts, Boston.[10]

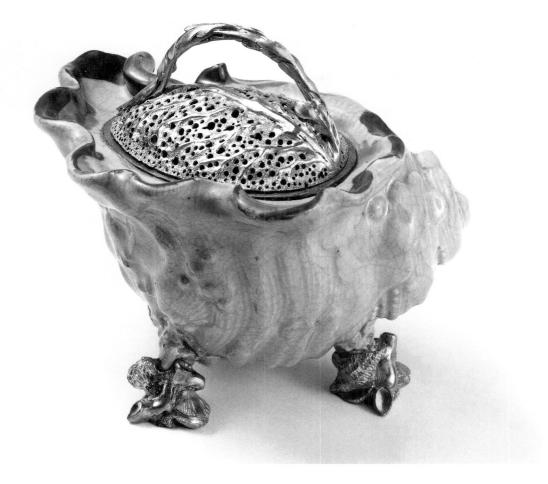

FIG. 16B

FIG. 16C

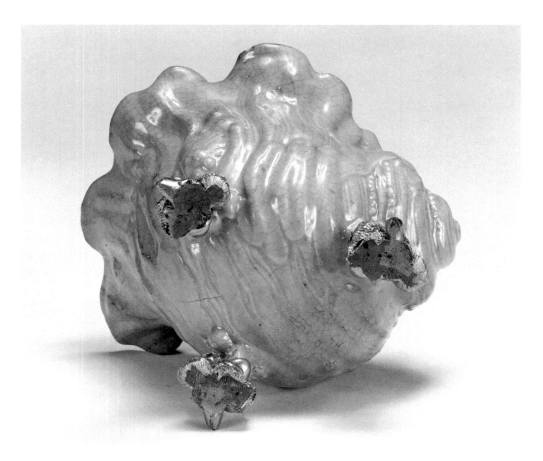

PUBLICATIONS

Wilson 1979, p. 37, no. 2; Watson 1986, pp. 82–83, no. 27; Geneviève Mazel, "1777: La vente Randon de Boisset et le marché de l'art au dix-huitième siècle," *L'Estampille* 202 (April 1987), p. 47, illus.; Michel Beurdeley, *Trois siècles de ventes publiques* (Fribourg, 1988), p. 53, illus.; Alain Gruber, *L'art décoratif en Europe*, vol. 2, *Classique et baroque* (Paris, 1992), p. 400, illus.; Bremer-David et al. 1993, p. 155, no. 261; Sargentson 1996, p. 68, pl. 10.

EXHIBITIONS

Mounted Oriental Porcelain, The Frick Collection, New York, 1986, no. 27.

PROVENANCE

Claude Julliot, (?) Paris, sold 1777; Didier Aaron and Claude Lévy, Paris; acquired by the J. Paul Getty Museum from Etienne Lévy, Paris, in September 1977.

NOTES

1. Lunsingh Scheurleer 1980, p. 312, fig. 284.
2. Sotheby Parke Bernet, Monaco, June 25–26, 1979, no. 66, collection of Akram Ojjeh, sold to Stavros Niarchos, New York; Watson 1986, p. 60, no. 16.
3. Paris, March 30–May 22, 1767. I am grateful to Theodore Dell for this information.
4. Paris, February 3, 1777 (Mazel, "1777," pp. 40–47).
5. Paris, April 22, 1782. I am grateful to Jean Dominique Augarde for pointing out this sale to me.
6. Paris, April 11, 1791.
7. I am grateful to Jean Nérée Ronfort and Jean Dominique Augarde for this information.
8. Gustave Macon, *Les arts dans la maison de Condé* (Paris, 1903), p. 86.
9. Watson 1986, pp. 88–89, no. 30.
10. Jeffrey H. Munger et al., *The Forsyth Wickes Collection in the Museum of Fine Arts, Boston* (Boston, 1992), pp. 184–86, pl. xxx, fig. 132.

17. INKSTAND

THE PORCELAIN: Chinese (Kangxi), from Dehua, early eighteenth century
THE GILT-BRONZE MOUNTS: French (Paris), circa 1750
HEIGHT: 8 in. (20.3 cm); WIDTH: 1 ft., 2 in. (35.6 cm); DEPTH: 10½ in. (26.7 cm)
76.DI.12

DESCRIPTION

The wooden stand is French, lacquered in red and gold, supporting bowls and figures of Chinese porcelain; the whole is mounted with gilt bronze.

The tray, of irregular trapezoidal shape, is framed in a scrolled and foliate border of gilt bronze. It is supported at each of the four cardinal points by a pierced lyre-shaped foot resting on two C-scrolls flanking a cabochon.

The surface of the tray is lacquered with a basket of flowers in dark brown and gold on a red ground. On it rest three white porcelain wine cups, symmetrically arranged, each held in position by three leafy sprays of gilt bronze. The cups are molded as open magnolia flowers, with leafy stalks, a butterfly, and another flying insect in low relief. The outer cups hold the inkwell *(left)* and the sand caster *(right)*; pierced mounts of leaves support their metal fittings. The central cup has no interior fittings and was probably intended to hold a sponge. At the rear is a candelabrum of two lights of foliate form springing from the branches of a gilt-bronze tree. The drip pans are in the form of corollas of leaves. The candelabrum rises behind a group of three white porcelain figures of a monk and a court lady holding a fan, leaning on the shoulder of her maid (fig. 17A). They stand on a rectangular white porcelain base that is supported on two gilt-bronze feet of scrolled shell form at the front and by a foliate mount below the tree at the rear.

MARKS None.

COMMENTARY

The wine cup on the left has been broken and restored. The central wine cup has failed in the kiln; it is discolored and crackled. The cups are of unusual form and were probably made for export.

A number of similar inkstands are known. One with some similar mounts and a similar japanned base was sold from the collection of Mrs. Anna Thompson Dodge in 1971.[1] Another, also with a red-japanned support and similar mounts but with blue-and-white cups, was sold in Paris in 1977.[2]

A third example—with a framing mount to the *vernis* stand of the same model, with an arrangement of vertical leaves forming the support for the three white porcelain "cornet" cups, and with a two-branch candelabrum carrying bobeches and leafy drip pans, all of the same model—was sold at auction in 1996.[3]

These inkstands were probably made in the same *fondeur*'s workshop and perhaps supplied by the same *marchand-mercier*.

Lazare Duvaux sold, on December 19, 1749, to: "*M. BROCHANT, correcteur des comptes: Une écritoire de trois cornets de porcelaine blanche sur un plateau verni. 60 livres.*"[4]

The 1770 inventory of a M. Portailis mentions: "*Un écritoire à trois potelets de porcelaine blanche sous une branche de cuivre antique avec une figure de porcelaine de Saxe le tout appliqué sur un plateau de lac.*"

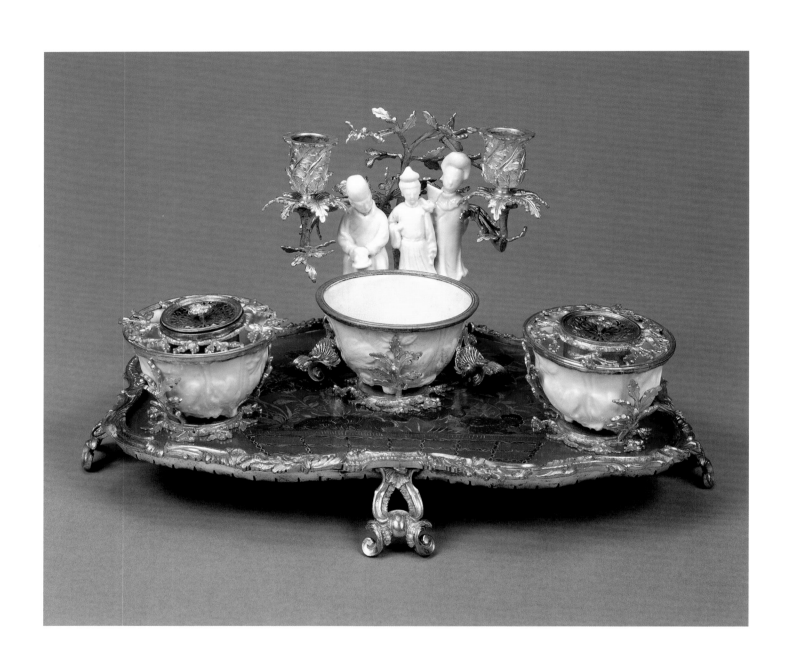

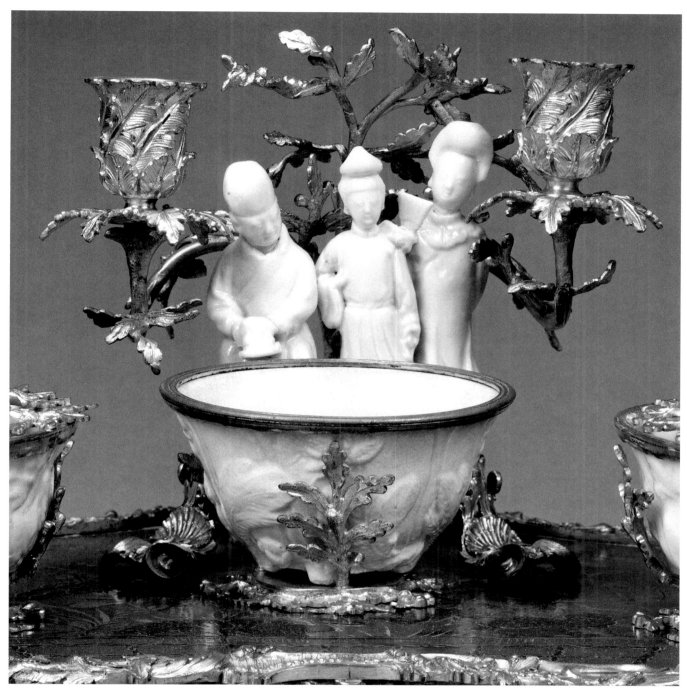

FIG. 17A

PUBLICATIONS

Wilson 1977, p. 46, no. 60; Bremer-David et al. 1993, p. 108, no. 180; Sargentson 1996, p. 73, pl. 13.

PROVENANCE

Acquired by the J. Paul Getty Museum from B. Fabre et Fils, Paris, in 1976.

NOTES

1. Christie's, London, June 24, 1971, lot 32.
2. Palais Galliera, Paris, March 22, 1977, no. 28.
3. Christie's, London, July 4, 1996, lot 245.
4. *Livre-journal de Lazare Duvaux* 1873, p. 38, no. 381.

18. BOWL

THE PORCELAIN: Chinese (Yongzheng), 1723–35
THE GILT-BRONZE MOUNTS: French, circa 1750–55
HEIGHT: 1 ft., 2½ in. (36.9 cm); WIDTH: 1 ft., 4¼ in. (41.2 cm); DEPTH: 11 in. (27.9 cm)
72.DI.42

DESCRIPTION

The deep, thickly potted oviform bowl has a clear pale gray glaze, with a fine dark gray crackle and a faint secondary golden crackle (fig. 18A). It is richly mounted around the rim and the foot with scrolled, foliated, and pierced gilt bronze. At each side a tall scrolling handle (fig. 18B) of gilt-bronze acanthus leaves entwined with flowers and berries links the rim to the foot, clasping the lower part of the bowl (fig. 18C). The foot ring of the bowl has been ground down to accommodate it to a tall, gilt-bronze base of scrolling acanthus that forms the four feet (fig. 18D). It is pierced with a band of ovaloes.

MARKS None.

COMMENTARY

A cluster of berries at the junction of the handle and the bowl is missing on one side. The porcelain is cracked beneath one of the handles. Approximately half an inch of the rim has been ground away to accommodate the upper mount.

Monochrome crackle porcelains such as this were inspired by the classic Kuan and Ko wares of the twelfth-century Song dynasty. The celadon glaze was applied over a black or dark gray body before the piece was fired in a reducing kiln; the variations in the crackle and glaze color were achieved by changes in the firing cycle. The crackle itself is due to a difference in the coefficient of expansion between the body and the glaze, so that in cooling, the tensions created caused the cracks to appear. This type of ceramic ware was accidentally discovered at the southern Song kilns five hundred years earlier.

A porcelain bowl with a gray-crackled glaze, but lacking the gilt-bronze handles and the mount around the rim, was formerly in the Wrightsman Collection at the Metropolitan Museum of Art, New York.[1] A simi-

FIG. 18A

larly glazed vase, with later mounts, is in the James A. de Rothschild Collection at Waddesdon Manor, England.[2] A similarly mounted bowl of enameled *famille rose* porcelain was sold in Paris in 1971.[3] The mounts of all these vases were probably made by the same *fondeur-ciseleur*.

The shape of the rim mount might suggest at first sight that this bowl was originally lidded. The shape of the handles, however, makes it impossible to insert a lid.

Porcelaine grise is very rarely mentioned in the *Livre-journal* of Lazare Duvaux, and most of the references to gray porcelain are clearly European; however, Madame de Pompadour brought to the shop for repair on June 12, 1753: "*Une . . . garniture de porcelaine grise, garnie partie en or & partie en argent doré rémise à neuf.*"[4] Such rich mounting would have been applied only to rare and highly prized Chinese porcelain.

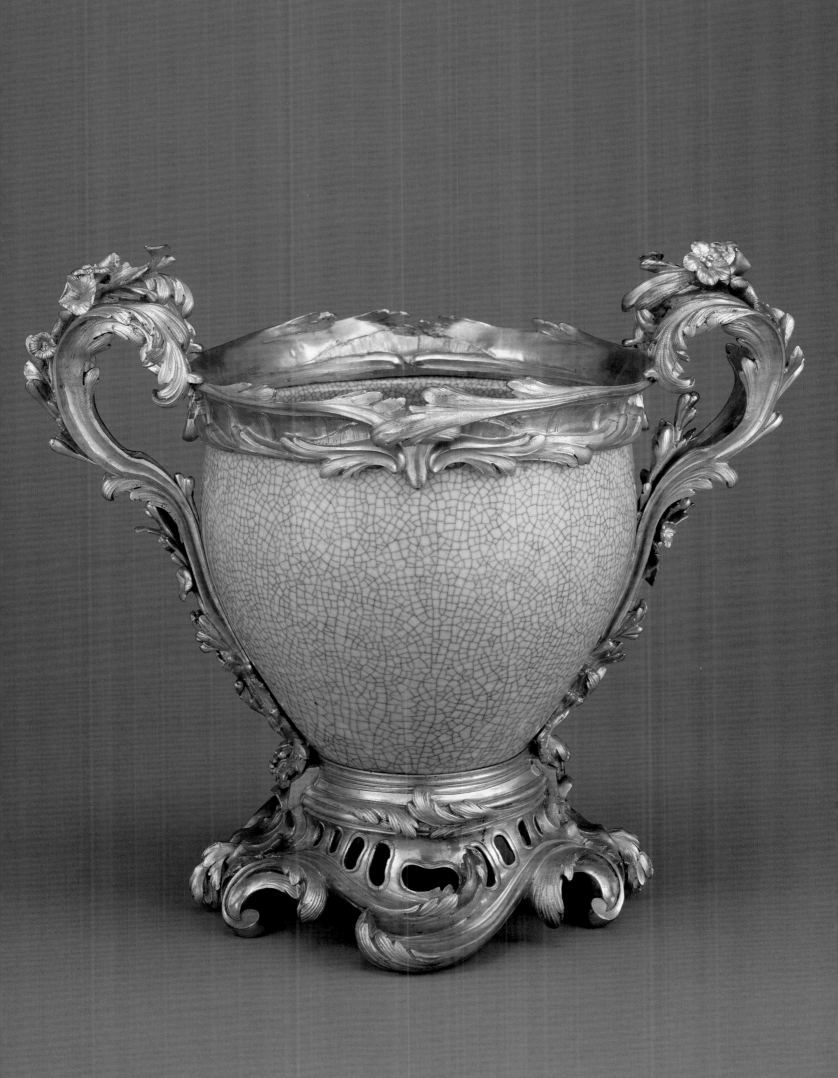

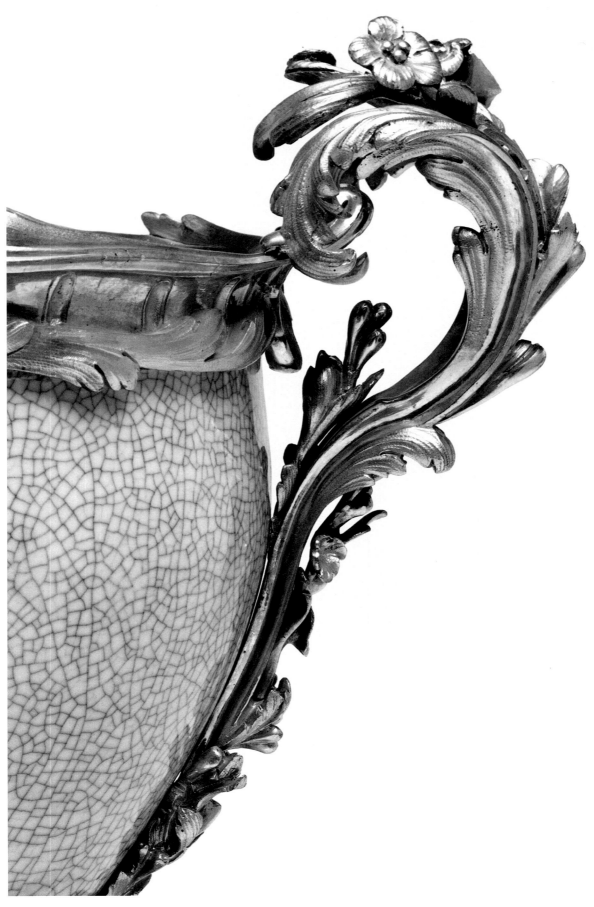

FIG. 18B

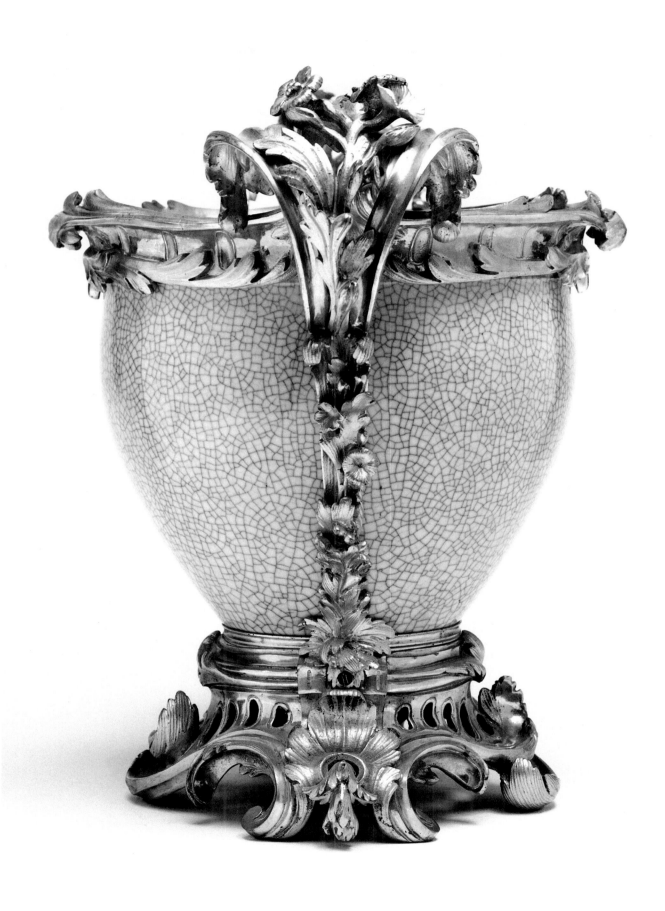

FIG. 18C

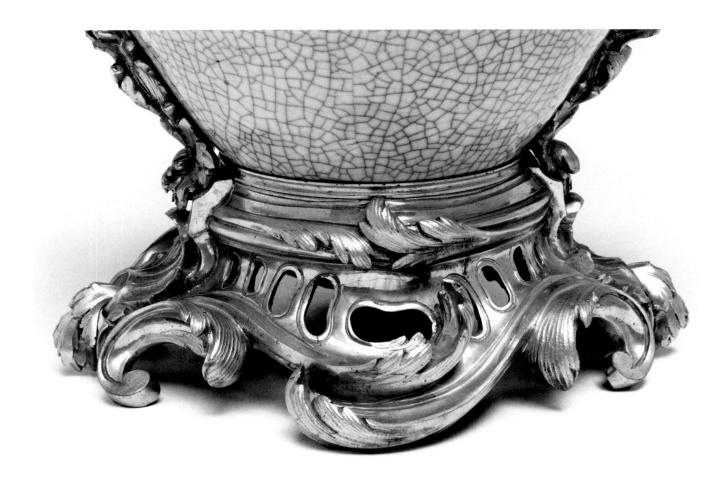

FIG. 18D

PUBLICATIONS
Lunsingh Scheurleer 1980, p. 334, fig. 326; Watson 1980, p. 32, no. 8; Bremer-David et al. 1993, p. 156, no. 262.

EXHIBITIONS
Chinese Porcelains in European Mounts, The China Institute of America, New York, 1980, no. 8.

PROVENANCE
Acquired by the J. Paul Getty Museum from Rosenberg and Stiebel, New York, in 1972.

NOTES
1. Watson and Dauterman 1966–70, vol. 2, p. 429, no. 240.
2. de Bellaigue 1974, vol. 2, pp. 764–65, no. 201.
3. Palais Galliera, Paris, June 8, 1971, no. 40.
4. *Livre-journal de Lazare Duvaux* 1873, p. 161, no. 1441.

19. LIDDED POT

THE PORCELAIN: Chinese (Kangxi), from Dehua, circa 1670–1700
THE GILT-BRONZE MOUNTS: French (Paris), circa 1765–70
HEIGHT: 9⅞ in. (25.1 cm); WIDTH: 7⅜ in. (18.7 cm); DEPTH: 6¼ in. (15.9 cm)
78.DI.359

DESCRIPTION

The hexagonal molded globular body is composed of six shaped panels molded in low relief with the following scenes: the philosopher Li Bai with his wine jar; Confucius in discussion with Laozi (the reputed founder of Daoism); a Tea Master with a boy who fans the fire to boil water for tea; a scholar with a boy attendant who holds the *chin*, a stringed instrument; a boy pointing to the sun implying a wish that his master will achieve high rank; and Confucius on his own.

The pot is clasped at each side by a gilt-bronze handle formed of foliate scrolls. The two handles are joined by a threaded rod extending the full width of the interior of the pot, brazed to one handle and attached to the other by means of a screw. The hexagonal foot of the vase is held by a deep gilt-bronze mount around which are repeating ovals enclosing cabochons. This in turn is clasped by six scrolled and foliate feet at the angles. The hexagonal neck of the pot is mounted with a collar of repeating ovaloes and clasped at four of the corners by a cluster of leaves; the two remaining corners are mounted with short sprays of leaves springing from the handles (fig. 19A). The porcelain lid, which fits into the collar mount, is surmounted by a gilt-bronze finial of pyramidal form that supports a cluster of berries held by scrolling acanthus leaves.

MARKS

The porcelain lid is impressed with an illegible seal mark now covered by the gilt-bronze finial.

COMMENTARY

The porcelain pot was originally a lidded teapot. The form is identical to contemporary metalwork vessels. The spout, the tall arched handle, and the finial, probably in the form of a seated Buddhist lion, have

FIG. 19A

been removed, thus converting it from a utensil into a purely decorative object (fig. 19B).

The porcelain lid is discolored and has a heavy cracklelure; the corners are chipped. Complete *blanc-de-chine* teapots of this type are known. Unmounted specimens are to be found in the British Museum, London[1] (fig. 19C), at Hampton Court, England (once in the collection of Queen Mary, 1689–94),[2] and at Blenheim Palace, England. Another is referred to in the inventory of white tea wares belonging to Augustus the Strong of Saxony (1670–1733). The inventory was begun in 1721, and the pot is the first entry in this section.[3] A complete wine pot, with an early-eighteenth-century gilt-bronze addition to the spout and the lid attached to the handle

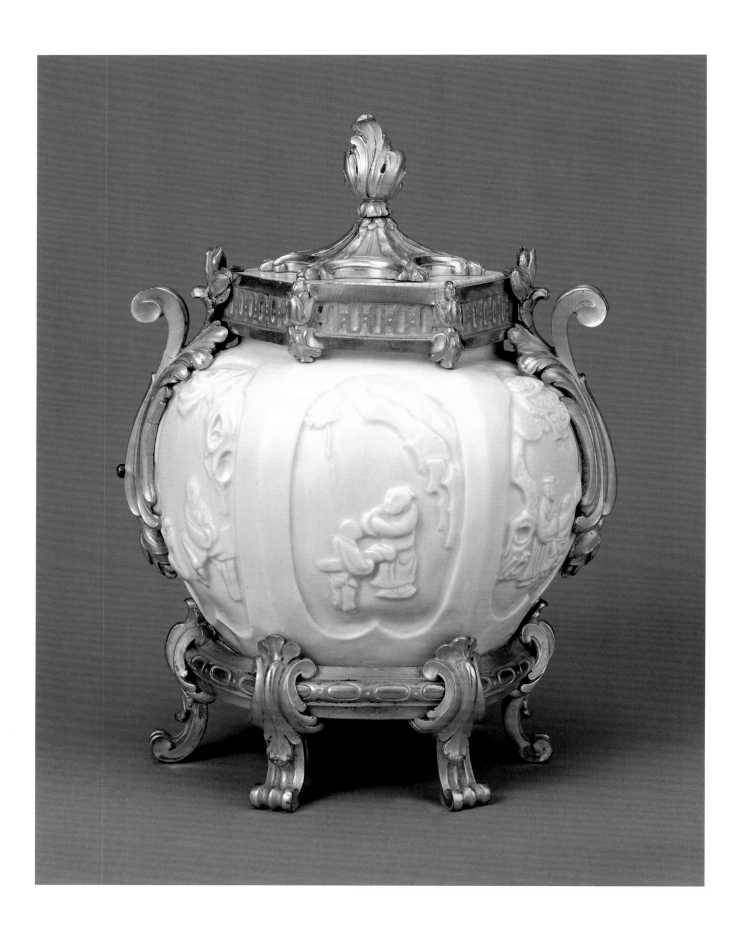

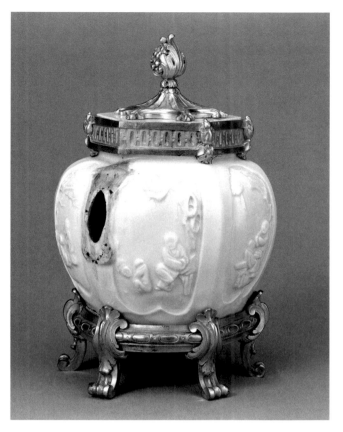

FIG. 19B

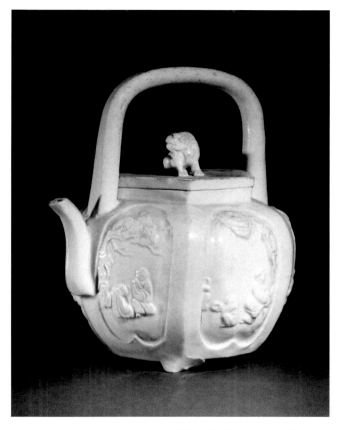

FIG. 19C. A complete, mounted *blanc-de-chine* teapot in the British Museum. *London, ©The British Museum.*

by means of a bronze chain, is in a Dutch private collection.[4] Vessels of this form must have been known to the potters at the Staffordshire factories in England. They produced red stoneware teapots closely following this model in the early eighteenth century,[5] and, by the middle of the century, Wheildon-type salt glaze white stoneware teapots were made from block molds.[6]

The gilt-bronze mounts appear to be of unique model.

PUBLICATIONS

Wilson 1979, p. 44, no. 9; Watson 1980, p. 35, no. 11; Watson 1981, p. 30; Bremer-David et al. 1993, p. 156, no. 263.

EXHIBITIONS

Chinese Porcelains in European Mounts, The China Institute in America, New York, 1980, no. 11.

PROVENANCE

Kraemer et Cie, Paris, 1960s; Henry Ford II, Grosse Pointe Farms, Michigan; sold from the collection of Henry Ford II at Sotheby Parke Bernet, New York, February 25, 1978, lot 61; acquired by the J. Paul Getty Museum from Partridge Fine Arts, Ltd., London, in 1978.

NOTES

1. Soame Jenyns, *Later Chinese Porcelain: The Ch'ing Dynasty (1644–1912)* (London, 1971), no. 2, pl. CXIX.
2. Lane 1949–50, pl. 8c.
3. Donnelly 1969, p. 121.
4. Lunsingh Scheurleer 1980, p. 287, fig. 230.
5. Jarry 1981, p. 91, pl. 86.
6. An example of both the teapot and the block mold from which it was made can be seen at the Delhom Gallery and Institute, The Mint Museum of Art, Charlotte, North Carolina (acc. no. 65.48.DC.EPy.SG121 and SG150).

20. PAIR OF VASES

THE PORCELAIN: Chinese (Kangxi), 1662–1722
THE GILT-BRONZE MOUNTS: French, circa 1770–75
HEIGHT: 1 ft., 7¼ in. (49 cm); WIDTH: 9¾ in. (24.7 cm); DEPTH: 7⅞ in. (20 cm)
92.DI.19.1–.2

DESCRIPTION

These vases of double-gourd form are covered with a black glaze. Much of their surface was once gilded but only traces of gold remain. The upper part of each gourd was gilded with flowers whose roots are tied with a ribbon; the body of the lower section was decorated with floral scrolls and chrysanthemums; and the shoulders with a band of six floral blossoms and a band of lotus at the base. A "ghost" of these designs can be seen where the mordant has bitten into the glaze (fig. 20A).

Each vase is mounted with gilt bronze from the lip down the neck to the shoulder, at the hip, on the sides, and around the foot. A band decorated with a Vitruvian scroll on a stippled ground separates the top section of the neck mount, which is pierced in vertical bands, from the pierced network of long, stylized leaves, which alternate with long stems that end in leafy buds and are draped over the shoulder (fig. 20B). The hip of each vase is set with two concentric bands separated by bunches of oak leaves and acorns bound with ribbons. Guttæ depend from the lower band. U-shaped handles decorated with piasters join the two bands at the sides of each vase (fig. 20C). Bunches of oak leaves and acorns bound with ribbon hang from the handles, which extend down the sides of the vase and are joined to the foot mount with pinned hinges. Each foot mount is decorated with a band of leaves on a stippled ground.

MARKS

The potter's mark of two concentric circles is painted in underglaze blue on the underside of each vase.

The foot mounts are stamped with the letters LH in a rectangle, presumably the initials of the former owner, Laurent Heliot (fig. 20D).[1]

COMMENTARY

The lips of the vases have been cut or ground down and the gilding on the porcelain is worn. The vases were probably once fitted with small gilt-bronze lids, now lost.

Vases of this form were first made in bronze during the Tang dynasty (618–906). They imitate the shape of a double-gourd, which since ancient times was used to carry water.[2] Vases of this type are known as mirror black ware (wu ju). They were often decorated with gilt floral and foliate patterns but, as is usually the case, the light Chinese gilding has mostly worn away. Nonetheless, the ghost of the pattern is visible on the surface of the glaze. It results from the presence of elements, such as bismuth of nitrate, used to consolidate the gold particles into a liquid form that could be painted onto the glaze. During firing, these elements were etched into the surface of the glaze beneath the gilded areas.

The gilding was added last and fired at a much lower temperature (about 700°C) than that used for the body and glaze. High-firing would have reactivated the glaze beneath. As a result, the gold did not adhere well to the limited surface area of the very hard glaze and, because of the low firing temperature, remained soft and wore easily when abraded.[3] There is mention of garlic juice being used as a mordant, but the exact recipe is not known.

Mirror black wares were very fashionable in France in the early eighteenth century. The Jesuit missionary Père François-Xavier d'Entrecolles (1644–1741) described their manufacture at Jingdezhen in a letter of September 1, 1712.[4] He reported that the black glaze, which he compared to oil, was made up of iron oxide and cobalt manganese, elements normally used in limited quantity for brown and blue glazes, respectively. Vessels were repeatedly dipped and high-fired with this glaze until their surface was saturated with color and

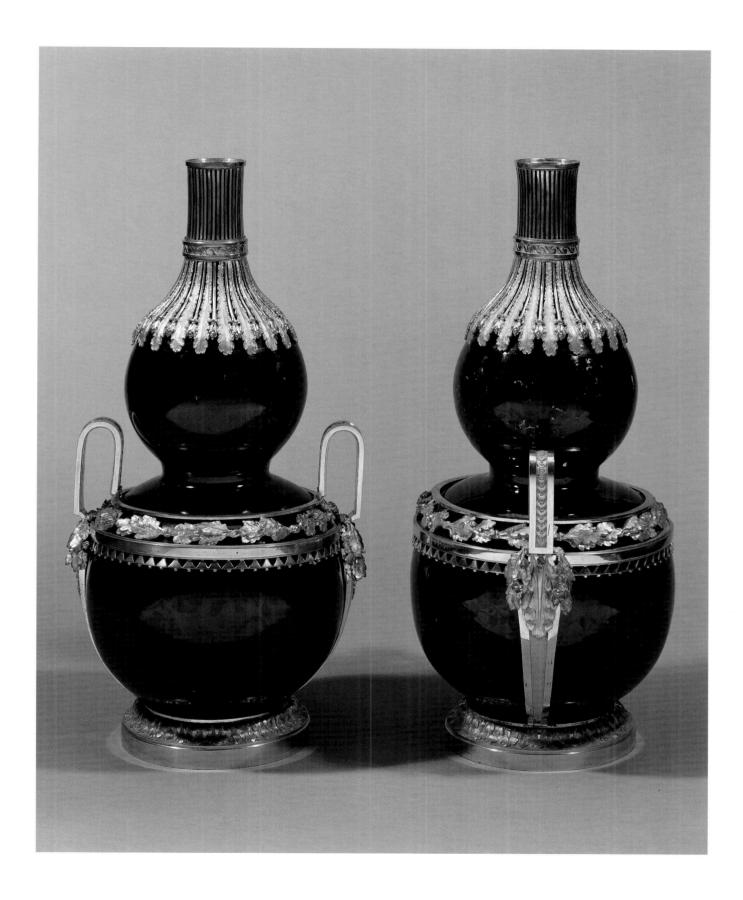

FIG. 20A. The "ghost" of the original gilded design on the porcelain.

appeared black. This process yielded their intensely hard surface which when polished gained a lustrous metallic sheen, hence the name mirror black. The purple and brown that make up the black can be seen on the Getty Museum's vases at the lip and foot, where the glaze is thin.

Double-gourd vases were mounted in France throughout the eighteenth century but appeared to greatest advantage in neoclassical mounts. The sobriety of this antique style, which gained wide acceptance by about 1765, suited the pure geometry of the double-gourd form.[5] On the Museum's vases this relationship is furthered by the contrast between the black glaze and the gilt-bronze mounts. This aesthetic aligned itself with the renewed interest during the neoclassical period in furniture set with panels of Boulle marquetry and Japanese lacquer, which remained fashionable. By contrast, most double-gourd vases with rococo mounts are celadons, such as the vase at the Huntington Library, San Marino.[6]

The gilt-bronze mounts on these vases appear to be of unique form. The U-shaped handles may imitate ceramic handles of the same shape seen on other double-gourd vases, such as the example at the Rijksmuseum, Amsterdam, that joined the body of the vase at the base of the neck and the top of the hip.[7] Although the identity of the *bronzier* is not known, the original design and high quality of the bronze casting and chasing indicate a craftsman of significant accomplishment.

FIG. 20B

Fig. 20C

PUBLICATIONS

Drouot, 1985–86, l'art et les enchères (Paris, c. 1986), pp. 210, 302; "Acquisitions/1992," *GettyMus* 21 (1993), p. 140, no. 64; Bremer-David et al. 1993, pp. 156–57, no. 264.

PROVENANCE

Laurent Heliot, Fils, Paris; sold Hôtel Drouot, Paris, December 3, 1985, no. 55; B. Fabre et Fils, Paris; acquired by the J. Paul Getty Museum from B. Fabre et Fils, Paris, in 1992.

FIG. 20D. Detail of the foot mount showing the stamp LH.

NOTES

1. Laurent Heliot was a prosperous Parisian dealer between the wars who specialized in Chinese porcelain. His collections were dispersed by his widow. Christie's and Sotheby's also sold objects from Heliot's stock. I am grateful to Michel Fabre for this information.

2. For the iconographic significance of the double-gourd form, see Watson and Dauterman 1966–70, vol. 4, p. 417. The prominent *marchand-mercier* Lazare Duvaux used the term *calebasse* to describe vases of this shape. On October 18, 1755, he sold to the collector Blondel d'Azincourt: *"deux vases céladon en forme de calebasse, à relief, montées avec des branchages dorés, 960 livres"* (*Livre-journal de Lazare Duvaux* 1873, vol. 2, p. 258, no. 2259).

3. I am grateful to Stephen Koob, formerly objects conservator, Freer Gallery of Art and Arthur M. Sackler Gallery, and Pamela Vandiver, senior ceramic research scientist, Conservation Analytical Laboratory, both of the Smithsonian Institution, for their assistance.

4. Père d'Entrecolles's first missionary area, in 1689, was Jiangxi province, and many of his parishioners lived and worked at Jingdezhen. In his letter of 1712 to Père Orry, *procureur* of the Chinese and Indian missions, he describes the composition, preparation, modeling, decoration, and glazing of porcelain and the stocking of the kilns. His collected correspondence was published as *Lettres édifiantes.* See Beurdeley and Raindre 1987, pp. 160, 162.

5. The neoclassical mounts on a pair of celadon double-gourd vases in the Wrightsman Collection are well married to the form of the vessels. See Watson and Dauterman 1966–70, vol. 5, p. 417, no. 191 A–B, height 1 ft., 2½ in. (36.8 cm).

6. Robert R. Wark, *French Decorative Art in the Huntington Collection*, 3d ed. (San Marino, 1979), p. 83, fig. 103, height 1 ft., 4½ in. (41.2 cm). This vase is thought to date from the Ming dynasty (1388–1644).

7. *Clair de lune* double-gourd vase with gilt-bronze mount of about 1745–50, height 1 ft., ½ in. (32 cm), Rijksmuseum, Amsterdam, in Lunsingh Scheurleer 1980, p. 311, fig. 279.

21. STANDING VASE

THE PORCELAIN: Chinese (Qianlong), mid-eighteenth century
THE GILT-BRONZE MOUNTS: French (Paris), circa 1785, attributed to Pierre-Philippe Thomire (1751–1843)
HEIGHT: 2 ft., 7¾ in. (81 cm); DIAMETER: 1 ft., 10¼ in. (56.5 cm)
70.DI.115

DESCRIPTION

The large oviform porcelain vase is covered with a powder blue glaze on the exterior; on the interior the blue glaze is irregularly spattered. It is mounted on four tall splayed legs of gilt bronze terminating in goats' hooves. Below the rim of the vase there are four gilt-bronze satyrs' heads. The heads are linked by swags of vine leaves, with tendrils and bunches of grapes.

Above each leg, the vase is clasped by vertical bands of gilt bronze. These bands are fluted and have rope moldings along their inner edges. The satyrs are crowned with vine leaves above which elaborately curling goats' horns spring to rest on the gilt-bronze rim of the vase (figs. 21A and 21B). This rim is mounted with alternating gadroons and wheat ears above a rope molding.

The vase is surrounded by an open-work band of oak leaves and acorns, beneath which a large grape cluster depends from a cup of gadrooned gilt bronze (fig. 21C). Above the hoofed feet, the legs evolve into elongated acanthus leaves.

The hooves rest on projections from the deep red griotte marble plinth. This is inset around the sides with rectangular panels of milled gilt bronze. The top of the base is inset at the center with a corolla of gilt-bronze leaves surrounded by an inset milled band and framed at each side by a bead molding.

The marble base rests on four short bulbous gilt-bronze feet.

MARKS

The undersurface of the porcelain vase is faintly inscribed in black ink "178(?)."

COMMENTARY

The vase was probably originally intended to hold koi. The type of glaze on the outside of the vase became known as *"bleu soufflé."* A powdered pigment was blown through a bamboo tube, covered at the end with a piece of fine gauze, while the unfired clay was still moist. This operation was repeated several times so as to produce a deep, unified color.

The interior of the vase is also covered with a glaze that was applied by blowing. It shows a mottled blue-and-white, and was known as *"salan,"* or sprinkled blue. Both glazes were first achieved in the Ming dynasty, during the Xuande reign (1426–35). These classic colors were revived in the Kangxi manufactories.

Two other mounted vases of the same design are known. One of these is in the British Royal Collection[1]; the other was sold in Paris in 1970.[2] There was probably a fourth, making either a set or two pairs. The mounts on these vases have been attributed from time to time both to Pierre Gouthière (1732–1813/14) and to Pierre-Philippe Thomire (1751–1843). The style of the mounts conforms to the early work of the latter *bronzier*. The swags of vine leaves and grapes closely resemble those found decorating the sides of a porphyry urn on a stand, attributed to Thomire, in the Wrightsman Collection at the Metropolitan Museum of Art, New York.[3] Other mounts on that elaborate piece can be compared with documented works by Thomire. The band of oak leaves and acorns around the base of the column is similar in design to that found on two mounted Sèvres vases made by Thomire in 1783 and 1784.[4] Each of these vases is set in a cup of leaves of comparable form to those found at the base of the Wrightsman porphyry urn. The ribbed and flattened horns, there springing from goats' heads, may also be compared with the curling horns on

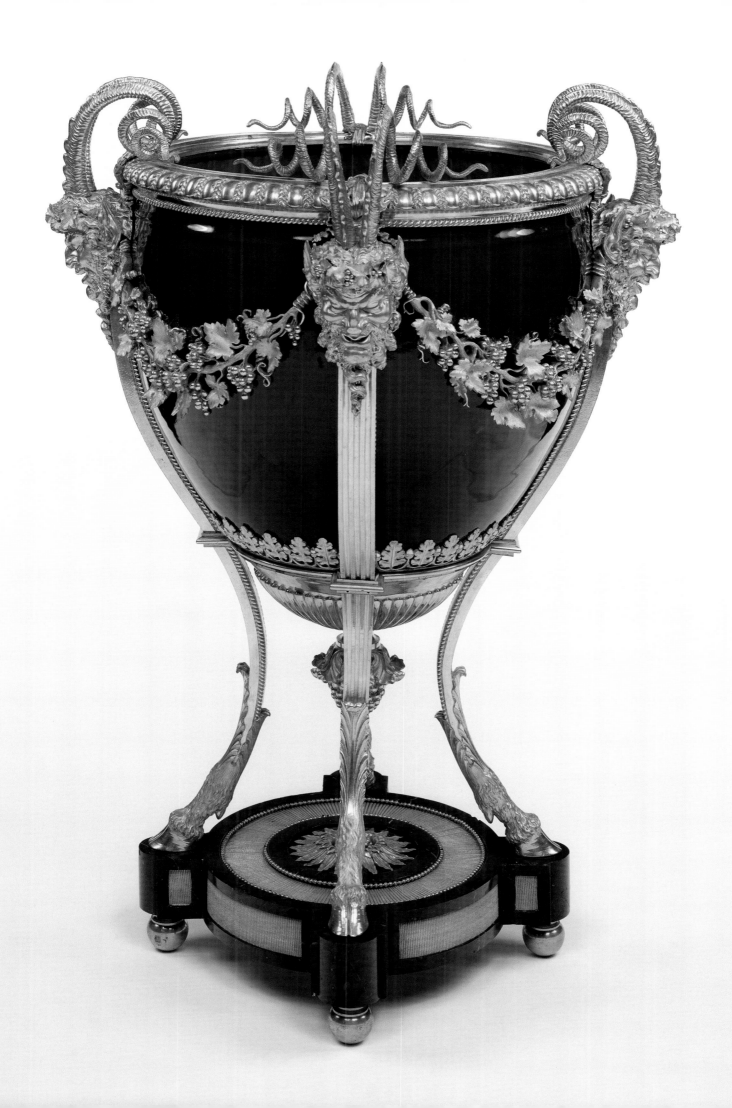

the Getty Museum vase. In turn, these goats' heads are almost identical to those found on a Sèvres vase dated 1814 in the Wellington Museum at Apsley House, London.[5] These last heads were modeled by Thomire, and the surviving document shows that he was paid 85 francs for the work. By inference it is therefore possible to attribute the mounts of the Getty vase to Thomire.

The vase was acquired by Rosenberg and Stiebel from Count Alfred Potocki. It is reputed to have been bought at the Revolutionary sales by Princess Isabella Lubormirska, who, after the death of her husband in 1783, spent much time in Paris and became an intimate friend of Marie-Antoinette. At the outbreak of the French Revolution, she returned to her Polish estates at Lancut, and the vase descended through her family to Count Alfred, her great-great-grandson. While there is no documentary evidence to prove that the vase was acquired at the Revolutionary sales, it is certainly true that the princess's ties with France and its royal family were strong.[6] It is therefore possible that the vase was once in French royal possession.

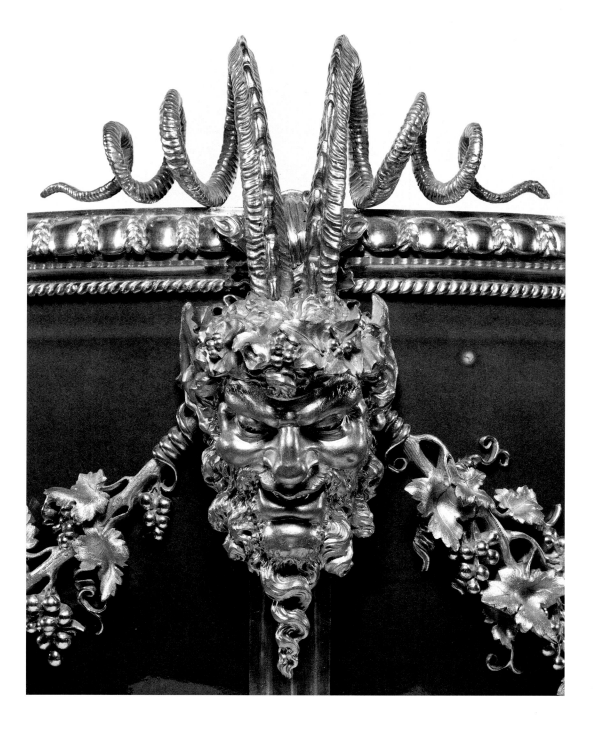

FIG. 21A

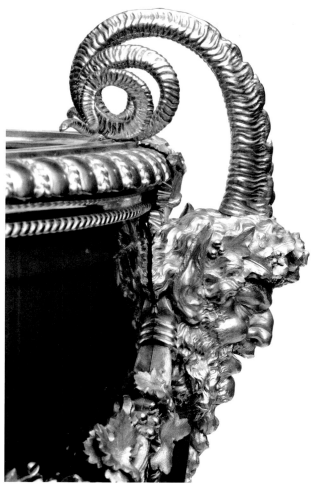

FIG. 21B

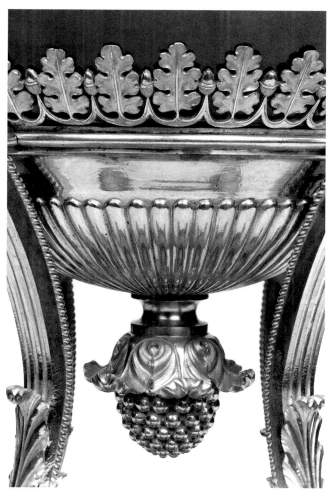

FIG. 21C

PUBLICATIONS

Burton B. Fredericksen, ed., *The J. Paul Getty Museum* (London, 1975), p. 181; Wilson 1977, p. 88, no. 113; *Sèvres Porcelain from the Royal Collection: The Queen's Gallery* (London, c. 1979), pp. 31–32, no. 11; Lunsingh Scheurleer 1980, p. 308, fig. 275; Michel Beurdeley, *La France à l'encan, 1789–1799* (Fribourg, 1981), p. 118; Hans Ottomeyer and Peter Pröschel, *Vergoldete Bronzen: Die Bronzearbeiten des Spätbarock und Klassizismus* (Munich, 1986), vol. 1, pp. 268–69; Rosalind Savill, *Sèvres* (London, 1988), vol. 1, p. 469; Bremer-David et al. 1993, p. 157, no. 266.

PROVENANCE

(?) Princess Isabella Lubomirska, after circa 1793; Count Alfred Potocki, Castle Lancut, Poland, by descent, removed 1944; Rosenberg and Stiebel, New York, 1953; acquired by J. Paul Getty from Rosenberg and Stiebel in December 1953.

NOTES

1. *Carlton House: The Past Glories of George IV's Palace* (The Queen's Gallery, Buckingham Palace, 1991–92), pp. 96–97, no. 49. Acquired by George IV from an unknown source, it was in the Rose Satin Drawing Room at Carlton House by 1813. It is now at Windsor Castle.
2. Collection of Madame Vigier, Palais Galliera, Paris, June 2–3, 1970, no. 82.
3. Watson and Dauterman 1966–70, vol. 3, pp. 70–74, no. 306.
4. Juliette Niclausse, *Thomire, fondeur-ciseleur (1751–1843): Sa vie, son oeuvre* (Paris, 1947), pls. 8–9.
5. W.M. 86162-1948.
6. See Pierre Verlet, *French Royal Furniture* (London, 1963), p. 69: "During the Directory, the Princess Potocki bought twenty coachloads of furniture in Paris for their castles in Poland. The dealers assured them, rightly or wrongly, that it all came from Versailles." The name Potocki does not appear in the lists of buyers at the Revolutionary sales nor is the name found among similar lists of buyers of objects excluded from the public sales. I am grateful to Christian Baulez for this information.

22. VASE

THE PORCELAIN: Chinese (Kangxi), 1662–1722
THE GILT-BRONZE MOUNTS: French (Paris), circa 1770, attributed to Pierre Gouthière (1732?–1813/14, master 1758)
HEIGHT: 1 ft., 9¼ in. (54.2 cm); WIDTH: 10⅝ in. (27 cm); DEPTH: 9⅞ in. (25 cm)
87.DI.137

DESCRIPTION

The surface of the vase is incised with magnolias, rocks, geese, a moon or a sun, and a bamboo plant around the base. It is covered with a dark purple glaze (fig. 22A).

The vase is mounted with gilt bronze around the lip and foot. A band of alternating gadroons and small leafy branches encircles the rim. Placed immediately below is a grapevine with leaves and fruit. Goats' heads are mounted on the side of the vase beneath the grapevine, their horns curled back and up onto the rim. From their necks depend trophies of crossed branches of grapevine with leaves and fruit, bound by a ribbon to panpipes (figs. 22B and 22C). The vase is supported on four lion's paws. At the sides double scrolling acanthus branches rise from the feet, each terminating in a cock's head. The scrolls support seated baby satyrs eating grapes (fig. 22D). At the front and back of the vase the lion's paw feet are topped with acanthus which extend over the foot mount. The latter is decorated at the top edge with a twisted band above a torus molding of laurel leaves and berries. A mount of opposed fruiting acanthus leaf scrolls flanked by vines rises above the foot rim at the front and back of the vase.

FIG. 22A

MARKS None.

COMMENTARY

The vase is intact and has not been cut down. Vases of this form were known as *rouleaux* during the eighteenth century because they were tall and cylindrical. The origin of this form is a ritualistic bronze vessel called a *gu*, which was first used in China during the Shang dynasty (circa 1600–1000 B.C.). The purple glaze was a new type, invented at the imperial kilns during the Kangxi reign. The magnolia is the symbol of nobility and purity. Its Chinese name, *yulan*, consists of two characters: *yu* for jade (long life) and *lan* for cymbidium (purity). Purple magnolia blossoms were used medicinally in China.

Originally, this vase was probably one of a pair. An almost identically mounted pair in the collections of the Baron and Baronne Cassel van Doorn was sold at auction in 1954 and again in 1981 from the Bensimon

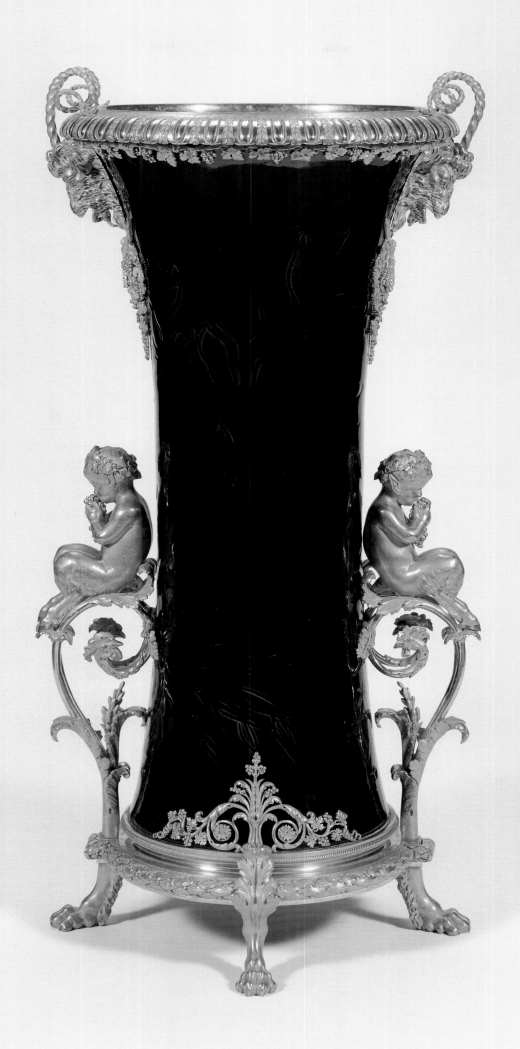

Collection, Paris.[1] Two related pairs with dark blue porcelain and similar gilt-bronze mounts were exhibited in 1970 and sold at public auction in 1986.[2] The mounts of all of these vases are in the style of the Parisian bronze chaser and gilder Pierre Gouthière.

The casting and chasing of the mounts on the Getty Museum's vase are of very high quality. The *matte* gilding of the mounts is a typical finish given Parisian bronzes during the 1780s. Its soft appearance is contrasted with the reflective surfaces of neighboring burnished areas.

Pierre Gouthière produced some of the finest gilt bronze of the period for members of the royal family and the nobility, such as Marie-Antoinette, Louis-Marie-Augustin duc d'Aumont (1709–1782), and his daughter the duchesse de Mazarin (1736–1781). For the duc d'Aumont he mounted a pair of bluish-purple ewers[3] (fig. 22E); they were acquired in 1782 by Louis XVI at the sale after the death of the duke. The base rims on the ewers are identical to those on the Museum's vase, except that all four lion's paws on the ewers are joined to the foot mount with acanthus leaf. The scrolling acanthus leaf mount above the feet takes the same form, but the flanking vines have been replaced by partial anthemia. Contemporary descriptions mention that baby satyrs sat above the handles of the ewers. They are now missing but were probably of the same model as those found on the Museum's vase. The mounts on the Museum's vase are attributed to Gouthière on the basis of this comparison and were perhaps designed by François-Joseph Bélanger (1744–1818), architect and designer to the duc d'Aumont. Gouthière and Bélanger collaborated for many years following their appointments by the duke to the *Menus Plaisirs* in 1767. The Museum's vase does not appear in the sale of the duc d'Aumont in 1782[4] or in the inventory of Marie-Antoinette's bronze-mounted porcelains that were confiscated in 1793 during the Revolution.[5]

PUBLICATIONS

"Acquisitions/1987," *GettyMusJ* 16 (1988), pp. 178–79, no. 74; Bremer-David et al. 1993, p. 157, no. 265.

PROVENANCE

Acquired by the J. Paul Getty Museum from Michel Meyer, Paris, in 1987.

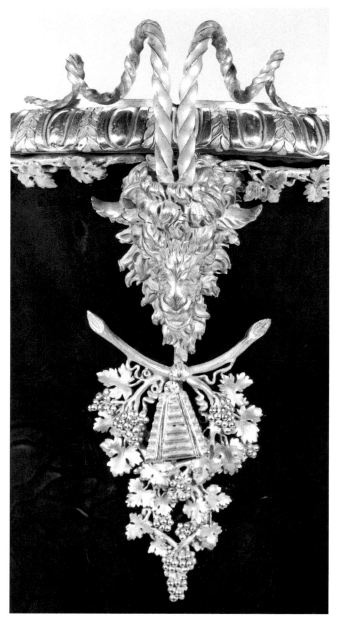

FIG. 22B

NOTES

1. Hôtel Drouot, Paris, March 9, 1954, no. 52, and Hôtel Drouot, Paris, November 18–19, 1981, no. 112. These pairs of vases do not have a grapevine mount with leaves and fruit below the lip mount.
2. The first pair was exhibited at the fifth biennale in Paris in 1970, by the Parisian dealer Jacques Perrin. The second pair was sold at Sotheby's, Monaco, June 16, 1986, no. 425.
3. Christie's, London, June 9, 1994, lot 35. These ewers are of the same form as the ewers discussed in catalogue no. 2.
4. *Le cabinet du duc d'Aumont* (reprint, New York, 1986).
5. The ewers were among a group of objects entrusted by Marie-Antoinette to the *marchands-merciers* Dominique Daguerre and Martin-Eloi Lignereux in 1789. They divulged the whereabouts of the objects in 1793, and an inventory was taken before they were moved to the museum (today the Musée du Louvre).

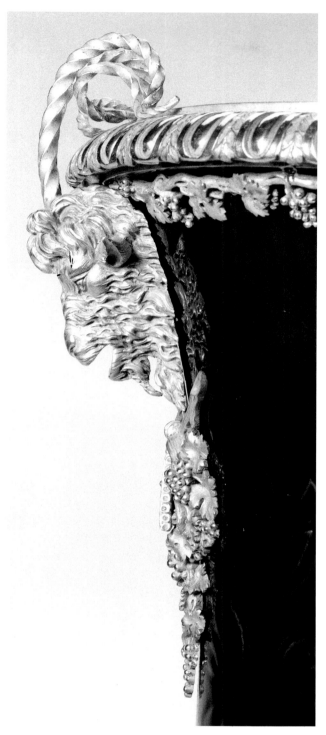

FIG. 22C

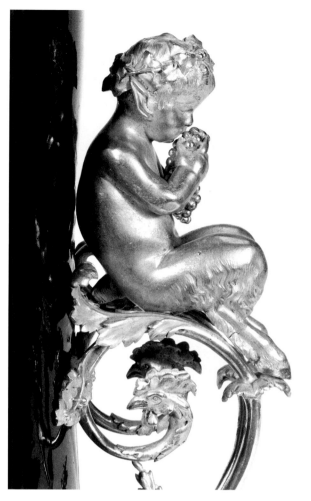

FIG. 22D

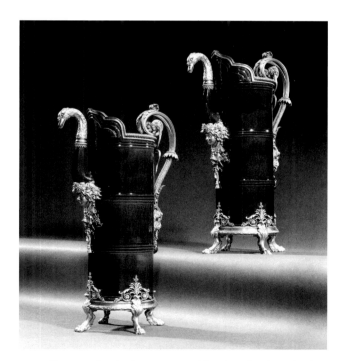

FIG. 22E. A pair of ewers mounted by Pierre Gouthière for the duc d'Aumont, subsequently owned by Marie-Antoinette. *Photo: Courtesy of Christie's Images.*

Appendix
Chinese Dynastic and Imperial Reign Dates

Dynasty	Reign Title	Dates
Yuan		**1279–1368**
Ming		**1368–1644**
	HONGWU* (Hung-wu)	1368–1398
	YONGLE (Yung-lo)	1403–1424
	XUANDE (Hsüan-tê)	1426–1435
	QUINGDAI (Ching-t'ai)	1450–1457
	CHENGHUA (Ch'êng-hua)	1465–1487
	HONGZHI (Hung-chih)	1488–1505
	ZHENGDE (Chêng-tê)	1506–1521
	JIAJING (Chia-ching)	1522–1566
	LONGQING (Lung-ch'ing)	1567–1572
	WANLI (Wan-li)	1573–1619
	TIANQI (T'ien-ch'i)	1621–1627
	CHONGZHENG (Ch'ung-chên)	1628–1643
Qing (Ch'ing)		**1644–1912**
	SHUNZHI (Shun-chih)	1644–1661
	KANGXI (K'ang-hsi)	1662–1722
	YONGZHENG (Yung-chêng)	1723–1735
	QIANLONG (Ch'ien-lung)	1736–1795
	JIAQING (Chia-ch'ing)	1796–1820
	DAOGUANG (Tao-kuang)	1821–1850

*The now-standard Pin Yin romanization of Chinese characters officially superceded the Wade Giles system in the 1960s.

Glossary

ARITA
A center of ceramic production on the island of Kyōshō in Japan. Very pure porcelain clays were found nearby. In the mid-sixteenth century many small private kilns sprang up in Arita and much porcelain for export was produced there.

CELADON
A widely used term to describe high-fired porcellaneous wares with blue-green glazes. Silica glazes with iron oxide in suspension reduce in wood-fueled kilns to the characteristic blue-green tones. In coal-fueled firing, the glazes oxidize to tones of darker olive. The term probably derives from the character of the shepherd Céladon, who was dressed in green in a play based on the romance *L'Astrée* (1610) by Honoré d'Urfé.

CISELEUR
A chaser of metalwork. When a bronze emerged from the casting process, its surface was rough and had to be finished by chasing (hammering with a tool resembling a small screwdriver with a circular end). By chasing various parts of the surface of a bronze with tools of differing size, great vitality was imparted to the finished object. Chased areas were sometimes contrasted with burnished surfaces. Chasing was carried out before the bronze was gilded.

CRACKLE
A network of irregular cracks in the glaze surface, caused by different rates of expansion and contraction of the glaze and clay body while the ceramic cools in the kiln. The effect is achieved by adding steatite to the glaze. Originally produced by accident, crackle is found in Chinese ceramics from the Han dynasty. Later it was developed deliberately for decorative effect. Ink, charcoal, or vermilion was rubbed onto the surface to emphasize the cracks.

FAMILLE VERTE
French descriptive term introduced by Albert Jacquemart in the mid-nineteenth century when the systematic study of oriental porcelain was first undertaken in Europe. It bears no relation to Chinese descriptive terms. The *famille vert* enamels were developed during the reign of the Kangxi emperor (1662–1722). The color takes its name from a brilliant transparent green often used in combination with iron red, blue, yellow, and aubergine.

FONDEUR
One who casts metals; the craftsman who casts the bronze mounts for porcelain.

GADROON
A short rounded fluting or reeding applied as a decorative pattern usually along a molding. The fluting is sometimes twisted.

IMARI
A European term to describe Japanese porcelain made at Arita, which was exported through the port of Imari from the seventeenth century onward. The decoration typically consists of a dark underglaze blue with red and gold overglaze enamels, sometimes with touches of turquoise blue and green enamel.

LUTE
Thinned porcelain clay used to pack a joint; a raised ring around a porcelain vessel originally created in two or more parts.

ORMOULU
A contraction of the words *bronze doré d'or moulu* (gilt bronze). The bronze was generally gilded by the mercury process in which the gold was ground or powdered (*moulu*) to form an amalgam with the mercury and attached to the bronze by the application of heat.

POTPOURRI
A mixture of dried flowers, herbs, and spices treated to scent a room; also the vessel holding the mixture.

ROULEAU VASE
A tall vase first produced in China from the twelfth century. The body is cylindrical with narrow, flat shoulders; the neck is low and wide; and the mouth is flared.

SOUFFLÉ GLAZE
Glaze applied to the ceramic body by blowing a powdered pigment through a screened tube to achieve a subtly mottled surface.

STRAPWORK
A decorative motive of interlacing bands or straps. It can be either executed in relief or painted on a flat surface.

Select Bibliography

Ayres, John, Oliver Impey, and John Mallet. *Porcelain for Palaces: The Fashion for Japan in Europe, 1650–1750*. London, 1990.

Belevitch-Stankevitch, H. *Le goût chinois en France au temps de Louis XIV*. 1910. Reprint, Geneva, 1970.

Bellaigue, Geoffrey de. *Furniture, Clocks, and Gilt Bronzes. The James A. de Rothschild Collection at Waddesdon Manor*. 2 vols. Fribourg, 1974.

Beurdeley, Michel, and Guy Raindre. *Qing Porcelain: Famille Verte, Famille Rose, 1644–1912*. New York, 1987.

Bushell, Stephen W. *Oriental Ceramic Art . . . from the Collection of W. T. Walters*. New York, 1896.

Courajod, Louis, ed. *Livre Journal de Lazare Duvaux, marchand-bijoutier ordinaire du Roi 1748–1758*. Paris, 1873.

Donnelly, P. J. *Blanc de Chine: The Porcelain of Têhua in Fukien*. London, 1969.

Impey, Oliver. *Chinoiserie: The Impact of Oriental Styles on Western Art and Decoration*. London, 1977.

Kerr, Rose. *Chinese Ceramics*. Hong Kong, 1998.

Li, He. *Chinese Ceramics: A New Comprehensive Survey from the Asian Art Museum of San Francisco*. New York, 1996.

Lunsingh Scheurleer, D. F. *Chinesisches und japanisches Porzellan in europäischen Fassungen*. Brunswick, 1980.

Ottomeyer, Hans, and Peter Pröschel. *Vergoldete Bronzen: Die Bronzearbeiten des Spatbarock und Klassizimus*. 2 vols. Munich, 1986.

Ricci, Seymour de. *Catalogue of a Collection of Mounted Porcelain Belonging to E. M. Hodgkins*. Paris, 1911.

Sargentson, Carolyn. *Merchants and Luxury Markets: The Marchands Merciers of Eighteenth-Century Paris*. Malibu, 1996.

Verlet, Pierre. *Les bronzes Dorés Français du XVIIIe siècle*. Paris, 1987.

Watson, Francis. "Chinese Porcelain in European Mounts." *Orientations* 12, no. 9 (September 1981), pp. 26–33.

Watson, Francis. *Mounted Oriental Porcelain*. Washington, D.C., 1986.

INDEX